Take Better Family Photos

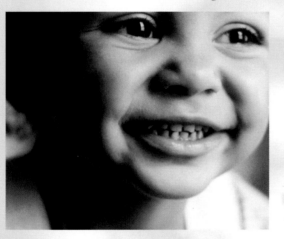

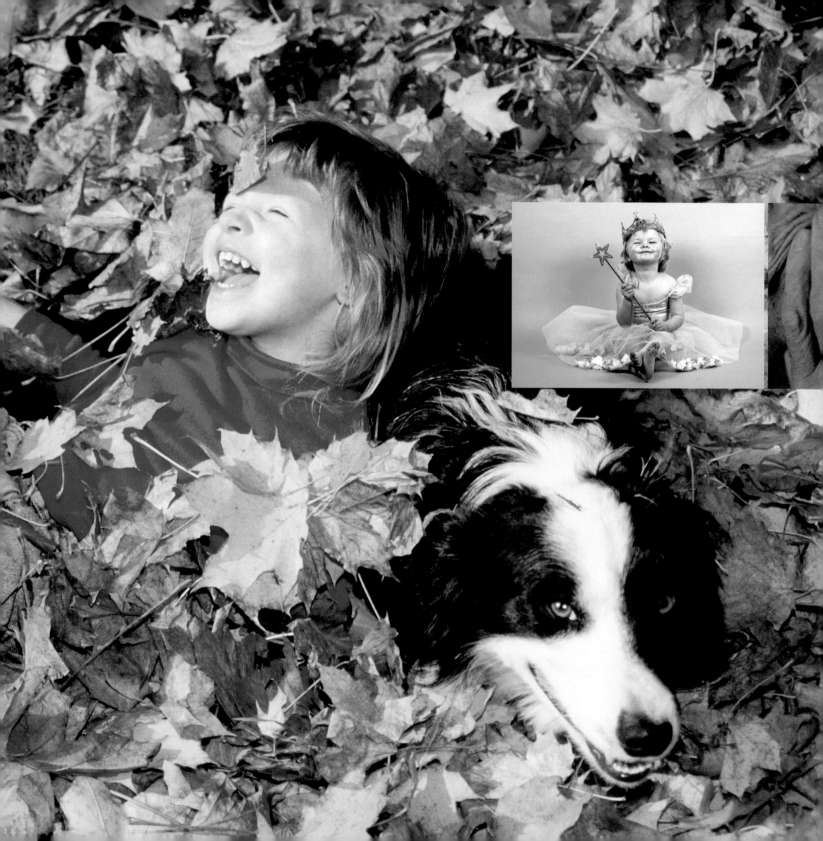

Take Better Family Photos

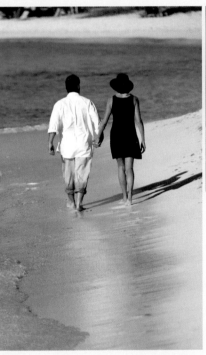
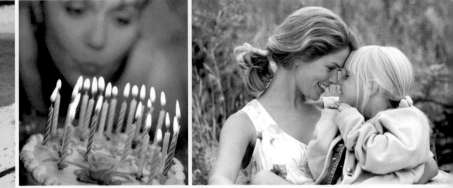

An Easy-to-Use Guide
for Capturing Life's
Most Treasured Events

Steve Bavister

Reader's Digest

THE READER'S DIGEST ASSOCIATION, INC.
Pleasantville, New York/Montreal

A Reader's Digest Book

Copyright © 2002 Quarto
Publishing Inc.

All rights reserved.
Unauthorized reproduction,
in any manner, is prohibited.

Reader's Digest is a registered
trademark of the Reader's
Digest Association, Inc.

Library of Congress Cataloging
in Publication Data

Bavister, Steve. Take better family
photos : an easy-to-use guide
for capturing life's most
treasured events/
by Steve Bavister.
p. cm.
ISBN 0-7621-0377-9
1. Portrait photography. I. Title.
TR680 .B348 2002
778.9'2—dc21 2002021399

Address any comments about
Take Better Family Photos to:
The Reader's Digest Association, Inc.
Adult Trade Publishing
Reader's Digest Road
Pleasantville, NY 10570-7000

For more Reader's Digest products and
information, visit our website:
www.rd.com (in the U.S.)
www.readersdigest.ca (in Canada)

This book was conceived,
designed, and produced by
Quarto Publishing plc
The Old Brewery
6 Blundell Street
London N7 9BH

FOR QUARTO PUBLISHING
Project Editor **Nadia Naqib**
Art Editor **Karla Jennings**
Designers **Karin Skånberg,
Michelle Stamp**
Text Editors **Mary Senechal,
Sarah Hoggett**
Assistant Art Director **Penny Cobb**
Picture Research **Sandra Assersohn**
Photographer **Will White**
Illustrator **Raymond Turvey**
Photoshop Designer **Trevor Newman**
Indexer **Dorothy Frame**
Art Director **Moira Clinch**
Publisher **Piers Spence**

QUAR.SMIL

FOR READER'S DIGEST
Contributing Editors
Susan Byrne, Vicki Fischer
Canadian Contributing Editor
Pamela Johnson
Project Designer **George McKeon**
Executive Editor, Trade Publishing
Dolores York
Senior Design Director
Elizabeth Tunnicliffe
Editorial Director
Christopher Cavanaugh
Director, Trade Publishing
Christopher T. Reggio
Vice President & Publisher,
Trade Publishing **Harold Clarke**

Manufactured by Pica Digital
PTE Ltd, Singapore

Printed by Midas Printing International
Limited, China

1 3 5 7 9 10 8 6 4 2

Contents

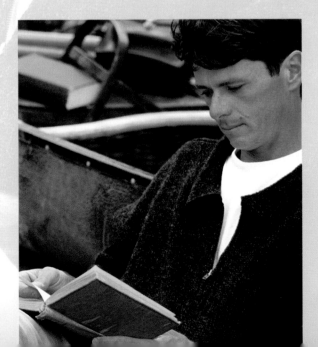

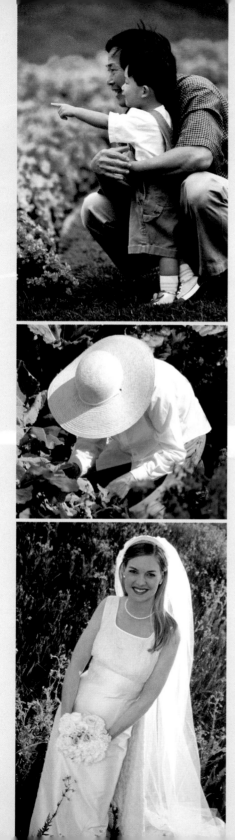

Introduction

It would be impossible to estimate how many of the billions of pictures taken since photography was invented 160 years ago have been of people—but the proportion is certain to be high.

People are the most popular subject on the planet—everyone takes pictures of family and friends. But all too often the results disappoint, failing to capture fully the personality of the subject or the magic of the moment. Even people you know really well can get tense and nervous when a camera is pointed at them, resulting in awkward poses that ruin the shot. Others are let down by unsuitable lighting, red-eye, or poor composition.

The main problem is that many photographers just pick up the camera and snap away without thinking about what they are trying to achieve or how to get the best from the situation. However, with the right approach—using natural posing techniques, appropriate lighting, and thoughtful composition—a picture can be a true and enduring portrait that reveals something of a subject's character or a lasting memento of a precious moment.

This book has been carefully conceived and designed to take you step by step through the essential techniques involved in taking better family photos. Featuring practical advice distilled from the author's 25 years of experience as a portrait photographer, and illustrated by hundreds of superb images with detailed captions explaining why they work, this book will make it easy for you to develop your observation skills and improve your own images.

The *Essential Portrait Techniques* chapter includes sections on candid photography, framing and composition, lighting, props, and much more, while further chapters explore the particular challenges of photographing couples and groups, and the pleasures of photographing babies and children. A wide range of special events, from weddings to vacations, is also covered.

Of course, these are changing times in photography, with digital imaging becoming increasingly popular, and certain to eventually take over film. The advantages of digital capture are obvious: there's no film or processing cost, you can see the pictures immediately, and once they're in the computer, there are virtually no limits over what you can do with them. Many of these options are discussed at length in the *Digital Dialogues* section.

But no matter what kind of camera you use, whether film-based or digital, the secrets of taking successful pictures of people are exactly the same. In the end, it is not sophisticated equipment that will guarantee good pictures of members of your family—it's the knowledge and use of some simple posing techniques, allied with the ability to connect with your subject, that counts. You may think that these are skills that you either have or you don't. But in fact they can be cultivated—and this book shows you exactly how.

CAPTURING THE IMAGE

The world of photography is changing rapidly, with an increasing number of people taking pictures using a digital camera. While there are undeniable advantages, there are disadvantages as well when it comes to taking pictures of people. Traditional cameras, though, are still going strong, with compact 35mm, APS (Advanced Photo System), and SLR (Single Lens Reflex) models to choose from. And using the right lens is important, too, if you want to produce flattering images of your nearest and dearest.

CONVENTIONAL CAMERAS

Conventional cameras can put you in control or manage the technical aspects
of picture-taking for you. Either way, they offer you wide creative choice.

Despite the advances of digital photography, there are many reasons to continue using your conventional camera. Film has been recording images successfully for over 160 years. It is relatively inexpensive to buy and process and gives high-quality results. You can't see your images immediately, as with a digital camera, but you can scan photos into the computer and enjoy all the advantages of digital manipulation and output. Conventional cameras are also preferable for shooting sequences (see page 100). Different film formats have come and gone over the years, but two in particular—35mm and APS (Advanced Photo System)—are now solidly established.

35MM CAMERAS

Originally developed in the 1930s, 35mm is currently the most widely used format in the world. Countless millions of 35mm cameras are sold around the globe, and the volume of production makes them less expensive today than ever before. In addition, you can choose between the convenience of a 35mm compact camera and the creativity of an SLR (Single Lens Reflex) camera.

35MM COMPACT CAMERAS

Compact cameras are designed for ease of use. Most are fully automated, with programmed exposure systems that set everything for you: autofocus or a fixed-focus lens; a built-in flash unit, often with overrides; an integral winder; and most likely a zoom lens. With most 35mm compacts, you can simply pick up the camera, point it at the subject, and be sure of getting good results without worrying about the technicalities. As the name suggests, compact cameras are small and portable—although some of the latest models, with wider zoom ranges, are bulkier.

How it works

All cameras, however sophisticated, feature the same fundamental design. The lens is an optical device made of glass that can bend light; its function is to focus the image of the subject onto the film. The shutter prevents light from reaching the film until the release button is clicked. Variable blades in the lens, called the diaphragm, make the aperture smaller or larger, thereby controlling the amount of light passing through the camera. The viewfinder allows you to see how much of the subject will be included in the photograph. Photographic film is the means by which images are recorded in a camera, with the exception of digital models.

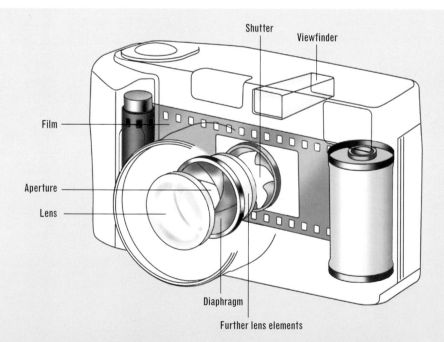

Typical 35mm compact

ZOOM LENS

Zoom lens is standard on many 35mm compact cameras, even relatively inexpensive models.

FLASH

Flash is built in, with several flash modes offering versatility.

VIEWFINDER

Direct-vision viewfinder is effective for subjects in the middle distance and at infinity, but it is less accurate for close-ups (see page 12).

PANORAMA

Panoramic option on some models allows long, thin images of groups and of people in front of landscapes.

AUTOFOCUS

Accurate autofocus systems are a feature on most models.

EXPOSURE

Programmed exposure system provides a range of shutter speeds and apertures.

FILM

High-quality 35mm film is readily available in color, black-and-white, and slide (or transparency) format— and is inexpensive to process.

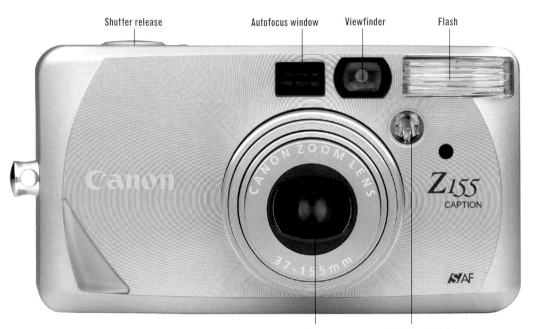

Shutter release · Autofocus window · Viewfinder · Flash

Lens · Self-timer indicator

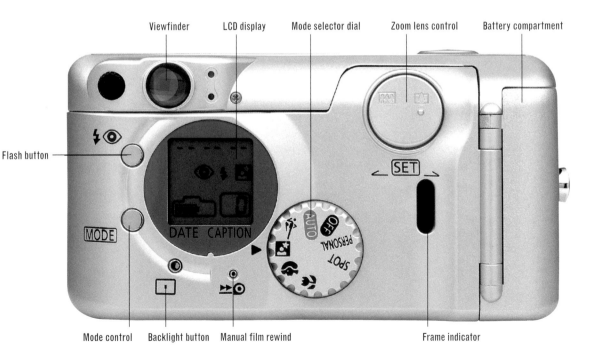

Viewfinder · LCD display · Mode selector dial · Zoom lens control · Battery compartment

Flash button

Mode control · Backlight button · Manual film rewind · Frame indicator

How the SLR works

SLR (Single Lens Reflex) cameras are so called, because they have a reflex viewing mechanism that allows you to see exactly what you are going to photograph before you take a picture. With the shutter covering the film, light passing through the lens with the aperture fully open is reflected by the mirror to the focusing screen and into the pentaprism, which turns the image the right way up for viewing. The eye therefore sees exactly the same image seen by the camera lens. When the shutter is released to take the picture, the mirror swings up and the aperture stops down to the desired size for exposure. The shutter opens and admits light onto the film, allowing the picture to be taken.

Focusing

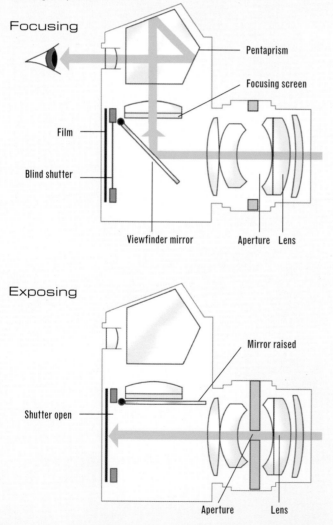

Pentaprism

Focusing screen

Film

Blind shutter

Viewfinder mirror

Aperture Lens

Exposing

Mirror raised

Shutter open

Aperture Lens

35MM SLR (SINGLE LENS REFLEX) CAMERAS

SLR (Single Lens Reflex) cameras are the choice to make for the most creative family photos because of the extra features they provide. First, there is the reflex viewing that gives the camera its name. This enables you to look through the lens that's taking the picture for "What You See Is What You Get" results (see panel, left). In a compact camera, the viewfinder is separate, on one side of the lens or above it—often both. This means that the image seen by the lens may not be the same as that which appears in the viewfinder (called "parallax error"). With a distant subject, the framing errors arising from this may be relatively unimportant. But as you move closer to the subject—in a head-and-shoulders portrait, for example—what the viewfinder sees can differ markedly from what the lens captures, resulting in part of the subject being cut off.

Second, you can change the lens on an SLR, unlike the lens on a compact camera. Of course, most compacts now feature a zoom lens—a lens with a variable focal length. The range of such zooms has been expanded in recent years. Zooms ranging from 35mm to 80mm are commonplace, and several manufacturers even offer compact models with a 35–200mm zoom. Most SLRs are also supplied with a general-purpose "standard" zoom, ranging typically from 35mm to 70, 80, 90 or 105mm. But being able to swap one lens for another on an SLR means you can take pictures outside this range.

Third, while compact cameras generally have automated exposure systems, making them easy to use in "point-and-shoot" style, most SLRs let you maximize creative control by allowing you to select the shutter speed and aperture yourself.

▶▶JARGON BUSTER

Autofocus Most compacts and SLRs feature autofocus systems that set the lens focus according to how far the subject is from the camera. Most have a sensor in the center of the picture area, which can be seen through the viewfinder, and it is important to ensure that the sensor is over the important part of the scene. If your subject is off-center, you will need to use the camera's focus lock to prevent the subject from appearing out of focus (see page 128). Simple cameras have "fixed-focus" systems, with the lens preset to give sharp results provided the subject is between 4.5 feet (1.5m) and infinity from the photographer.

Typical 35mm SLR

CAMERA MODES
A range of "modes" allows users to tailor operation to personal preferences.

EXPOSURE
Fully programmed exposure system offers creative control over shutter speeds and apertures.

LENS
Interchangeable lens facility allows lenses to be swapped while film is in the camera.

REFLEX VIEWING
Reflex viewing system enables the user to look through the lens that is taking the picture for accurate composition.

ADVANCED EXPOSURE
Advanced "multi-segment" exposure systems deliver the ultimate in exposure accuracy.

FLASH
Flash is usually built in, with a wide range of creative options.

INTEGRAL WINDER
Integral winder sends film through the camera, often at up to four frames per second.

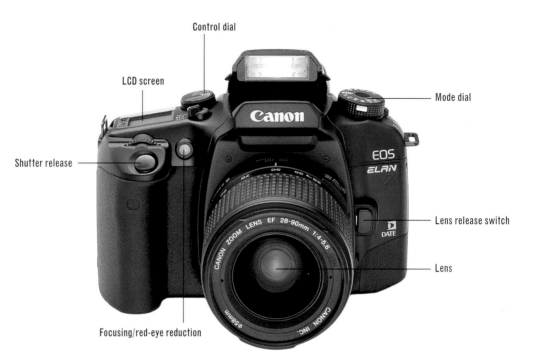

Control dial
LCD screen
Mode dial
Shutter release
Lens release switch
Lens
Focusing/red-eye reduction

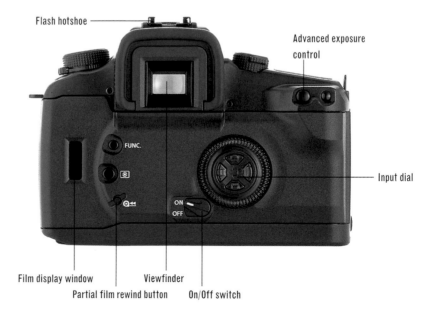

Flash hotshoe
Advanced exposure control
Input dial
FUNC.
ON OFF
Film display window
Viewfinder
Partial film rewind button
On/Off switch

ADVANCED PHOTO SYSTEM (APS)

The APS was introduced in the mid-1990s, and after a slow start it grew steadily in popularity. APS was conceived as a total system, linking cameras, film, and photo-finishing equipment. Most models feature autofocus, automatic exposure, and integral flash and winders—making them quick and easy to use for taking family photos. Both compact and SLR designs are available, though the compacts are by far the more popular.

APS ushered in a smaller format that is at the heart of its many advantages. The film comes in a sealed cartridge which you simply drop into a chamber in the camera, so loading and unloading are totally foolproof. The film is narrower than 35mm film, with a negative size of 16.7 x 30.2 mm (⅔ x 1⅕ in)—just 60 percent of the area obtained from the 24 x 36 mm (1 x 1½ in) frame of 35mm emulsions. APS film is also thinner, so it can be wound more tightly in the cartridge, allowing it to be both smaller and lighter.

For many people, the key benefit of the APS system is that it offers the choice of three film formats, producing different-sized prints—all from the same film. "C" size is the classic 35mm ratio of 2:3, yielding regular 6 x 4-inch (15 x10-cm) prints; "H" is a 9:16 ratio, yielding 7 x 4-inch (18 x 10-cm) prints; and the "P" format is a 1:3 ratio, yielding panoramic 10 x 3.5-inch (25 x 8.75-cm) or 11.5 x 4-inch (29 x 10-cm) prints. In fact, the picture is always captured in "H" format and cropped at the printing stage. You can see this clearly on the "index print" supplied with the prints, which is useful as a reference and for ordering additional prints.

An important APS development is known as information exchange (IX). During the taking of the picture, a magnetic strip along the edge of the film records such information as date, time, title, print type, film orientation, flash on/off setting, subject brightness, and exposure data. During photo finishing, the lab uses that information to ensure optimum color balance and density in the printing.

C FORMAT

H FORMAT

The format selector on an APS camera allows you to choose among three different picture ratios: from left to right, C (2:3), H (9:16), and P (1:3). In fact, the image is captured in H format and cropped during printing to produce the other formats. The prints are subsequently enlarged after cropping to yield the desired sizes.

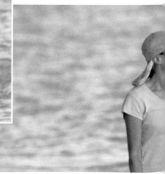

P FORMAT

Typical APS camera

LOADING
Foolproof loading means no risk of
exposure to stray light—drop the
cartridge into the chamber and
close the camera back.

FILM CARTRIDGE
Film cartridge is smaller and lighter
than a 35mm cassette.

DATE/TIME BUTTON
Date/time button allows you to record
these details on each print.

MID-ROLL CHANGE FACILITY
A mid-roll change facility allows you to
remove partly used film, which can be
reinserted and finished later.

TITLING/CAPTION FUNCTION
Titling/caption function lets you add a
name or comment to your image.

PRINT QUANTITY BUTTON
Print quantity button lets you select in
advance the number of prints you
want—if there are four people in the
picture, you can order four copies.

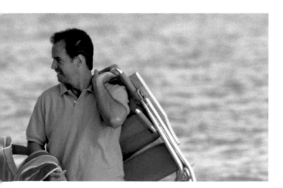

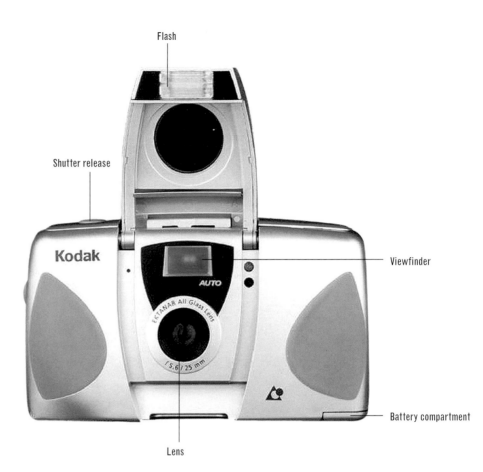

Flash

Shutter release

Viewfinder

Battery compartment

Lens

Film speed

Film is available in different speeds, or sensitivities. These are given an ISO
(International Standards Organization) rating and are categorized as slow
(ISO 25–50), medium (ISO 100–200), fast (ISO 400–800), and ultra-fast (ISO
1600–3200). The faster the film, the more sensitive it is to light and hence the
less light you need to produce a satisfactory photograph. However, the faster
the film, the coarser and more visible the grain structure and the lower the
sharpness and color saturation of the final photograph. Nonetheless, the
quality of fast film has improved considerably in recent years, and for general
picture-taking in mixed light an ISO 400 is ideal, especially if you have a zoom
lens. In sustained bright light go for ISO 200, and when light levels get really
low outside, opt for ISO 800 or even ISO 1600.

INSTANT PHOTOGRAPHY

Instant photography cameras from companies such as Polaroid, Kodak, and Fuji, which provide a print in around a minute, are still widely used. The cameras are somewhat bulky, the film is relatively expensive, and the results are of doubtful quality. The only real advantage is that you can see your pictures printed out almost immediately. If you have such a camera, there may be situations where you continue to find it useful, but if you're planning a purchase, a digital model, which enables you to see your results in seconds, is a better (though much more expensive) choice.

SINGLE-USE CAMERAS

Single-use cameras—sometimes described as "disposable"—are combined film and lens packages. As the name suggests, you use the camera for one set of photos only, handing in the entire camera for processing, and buying another camera if you want to take more shots. Single-use cameras are convenient for occasional picture-taking, but their scope is limited by the lack of facilities such as zoom or flash control. Most single-use cameras are loaded with 35mm film, but a number of APS models are also available.

If you're worried about taking your regular camera to the beach, a single-use model can be a useful alternative—and waterproof versions can be used if you plan to be under water.

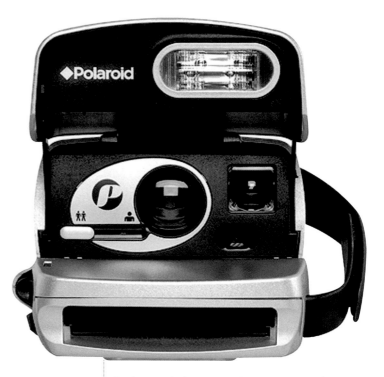

Popular at parties for many years because you can see the results immediately, instant cameras are increasingly being replaced by digital cameras, which offer many of the same benefits and the possibility of getting more copies later.

Single-use disposable cameras are supplied pre-loaded with film. When the film has been exposed, the whole camera is taken to the processing laboratory. Various types are available, including underwater versions. However, the quality isn't as good as that of a 35mm compact or SLR.

▶▶JARGON BUSTER

Rollfilm Whereas 35mm film is supplied in a light-tight cassette, rollfilm comes on an open spool that is attached to a lightproof backing paper. The most frequently used rollfilm is 120, used for medium-format cameras owned mainly by professionals. Different negative sizes can be obtained from 120 roll film depending on the camera in which it is used. These include 6 x 4.5 cm (2⅜ x 1⅝ in) and 6 x 6 cm (2⅜ x 2⅜ in). These negative sizes are larger than those of 35mm film, hence the superior quality of the pictures they produce.

If you are interested in becoming a professional, then a medium-format SLR is well worth the investment. While most SLRs take 35mm format film, medium-format SLRs use a larger film size, which in turn yields better-quality photographs for larger image sizes.

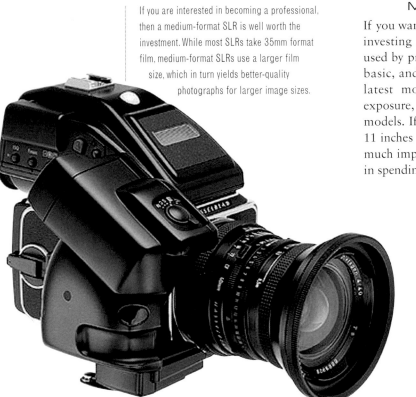

MEDIUM AND LARGE FORMAT

If you want to maximize the quality of your pictures, consider investing in a medium- or large-format camera of the type used by professional photographers. Most are big, bulky, and basic, and not really suitable for amateurs, but some of the latest models have autofocus, built-in flash, and auto-exposure, which make them as easy to use as 35mm and APS models. If you rarely have your pictures enlarged beyond 8 x 11 inches (20 x 28 cm), however, you are unlikely to perceive much improvement in quality, and there would be no benefit in spending a considerable sum on such a camera.

If you have an old camera, such as this 110 model introduced in the 1970s, it will give you satisfactory results when used within its limitations. But more up-to-date cameras will give you higher-quality images.

OLDER CAMERAS

Before 35mm and APS became established, there was a succession of different film formats, including 110, 126, and disk. Many are still used, as are older "rollfilm" formats, such as 120 and 127. While "old fiddles" can certainly continue to play good tunes, such cameras are relatively unsophisticated by today's standards, and the results will often fall short of those from more recent models. The exposure system in older cameras is usually basic, making it difficult to take pictures successfully in anything other than bright light; flash arrangements are hit-and-miss, depending upon hard-to-find flash cubes; and the small negative size of some of the formats means that even regular-sized prints lack sharpness. If you plan to take more than a couple of rolls of film a year, it's worth upgrading to a modern camera.

DIGITAL CAMERAS

A digital camera gives you—and your subjects—the excitement of immediate results and puts you in charge of the picture-making process from start to finish.

Within seconds of taking a picture with most digital cameras, you can review it on the camera's display screen and check that it's perfect before moving on to capture the next great shot. Plus, you never need to buy film again. When the camera's removable storage card is full, you can transfer the images to your computer, wipe the card clean, and start over.

Until recently, the quality of digital made it the poor relation of film. But technological advances mean that today's cameras are easily capable of producing acceptable A4 (8 x 11-inch [20 x 28-cm]) inkjet prints—and some can print at A3 (11 x 17 inches [28 x 43 cm]) size.

BUYING A DIGITAL CAMERA

The most important feature to consider when buying a digital camera is the resolution. The images captured by the CCD (Charge Coupled Device) of a digital camera are composed of colored dots, known as pixels (from PICture ELements). The

What is a CCD?

While the lens, aperture, and shutter on a digital camera function in the same way as those in a conventional camera, the means by which the image is recorded is very different. For the past 160 years, film coated with a light-sensitive emulsion on a gelatin base was developed to produce the final image. In digital cameras, the image is captured by means of a CCD (Charge Coupled Device). This has a rectangular array of light-sensitive picture elements (pixels), which produce an electrical charge proportional to the amount of light that falls on them. Each pixel is a tiny part of the overall picture, and the total number determines the resolution of the final image. The figures quoted for CCDs will be a total number of pixels (for example, 2 million) or two figures (for example, 1,800 x 1,200—the dimensions in pixels of the CCD picture).

higher the resolution, the more pixels are recorded, and the more pixels there are in the image, the higher the quality of the picture when seen on the screen or printed out. Check that the resolution quoted in the sales material refers to the number of pixels actually captured. Some advertisers quote the size of the sensor instead, or supply a figure that includes the pixels added by software—a process known as "interpolation," which tends to give softer results. The minimum resolution you should aim for is 4 million pixels, which will give you an A4 print that pretty much matches the quality obtainable from a 35mm camera. All but the most basic digital cameras are likely to have sufficient resolution for amateur photography, so there is no need to pay extra for peak resolution unless you are aiming for professional status.

Typical digital camera

REMOVABLE STORAGE

Images are captured on removable storage cards, which can be used over and over again. The number of images that can be stored depends upon the amount of memory in the card and the resolution of the images. The fewer the number of images stored, the higher the resolution of the images.

POWER SOURCE

If you use the LCD (Liquid Crystal Display) monitor regularly, digital cameras can consume a lot of power—and use up alkaline batteries at an alarming rate. For that reason, many manufacturers now supply cameras with rechargeable cells.

RESOLUTION

One of the key factors in image quality, resolution is indicated by the number of pixels captured by the CCD. The more pixels, the better the picture. The minimum resolution you should aim for when buying a camera is 4 million pixels, which will give you a quality print.

LENS

Zoom lenses are a feature on most digital cameras. What you need to consider is the ratio of the *optical* zoom. Some cameras offer extravagant ratios based upon a *digital* zoom, which only enlarges the center of the image (see page 25).

LCD SCREEN

The built-in LCD monitor can be used to compose the picture at the time of taking and to review, delete, and store images already captured.

IMAGE CONTROLS

Controls allow you to review, erase, file, or lock the pictures you shoot. Pictures are automatically saved, but locking them prevents them from being accidentally deleted or written over.

OUTPUT SOCKETS

These allow images to be downloaded from your camera via a cable to your computer. With some cameras, you can also show the pictures on a regular television set or produce hard copies by means of a direct connection to a printer.

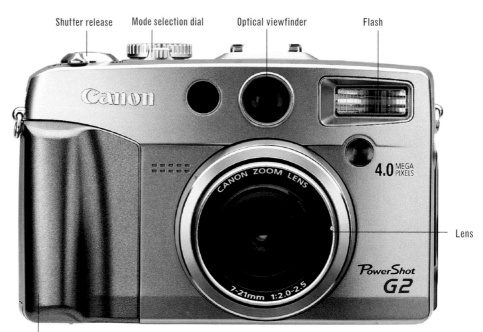

Shutter release Mode selection dial Optical viewfinder Flash

Lens

Molded handgrip

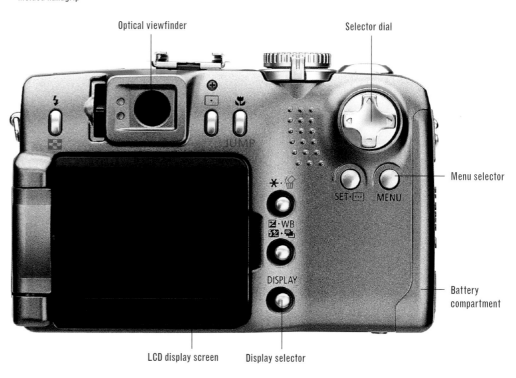

Optical viewfinder Selector dial

Menu selector

Battery compartment

LCD display screen Display selector

REMOVABLE MEMORY

The earliest digital cameras stored images on a built-in chip, which was very limiting, because it meant that once the chip was full, you couldn't use your camera again until you had downloaded the images. But today virtually all the models available feature removable memory cards. The number of images you can take at any one time without downloading them to a computer is determined by the number and size of cards you have and the resolution of the camera. The higher the resolution, the bigger the file size, and the fewer images the card will hold.

CompactFlash and SmartMedia removable memory cards, both made by many manufacturers, are the longest-established systems, but others, such as Sony's Memory Stick and IBM's MicroDrive, work equally well. Some of the larger cards can hold several hundred images—equivalent to a bagful of film. High-capacity cards are expensive, but useful if you're planning a long trip and more convenient than exchanging cards when one fills up. There is apparently no practical limitation to the life of the cards, one manufacturer guaranteeing that its CompactFlash cards can be used at least one million times.

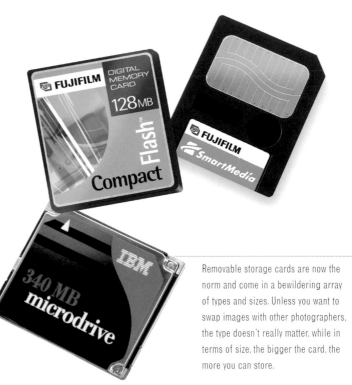

Removable storage cards are now the norm and come in a bewildering array of types and sizes. Unless you want to swap images with other photographers, the type doesn't really matter, while in terms of size, the bigger the card, the more you can store.

Removable memory cards

In digital photography, memory cards are the electronic equivalent of film and they come in several formats depending on the camera brand. Card sizes are measured in megabytes. A megabyte (Mb) is the unit of measurement for the memory—or information storage capacity—of a computer, and is equivalent to 1,048,576 bytes. Common card sizes are 32 or 64 megabytes, although 128-megabyte cards and higher are increasingly popular. Since your digital camera has a fixed maximum resolution per image, higher-volume cards allow you to take more pictures at maximum resolution. Although nearly all cameras allow you to compress pictures into smaller-sized computer files that are stored on the memory card, these produce poorer-quality photographic prints in return. If you can store only a handful of high-quality images on your card, consider buying a card with bigger capacity.

THE LENS

No matter how the picture is captured, the lens is still one of the most important parts of a camera, so choose a manufacturer with a reputation for high-quality optics. It's in this area that traditional photographic companies often score. Their many years of experience give them a thorough understanding of the intricacies of lens design, along with access to advanced technologies and materials.

Most digital cameras feature zooms, but an ultra-wide range is not necessarily an advantage. Although it can be appealing to have a powerful, top-of-the-line zoom, there's a risk of camera shake unless the camera is equipped with an image stabilization system. Don't be taken in by extravagant "digital zoom" claims. Some models offer a 20x digital zoom—but that enlarges only the central area of the picture, and you can do that later in your editing program.

The close focusing distance is important, however. While some cameras allow you to place the lens less than half an inch (1cm) from the subject for shots with a dramatic perspective, other models limit you to around 8 inches (20cm).

IMAGE CONTROL AND BATTERY POWER

The LCD (Liquid Crystal Display) monitors that enable you to compose and preview your pictures also vary in size and quality. Most have 1⅘-inch (4.6-cm) TFT (Thin Film Transistor) screens, but some are bigger and therefore easier to see. All screens can be difficult to read on a sunny day, however, and they all drain the batteries quickly, so it's useful to have a regular optical viewfinder, too—a feature that comes with most, but not all, digital cameras.

Almost all digital cameras have an integral flash unit, which operates like those in conventional cameras—firing automatically when required—but check that there is a range of flash modes, including the option to switch off the flash when you want to retain the mood of the natural lighting.

Fewer digital cameras offer direct control over shutter speed and aperture—though the number is increasing. This extends the creative control available to the photographer. Also very valuable are overrides that allow you to compensate for tricky lighting situations—such as shooting into the sun, or with the subject against a dark-toned background. A "white balance" control is also useful for removing the color cast that occurs under tungsten or fluorescent lighting.

HANDLING MATTERS

The handling characteristics of a camera are inevitably a personal preference. Some people prefer a small camera; others favor the ease of chunky controls. It's important to try the camera before making a purchase. Don't rely on reports—the reviewer's taste may differ from yours. Take a few shots in the store, review them, and erase them. Check how easy it is to read the external information panel and viewfinder display, especially if you wear eyeglasses.

▶▶JARGON BUSTER

Resolution This term describes the level of detail in an image. In film, the resolution is determined by the size of the silver grains in the emulsion. In digital imaging, resolution is measured by the number of pixels.

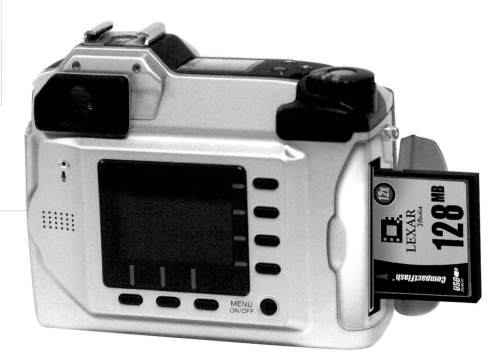

This compact digital camera has a large-capacity (128-Mb) removable memory card. It is vital that you handle cards of all types with care and that you never allow water or sand near them. Once you have captured images on your camera memory card, the next step is to transfer them to your computer, either directly or using a card reader (see page 22).

Using a Digital Camera

In many respects, using a digital camera is like using a conventional camera—but there are important differences.

Mini printers such as the one shown below allow you to make quick prints directly from your digital camera. If you don't like what you see, you can enhance or manipulate your image later on your computer and print the image again.

A key advantage of shooting digitally is that you see the results immediately. When you know that you have the picture you want, you can stop shooting. Alternatively, you can take lots of photos and review them later, deleting those that weren't successful and saving those that were. You can also show the pictures to your subjects and receive feedback. You may even be able to change an aspect they dislike.

It is more difficult to shoot a sequence of photos with most digital cameras than with a conventional model. That's because it takes time for the images to be stored. There's a limit to the speed at which that can happen—and the larger the image, the longer it takes. Increasingly, digital cameras are featuring a "burst" mode, which allows you to take several shots in succession—although you must then wait for all of them to be processed.

RESOLUTION OPTIONS

On most digital cameras you can capture images at a lower resolution than the maximum, but that is rarely a good idea, since you might want to make bigger prints later. It's preferable to save at maximum resolution and make a copy at a smaller file size in the computer, if necessary.

The screens on digital cameras are especially good for pictures of people because they remove the need to hold the camera to your eye, which inhibits rapport. But they can be difficult to read on a sunny day, so it's helpful to have a regular optical viewfinder, too. Or you could find a shady spot to shoot from when conditions are really bright.

Battery life is a crucial factor. Preview monitors use a lot of power and can quickly exhaust the camera's batteries. If your camera uses rechargeable cells, it's wise to have two batteries, so that one can be charged while the other is being used.

Firewire cable

USB cable

TRANSFERRING IMAGES TO THE COMPUTER

You can have your images printed directly from the memory card, but many people prefer to transfer their digital photos to the computer in order to enhance them and print them out. There are a few ways of doing this. The easiest and least expensive method is through a USB (Universal Serial Bus) cable. First, install the necessary software, which is usually provided on a CD. Then connect the cable to the appropriate sockets and set the software to download. There is a slightly faster cable option known as Firewire. Always check that your computer has the right sockets before buying a cable. A quicker way of getting the images onto the computer is by means of a "card reader." Slip your removable storage card into the reader, which connects to your computer via the USB cable, and the card will appear on your desktop as a hard drive, allowing you immediate access to the images. USB and Firewire cables are the standard means by which computers and peripherals are connected.

COMPUTER MATTERS

Digital imaging requires a computer, and because high-quality images contain an enormous amount of information, you'll need a computer with a reasonably powerful processor and plenty of memory to be able to work with them efficiently. Most of the computers launched in recent years meet these criteria—but some older models may struggle when it comes to handling larger files.

If you're buying a computer, think about a model designed with digital imaging in mind. Both PCs and Macintoshes are suitable. Macintoshes are easy to set up and use and don't need "extras," such as sound cards. They are widely used by professionals working in digital imaging. But PCs tend to be cheaper, there's a much wider range available, and there's more software to choose from.

The key factor to check is whether the computer has enough memory to run your image manipulation software effectively. The minimum amount of RAM (random-access memory) you need is 128 Mb; more is preferable if you want

Apple Macintosh computer

to work with big images or use heavyweight programs, such as Adobe Photoshop, which needs lots of space. Buy the biggest monitor you can afford—a 17-inch (43-cm) screen is larger than a 15-inch (37.5-cm), but doesn't cost a great deal more. Check that it can display at least 1024 x 768 pixels at 24-bit depth (a 24-bit monitor provides a 16.7 million color range).

STORAGE

The size of the hard disk is also important because digital files take up a lot of memory—so buy the largest you can, within reason. Even so, if you use a high-quality digital camera, you will quickly find the system running out of storage space, unless you're extremely disciplined about discarding unwanted pictures.

One solution is to use the CD writer that is fitted to almost every computer these days. Archiving images on CDs should meet most storage needs. Another flexible option is a Zip drive, which offers 250Mb of storage space in a cartridge that's not much bigger than a floppy disk. The advantage is that you can add or remove files at will, but Zip disks need to be handled with care. Because the digital data is stored magnetically, you must keep the disks well away from the magnetic fields created by audio speakers to prevent the disks from being wiped clean. The disks are also susceptible to damage if they are dropped.

Compaq PC

LENS SETTINGS

The lens is the "eye" of the camera, and one of the most important controls you have when taking pictures. But unlike the human eye, which can't vary the amount of the surroundings it takes in, camera lenses can be designed with a wider or more focused angle of view.

The measurement that indicates how much a lens can "see" is the lens's focal length—measured in millimeters. The smaller the focal length of a lens, the more of a scene it includes in its vision. In a 35mm camera, a "standard" lens—with a field of view similar to that of the human eye—has a focal length of 50mm. Lenses with a focal length above 70mm are known as telephotos. Those with a focal length below 35mm are termed wide-angle lenses. The numbers are different for APS (Advanced Photo System) and digital cameras, but the principle is the same. Each type of lens produces different effects and is suitable for different photographic approaches.

ZOOM LENSES

Most simple compact and digital cameras have a wide-angle lens equivalent to 35mm, which is well adapted to general use because it takes in a generous sweep of a scene, without

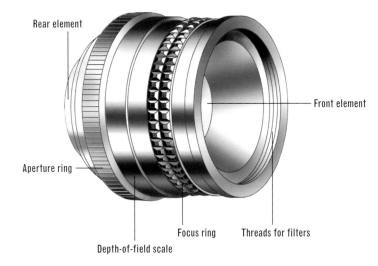

Rear element

Front element

Aperture ring

Focus ring

Threads for filters

Depth-of-field scale

distortion, and keeps virtually everything in sharp focus. More expensive models have a built-in zoom lens, which enables you to vary what's included (see page 12). This gives you the freedom to frame the shot in different ways without having to change your position, and it also allows you to alter the perspective of the shot. Most built-in zoom lenses start at a moderate wide angle—typically 35mm, but sometimes 28mm—and range up to short or medium telephoto. A 3x "ratio" (often from 35mm to 105mm) is usual, but newer models can range from 5x to 10x. Generally speaking, the wider the zoom range, the better—though the resulting camera tends to be bulkier.

How it works

Camera lenses are constructed from a number of glass elements, often arranged in groups. The lens "elements," some convex, some concave, are grouped in such a way as to focus the image accurately onto the film. By varying the number of elements used, and their configuration, the angle of view—that is, how much of the scene is captured—can be controlled. The focal length of a lens is the distance from the center of the lens to the film plane when the lens is set at infinity.

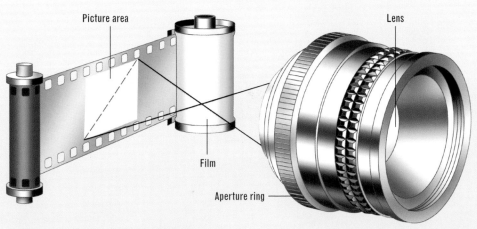

Picture area

Lens

Film

Aperture ring

One of the great advantages of SLR (Single Lens Reflex) cameras (see page 12) is that the lenses are interchangeable. This offers the ultimate in versatility and control, with everything from an 8mm fisheye (capable of taking in a full 180 degrees) to a 1,000mm (equivalent to 20x magnification binoculars). SLRs are usually sold with a "standard" zoom, similar to that built into compact cameras, but most users add a telephoto zoom, and sometimes other lenses also. It is now possible to buy one lens for an SLR that goes all the way from 28mm wide angle to 300mm telephoto.

Many digital cameras also feature a "digital zoom," which is often extremely powerful and sounds impressive. However, this zoom works by enlarging the central area of the picture— something you could do in the computer afterward. The important feature is "optical," not "digital," zoom.

Here are some suggestions for the settings and lenses that are most suitable for different kinds of portrait subjects.

Good photographers in possession of an SLR camera may want to build up a range of lenses that meet every portrait need and possibility.

A WIDE-ANGLE SETTING

The wider the angle of view, the more the lens will take in. A 24mm includes more than a 28mm, which includes more than a 35mm. Wide-angle lenses are especially useful when photographing large groups of people in a restricted space, where it's not possible to include more by stepping back. They are also useful for candid photography because the subject is more likely to be included on those occasions when you're not looking through the viewfinder. The danger of wide-angle lenses is that everything can look far away. The wider the lens, the greater the risk of this happening. Prevent this, whenever possible, by having something of interest in the foreground of the picture, to lend depth to the shot—a bunch of flowers in a bottom corner, or a doorway, for example. When

photographing groups, do not position people too close to the edge of the frame, or they can look distorted. Similarly, do not crop in too close. It can make faces look fuller than they are and be extremely unflattering.

The wide angle can provide a dramatic perspective, with those parts of the scene that are closest to the camera looming large while elements farther away seem to recede into the distance—an effect to exploit in creative compositions.

A STANDARD SETTING

A zoom lens set to the middle of its range—around 50mm on a 35mm camera—provides a natural-looking perspective similar to that seen by the human eye, so that the results look "right." This makes it a good general choice for pictures of people and for photographic "records" where the emphasis is on the subject, not the photographic technique. Again, it's important not to get too close—no nearer than 5 feet (1.7 m)—or distortion may result.

The only real drawback of this setting is the neutral interpretation it gives. If the subject is not especially interesting, you might want to consider whether a wide-angle or a telephoto setting would be more effective.

▶▶JARGON BUSTER

Filter Thread The lenses on most SLR cameras feature a filter thread into which special effects filters and other accessories can be screwed to enhance the image. A thread is not generally provided on compact cameras, although special filter holders are available.

A TELEPHOTO SETTING

Lenses with a focal length from 70mm upward on 35mm cameras are known as telephotos. Lenses up to 130mm are classified as "short telephotos," 135mm to 200mm are "medium telephotos," and those above 200mm are "super telephotos." Lenses in the 85mm to 135mm range are often described as "portrait" lenses because they give a flattering perspective, especially in a head-and-shoulders shot.

A telephoto setting brings distant subjects closer—allowing you to capture people in a spontaneous way. You can stand back and choose the moment to take the picture when the person is most relaxed. Even when people are posing, a telephoto setting can be of benefit. By setting the zoom toward the top of its range, you can have tight framing without the person feeling "crowded." A telephoto can also isolate your subject from an uninteresting or potentially distracting background—by cropping in tightly on what is most important.

The problems with using telephoto lenses relate to sharpness. The first is the risk of camera shake. Telephoto lenses built into compact cameras let in less light than wide-angle settings—in technical terms, they have a more limited maximum aperture. So take special care to hold the camera steady when using the zoom at the top of its range, especially if the light isn't bright. The second problem is poor focusing. It's essential to make sure that you focus on the eyes of your subject, or the picture can look blurred.

The pictures to the right were all taken from the same position, with neither the subject nor the photographer moving. Only the focal length was altered. As the pictures show, the angle of view becomes progressively narrower and the magnification of the subject increases as the focal length increases. So with a 20mm lens, the angle of view is very wide and the subject very small in the frame. With a 400mm lens, the angle of view is extremely narrow and the subject is large in the frame. That is why a lens with a long focal length (that is, at the telephoto end of the zoom scale) is said to "pull" a faraway subject closer to you.

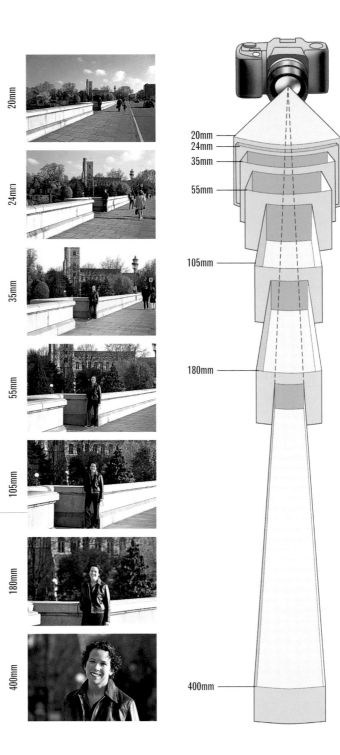

20mm
24mm
35mm
55mm
105mm
180mm
400mm

Comparison of Advanced Photo System (APS) lenses and their 35mm equivalents

APS	35mm
24mm	33mm
30mm	42mm
48mm	67mm
60mm	84mm
80mm	112mm
100mm	140mm
120mm	168mm

MEDIUM RANGE LENS

TELEPHOTO LENS

STANDARD LENS

The standard lens (at right), with a 50mm focal length is the one most frequently supplied with an SLR camera at the time of purchase. This can be removed and replaced with any one of a number of other fixed-focal-length lenses. It can be replaced with a medium-range zoom lens (at top), typically offering variable focal lengths of 35–70mm. Long (telephoto) lenses such as the one shown directly above can offer focal lengths of 70–120mm and are ideal for taking pictures of subjects from a long distance while keeping them large in the frame.

OTHER LENSES: USING AN SLR

While the 35mm to 105mm range of most 35mm compact cameras is more than adequate for the majority of portraits, an SLR camera with a selection of lenses gives you the chance to be even more creative. Wide-angle and ultra-wide-angle lenses, such as 24mm and 17mm, are good for showing a person in a particular context—in front of the Grand Canyon, for example. Longer focal lengths, such as a 300mm super-telephoto, enable you to throw backgrounds completely out of focus to concentrate attention fully on your subject.

APS LENSES

Because of the different film size and negative format, the focal lengths of the lenses on APS cameras are different from those on 35mm cameras—which can be confusing when making comparisons. For example, many single-lens APS cameras have a focal length of 24mm, which could sound like an ultra-wide-angle to those accustomed to 35mm cameras, whereas it is, in fact, the equivalent of 33mm in traditional terms (see table above). The advantage is that the lenses on APS models are physically smaller and shorter than their equivalent focal lengths in the 35mm format, allowing cameras to be even more compact.

USING A SCANNER

A scanner offers you the best of both worlds—it enables you to turn your original
print or slide into a high-quality digital image that you can edit on a computer.

A scanner allows you to continue using all of the creative facilities of your conventional camera and to convert your pictures subsequently into digital images. Although you lose the immediacy and economy of digital capture, you gain the flexibility of having an original print or slide and being able to rework, store, or e-mail it in digital form. It also means that your archive of past pictures—including all of your favorites—can be scanned into new life. They can be printed, e-mailed, stored—and even enhanced and corrected to achieve their full potential.

ONE-BUTTON OPERATION

Scanners are easy to operate—a single push of the button can be all you need for great results. Machines that take originals up to 8 x 11 inches (20 x 28 cm)—called A4 scanners—are more than good enough for most amateur needs, and they are surprisingly affordable. Look for a "flatbed" scanner (so named because you can place the original flat on its surface, as with a photocopier) with a resolution of 600 x 1,200 dpi (dots per inch). A more expensive machine will give you a higher resolution—1,200 x 2,400 dpi is the next step up—but this will only be useful if you want to produce digital prints significantly larger than the original. Flatbed scanners that enable you to work with prints up to 11 x 17 inches (28 x 43 cm)—called A3 scanners—cost considerably more and are only necessary if you need to scan large originals.

Flatbed scanner

DPI and PPI

The terms dpi and ppi cause considerable confusion among photographers working digitally, who think they are the same and use them interchangeably, when in fact they are quite different. Dpi stands for dots per inch, which is a measure of the resolution used for scanning and printing: 300 dpi means there are 300 dots in every inch of the image. As a general rule, having more dots per inch means a higher resolution, a greater amount of visible detail in the image, and a larger file size. Ppi stands for pixels per inch, and is most commonly used in respect to computer monitors and the images displayed on them. The resolution of most computer monitors is between 50 ppi and 96 ppi, depending on their type, size, and how they have been set up. Most digital cameras capture images at 72 ppi, and this is the resolution of most of the images you see on the Internet. Confusingly, many inkjet printers claim an output resolution of 1440 or 2880 dpi, but to get the best results from them the resolution of your image should be around 300 dpi.

DPI info

The resolution at which you scan your pictures depends to a large degree on what you intend to do with the picture. If you want to publish it in a magazine or produce a hard copy on an inkjet printer, then 300 dpi (dots per inch) is ideal. But this not only takes up a lot of computer storage space, it is also unsuitable for sending by e-mail or posting on a Website—the transfer times are too great. For e-mail or the Internet, 75 dpi or 100 dpi will produce a more manageable file size.

SLIDE SCANNERS

A transparency hood can be fitted to most flatbed scanners for scanning slides. This shines a light through the image instead of reflecting back from it. The quality is not good enough for serious digital imaging, however, and a dedicated film scanner is a better solution. These are now less expensive than in the past, and a flurry of new models means that there's plenty of choice. They can scan 35mm and APS originals—both slides and negatives, and with an optional adapter, strips of slides and negatives.

Unfortunately, if you use a professional medium-format camera, the larger negative size and the more limited market means that prices for scanners are significantly higher—and you can expect to pay a considerable amount of money if you want to scan the images yourself.

Most scanners come bundled with software that enables you to enhance and manipulate the scans that you capture. Anyone who is serious about digital imaging will want both a digital camera and a scanner. If you're new to photography, the best route is almost certainly to go straight to digital capture, adding a scanner later when you feel it is necessary. If you already have a certain amount of photographic equipment, the scanner or scanners (flatbed and film) should come first, and the digital camera can wait.

Film scanner

Top tip

Don't assume that using the highest resolution on your scanner will give you better-quality images. Settings of 600 dpi and above should only be used when you want to enlarge the original. The file size obtained at such a resolution is high, and it takes longer to open and manipulate such images.

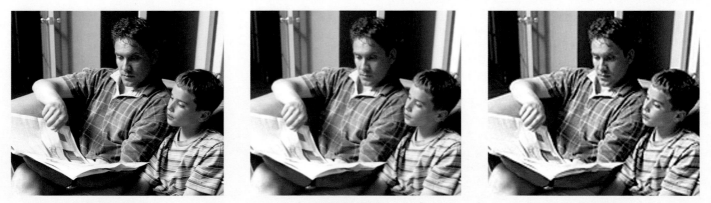

Image at 300 dpi Image at 150 dpi Image at 75 dpi

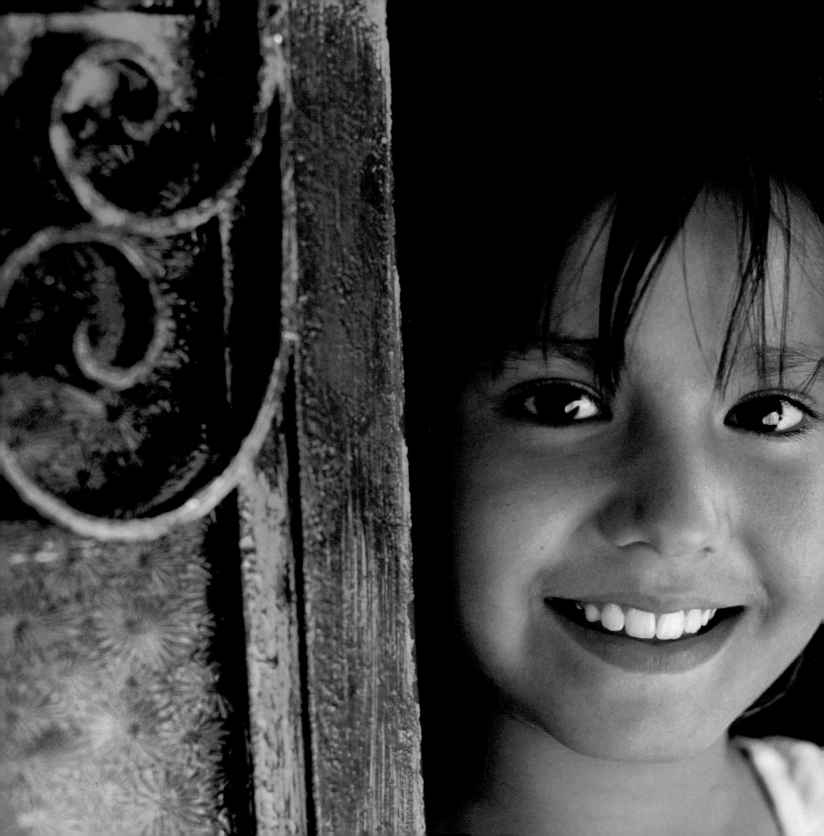

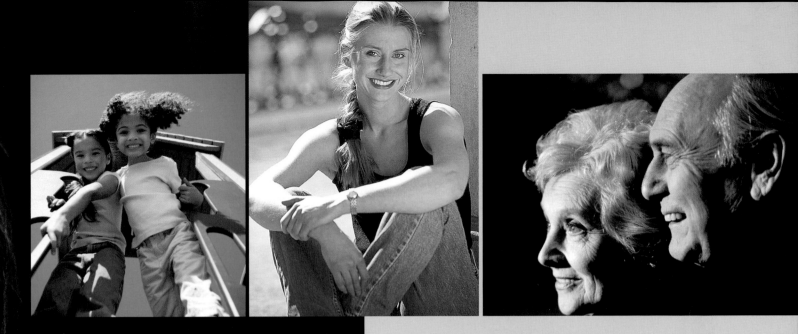

ESSENTIAL PORTRAIT TECHNIQUES

Most people just snap away without thinking about what they're doing, but taking a few simple steps can make an enormous difference to the quality of the results you get. Shooting candids is sometimes better than asking people to pose, and getting them to relax is easy when you know how. There are many ways you can compose a picture, and lots of different posing options available. Plus, of course, it's important to be able to understand and make use of light.

POSED PICTURES

When you ask people to pose, you give up spontaneity in favor of control. But the results can be worth the exchange. The main advantage of asking people to pose for you is that you are in charge: you can direct people to gaze a certain way, to turn at a particular angle, or to hold their hands the way you choose. And most of the people you photograph will take this process for granted. As soon as you take your camera out, they'll get ready to pose for you—which generally means looking at the camera and smiling.

The disadvantage is that some people become self-conscious when they pose and assume a "mask" that makes it more difficult for you to capture their personality on film. That mask, however, can be interesting in itself, because paradoxically it's an essential part of who the person is.

FEELING IMPORTANT
A posed session has a formal air that makes your subjects feel important. So you need to plan it carefully. Think about the kind of pictures you want to take, the best place to take them, the clothes you want your subjects to wear, and how you would like people to pose. An inexperienced photographer can feel pressured to "perform" in a posed situation, and planning things in advance will give you confidence.

BEING DIRECTED
Most people prefer to be directed rather than left to their own devices. So the more you tell them what to do—within reason—the better. You don't need to be bossy; just offer clear guidance about what you want. Keep to your plan, but be ready to make any minor adjustments that become necessary during the session, perhaps in the light of suggestions from your subjects. Whether you know the people well or not, the relationship between the photographer and the subjects is essentially a partnership in which both work together to produce the best possible images.

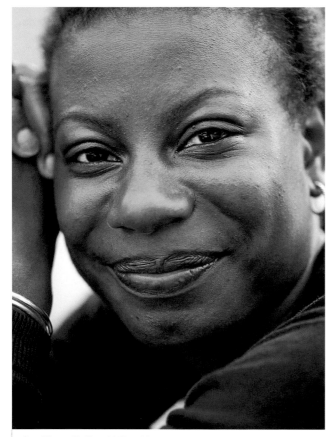

By talking and joking with his subject once he had framed this shot, the photographer was able to draw a smile, not only from the lips but also from the eyes—creating an engaging and attractive photo.

▲▲ **WHY IT WORKS**
The photographer cropped in close, using the telephoto setting of the zoom lens on a compact camera. This concentrates attention upon the subject's face—and excludes any potentially distracting background. Don't be afraid to chop off the top of your subject's head if it makes the picture more powerful—striking compositions can help emphasize the subject's features.

Posed subjects don't always have to look at the camera—the photo of this young girl with her brother works every bit as well as the shot of her alone staring at the camera.

▶▶ **WHY IT WORKS**

The window light coming from the left in both of these shots brings all texture and detail to life. The combination of boots and tutu makes for a humorous composition, while the way the siblings have their arms wrapped around each other describes a wonderful sense of closeness.

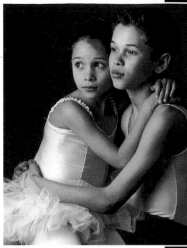

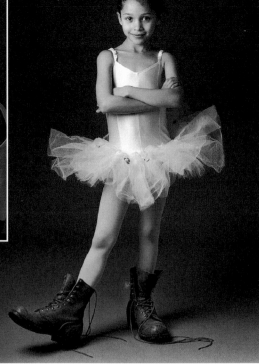

Some people are so comfortable in front of a camera that even when you pose them the results look natural. This beautiful young girl with her delightful expression is a wonderful example of what can be achieved with the simplest compositional devices.

▼▼ **WHY IT WORKS**

The out-of-focus door in the foreground brings a sense of location to the photo and acts as a frame to the girl. Its colors and textures add warmth and interest to the photo without distracting from her face.

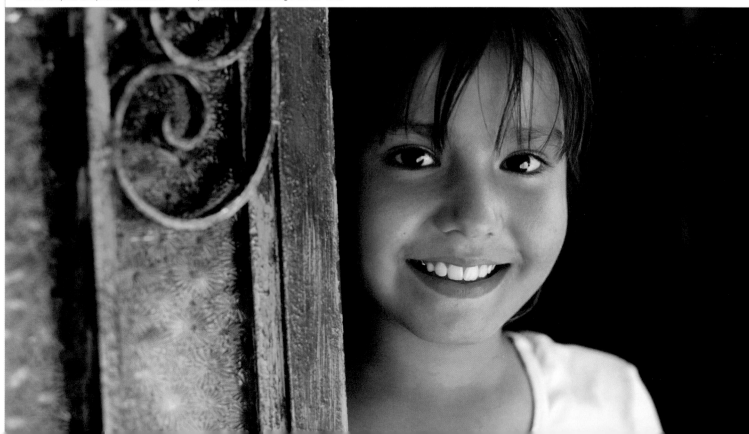

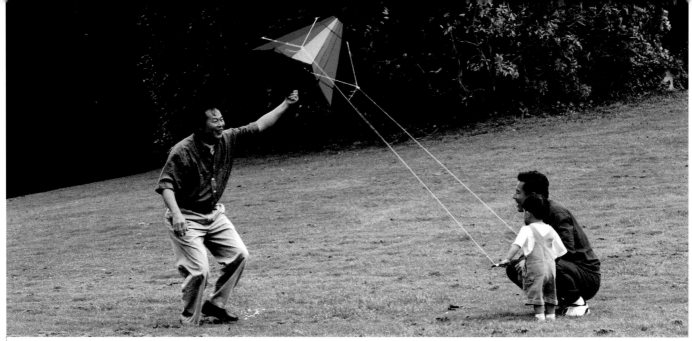

With candid photography, timing is everything, and families at play are the perfect subjects on which to practice your skills. Stand well back and bide your time until the decisive moment when all the elements you want come together, then click away!

▲▲ WHY IT WORKS

The subjects have been caught spontaneously in mid-action. The clean background makes them stand out, while the photo's triangular composition has a natural rhythm that impels the viewer to glance from each point on the shape to the next. The horizontal crop adds to the picture's expansive feel.

CANDID CAMERA

For relaxed pictures of people that reveal their true character, nothing beats candid photography: snapping your subjects when they're unaware of you and your camera. Have you noticed how some people adopt a "telephone voice"? A similar thing happens with photography. Many people put on a "picture-taking face" the minute they spy a camera. It's an artificial face, framing a programmed smile that is often less attractive than their natural expression.

DOS AND DON'TS

- DO set everything up ahead of time so you can shoot automatically.
- DO find a quiet place where you won't be noticed.
- DON'T use flash—it will attract attention immediately.
- DON'T wear bright clothes that make you stand out.

▶▶ JARGON BUSTER

The Decisive Moment

The French photojournalist Henri Cartier-Bresson coined the expression "The Decisive Moment" to describe the moment when all the elements in a photograph come together to create the perfect composition.

The television show *Candid Camera* appealed to audiences because it captured people being themselves. And that's the attraction of candid photography. By taking pictures of people when they're unaware of the camera, you commit their true character to film. Do it right, and your family and friends will love the pictures you take of them: no more starchy poses, but photographs that show the warmth of the person within.

DIFFERENT WAY OF WORKING

Shooting candids isn't hard. It just calls for a different approach. Instead of asking people to pose and "Say cheese!", stand back and become a detached observer, waiting for the

right moment to release the shutter. The key to success is alertness. Expressions change in a second, and photo opportunities can vanish with them. So learn to concentrate completely on your subject. Anticipate the right moment—and then act decisively.

INSTINCTIVE SHOOTING

To do so, you must learn to use your camera instinctively: pick it up and take a picture, without a pause for thought. How do you do that? As with any other skill—by practicing. Put a little effort into it, and you'll soon find it's second nature.

The best equipment for candids is a camera with a zoom lens, which allows you to fill the frame with distant subjects. That way, you can stay as far away from your "target"as possible to reduce the chance of being seen. Unless conditions are extremely bright, load up with a medium to fast film (ISO 200 or 400) to minimize the risk of blurring if the person moves suddenly. A digital camera offers you the additional option of blowing up the central part of the image if you want to make the subject bigger in the frame.

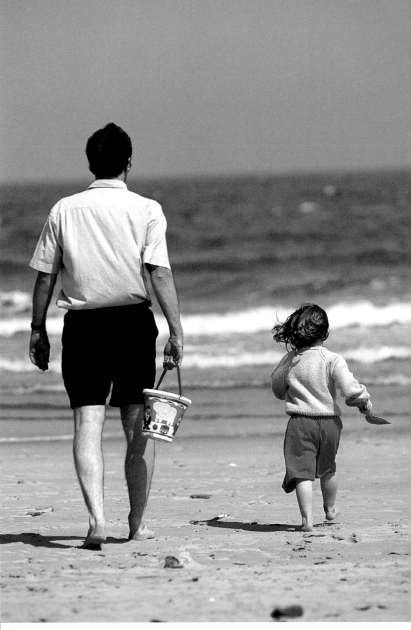

Once your subjects are immersed in something, they'll forget all about you and your camera, giving you the freedom to capture them at their most natural and appealing. This photo captures an unguarded childhood moment that will be treasured forever.

▼▼ WHY IT WORKS

The longest setting on a zoom lens was used to fill the frame with interest, allowing the photographer to shoot from a distance. The light is soft and flattering, and the background similarly gentle, adding to the photo's dreamy air.

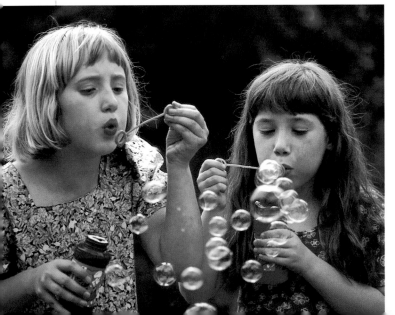

You may not consider photographing people from behind, but this can be every bit as effective as frontal compositions. A shot like this, of father and daughter walking down to the sea, is a delightful way of capturing a special moment—and relationship—in time.

▲▲ WHY IT WORKS

Small splashes of color can make all the difference to a picture, and here the yellow of the bucket and red of the girl's shorts and spade contrast vividly with the calm blue of sky and sea and the gold of the sand.

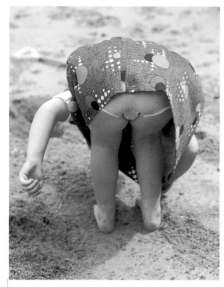

It's sassy shots like these that always get smiles and "aaahhhs" when prints are passed around. The key is to have your camera ready for use at a moment's notice, so that you can react immediately when something amusing or interesting happens.

▲▲ WHY IT WORKS
The plain backdrop of the sand and the tight, close cropping mean your eye goes straight to the girl. The photographer may only have had a few seconds to grab the picture, but everything has come together perfectly.

With modern autofocus cameras it's no longer essential to look through the viewfinder when you take the picture, as everything is set for you automatically. Here the photographer held the camera over his head, pointing down at the girl on the merry-go-round, and clicked the shutter.

▶▶ WHY IT WORKS
Just as the picture was taken, the girl stuck out her tongue, creating an even livelier shot. Also, by photographing his subject at an angle, the photographer achieved a dynamic composition that enhanced the photo's sense of movement.

"CANDIDS WITH PERMISSION"

The choice of candid or posed pictures is not the only one. It is possible to blur the distinction between the two for even greater pictorial benefit. You might, for example, be poised for a candid shot and at the last moment call out the person's name—releasing the shutter as the person looks at you. That way, you get both a spontaneous expression and eye contact—a bonus, because in most candids the subject is looking away from the camera.

You can also set up "candids with permission" when you ask people if you can take pictures of them but hold off doing so until they forget about you and your camera.

SHOOTING FROM THE HIP

You need not even look through the viewfinder when shooting candids. Simply point the camera in the general direction of the subject, and press the release. The automation in the camera will handle all the technicalities for you. The picture might not be perfectly straight, but that can add to the "paparazzi" effect. If you used a digital camera, you can reorient the image in the computer. Remember to switch off the flash—if it fires automatically, it will give the game away!

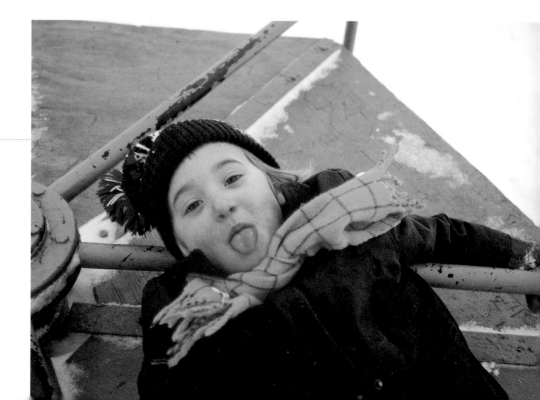

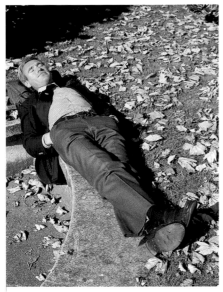

It is relatively easy to photograph people while they're asleep, provided you don't make too much noise!

▲▲ WHY IT WORKS

The feet at the corner create a nice composition, which, thanks to the shadow area in the background, breaks the picture up into triangular-shaped areas. The bright light brings the colors to life and complements the man's contented expression.

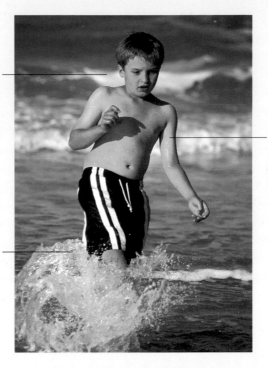

Aperture control enables you to make your subject stand out from the background through the selection of a large aperture such as f/5.6.

A fast shutter speed freezes the movement of both the water and the boy's leg.

Because the lens of an SLR is interchangeable, more powerful lenses can be used to bring distant subjects like this closer.

QUESTIONS AND ANSWERS

Are candids always of one person, or can they be group shots?
You can have as many people as you want in a candid. Group shots provide the fun of seeing what each of the individuals is doing, and how people are relating to one another.

Are children good subjects for candid photography?
They're the best. Children are not self-conscious in the way that adults can be, and they quickly become so absorbed in their activities that they forget everything else. Often you can take candids from really close quarters without their noticing. See the section on children (pages 112–123) to find out more.

Shooting candids with an SLR

One of the secrets of shooting successful candids is to set everything in advance. If your SLR (Single Lens Reflex) camera has an automated metering system, select "program" or one of the other easy-to-use modes. If it has manual metering, select the aperture and shutter speed before thinking about taking your shot.

In most situations, autofocus is a benefit, because it allows you to home in on your subject without hesitation. But when using a wide angle, there's a danger the autofocus sensor will miss its mark, so estimating how far away your subject is and presetting the lens on manual is a sensible precaution.

The aperture you set will depend upon the approach you're taking. When using a telephoto lens, it's best to shoot at a wide aperture, such as f/4 or f/5.6. This produces extremely shallow depth of field for a dramatic, almost three-dimensional effect, and maximizes the shutter speed, which reduces the risk of camera shake.

When using a wide angle up close, set a small aperture. This maximizes depth of field as a precaution against errors in focusing. F/8 is adequate most of the time, but f/11 or f/16 is preferable.

ENVIRONMENTAL PORTRAITS

Showing people in their natural environment—where they live, work, and play—
can tell you a lot about them. People also tend to be more relaxed on their
"home turf," which helps you avoid stilted expressions and wooden poses.

Your family home is a likely location for your pictures—and a good place to start. The right choice is often to photograph family members in a favorite part of their environment, against the existing background: Mom answering the telephone in the kitchen, Dad watching TV, or the kids playing in their rooms. The environment adds to the appeal and creates a useful context. But you can also spend a few minutes thinking of variations, and maybe set things up a little, so that you achieve more than a simple record.

Home, sweet home. A cozy domestic scene like this makes a perfect location for a picture. Just make sure the surroundings are reasonably neat, find the best vantage point, and click away.

▼▼ WHY IT WORKS
This intimate moment of a mother and daughter reading a book has been captured in true fly-on-the-wall style, with no sense of the photographer being present. There's also sufficient background for us to locate the subjects, but nothing so dominant as to draw attention away from them.

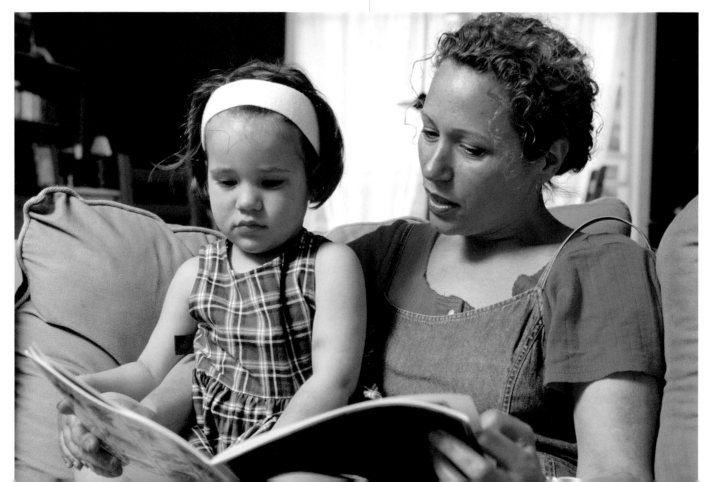

WIDER PERSPECTIVE

Generally when shooting environmental portraits, you want a wide perspective, showing not only the person but something of the surroundings also. On a compact or digital camera with a zoom lens, choose the widest setting. For an SLR camera with interchangeable lenses, fit a wide-angle lens.

This opens up the perspective of interior shots, making them look bigger than they really are. It also enables you to compose the shot in more imaginative ways—by having an item in the foreground and another in the background. With this approach, the people need not be the most dominant element in the photograph; they can be much smaller and not necessarily the center of attention.

Depending upon the time of day and the number of windows, you might need to use flash, but whenever possible, maintain the natural ambience by using daylight.

OUTDOOR PURSUITS

Lighting is less of a problem outdoors, and you'll find plenty of photo opportunities there: couples standing proudly in front of their home, working in the yard, or departing on vacation. Use a semi-candid approach, and it will not be hard to achieve good pictures in situations like these. The same is true when you visit friends and take your camera with you. There, a less familiar location can help to stimulate creative ideas and result in pictures that are memorable for their detail as well as their subject.

WORK AND PLAY

Photographing people at play can also be highly rewarding: a player who is poised for a catch will not be putting on a "photo face." Whether spectating, singing, or absorbed in conversation, people forget the camera. Take your camera to work, if possible, and explore a completely different environment, where people spend much of their time and are less often photographed.

If the aim of portrait photography is to reveal something of the subject's personality, then capturing a person lost in their favorite hobby is one way of achieving this. This woman is immersed in her gardening, encircled by a frame of leaves and flowers, and seemingly oblivious to the world around her.

Documentary-style pictures work well when the photographer uses, as much as possible, the combination of the subject, the surroundings, facial expressions, clothes, and gestures to convey important information to the viewer.

▶▶ **WHY IT WORKS**

The man's clothes clearly identify him as an enthusiastic walker—and the location is perfect. The strong lines of the rope bridge lead the eye to the subject while cleverly implying the long distances behind and beyond him.

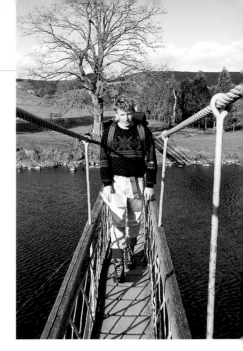

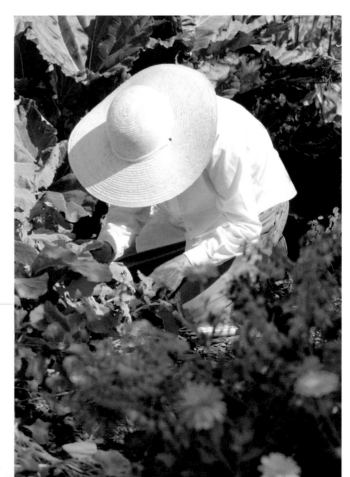

▶▶ **WHY IT WORKS**

You don't need to see the subject's face to get a sense of what she's like. By shooting from a higher perspective than normal, the photographer has created an absorbing composition, while the out-of-focus foreground foliage gives the photo added depth and interest.

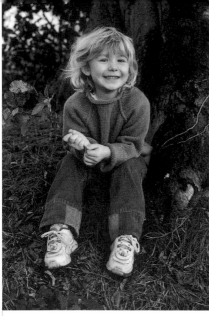

Choosing a Location

Don't be tied to your own locations—go out and explore! Photographs in outdoor settings can have a naturalness that is difficult to achieve indoors. Subjects tend to be more relaxed, while different backdrops and new locations offer great scope for inventive and evocative compositions.

Most of us don't live in mansions, and while we can dream of leading our loved ones down to the summerhouse for a session of photography, that's not how it is. But that doesn't mean we're limited to our own four walls. The world is full of fascinating locations. Every neighborhood contains interesting features for photos—whether in details such as a wall, seat, or flower, or substantial backdrops, such as a cathedral or rolling countryside.

If you don't have a tree in your own yard, there's bound to be one not far away. Here, the tree suits the subject perfectly, providing a natural seat on which she can sit comfortably while pictures are taken as well as a neutral, unobtrusive background.

▲▲ WHY IT WORKS

The clean black-and-white treatment and the girl's relaxed manner give this photo a tranquil, textural quality. Most processors will make a monochrome image from a color negative, and it's easy to do the same digitally.

DOS AND DON'TS

- DO keep your eyes peeled for suitable locations in your area.
- DO ask family members to suggest where they'd like to be photographed.
- DON'T go onto private land to take pictures without the owner's permission.
- DON'T make yourself a nuisance—be mindful of other people's needs.

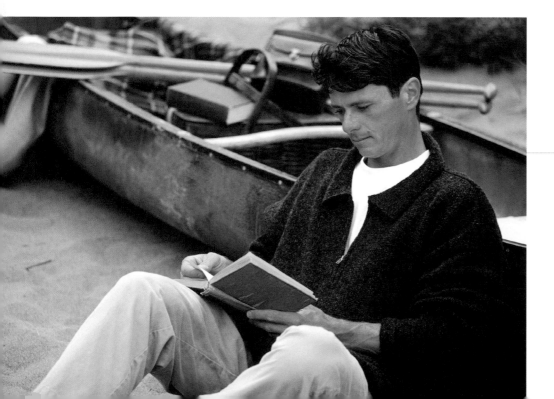

Plain backgrounds get boring after a while, so search for something that will add interest and atmosphere to your picture.

◄◄ WHY IT WORKS

The boat at rest complements this man's dress and relaxed pose and provides a far more appealing backdrop than just the sand. The photographer's use of a long lens setting from farther away means the boat is out of focus and doesn't compete with the main subject.

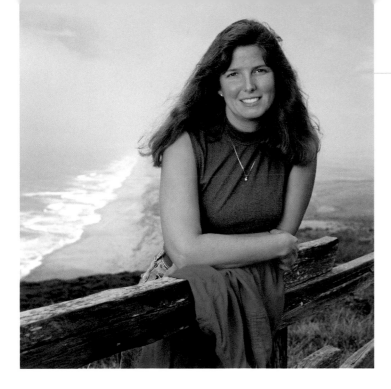

The seaside is always a prime location for taking photos, especially when the light is as soft and gentle as it is here.

◄◄ **WHY IT WORKS**
By positioning himself a little lower than the subject, the photographer has allowed the fence to lead the eye into the shot, while the head's position in the topmost corner of the shot—according to the rule of thirds (see page 53)—produces a balanced composition. The sea mist behind helps blur and soften the backdrop, allowing the subject to stand out.

THE RIGHT SPOT

Chances are, as you start to think about places to photograph in your area, some possibilities quickly come to mind. And with the locations might come the discovery of whom you would like to photograph there, and how. Whether you live in the middle of nowhere or the middle of a city, there are usually plenty of places to choose from.

Most people will be happy to go along with your plan. You could even make the photography part of a larger excursion. Check out the location in advance for the best places to shoot and the time of day when the light is right.

VACATION TEMPTATION

Vacations are the ultimate opportunity to investigate a wider range of locations. And because you're away from the everyday hustle and bustle, you have more energy to devote to new experiences. You can explore the sites in the guidebook or wander at leisure to see what you discover. Avoid the temptation to take pictures that simply say "Here's Mom in front of Caesar's Palace in Las Vegas." You probably want some shots for memory's sake, but also aim for pictures that are more imaginative in composition and approach.

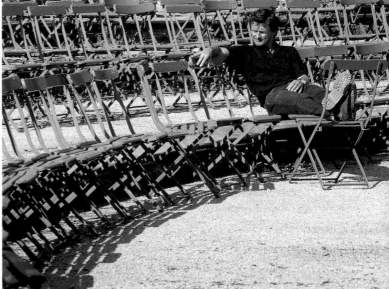

Learn to look at the world around you with a fresh, exploratory eye, and you'll discover no shortage of potential locations—some of which may not be obvious candidates for your photographs. Learn, too, to notice the shapes and lines created by landscapes and inanimate objects.

▲▲ **WHY IT WORKS**
The subject could have been made to sit anywhere, but this choice of seat works best because the eye is compelled to follow the curve of the seats until it finds him. Although the man's pose is very casual, the shot manages to be anything but ordinary.

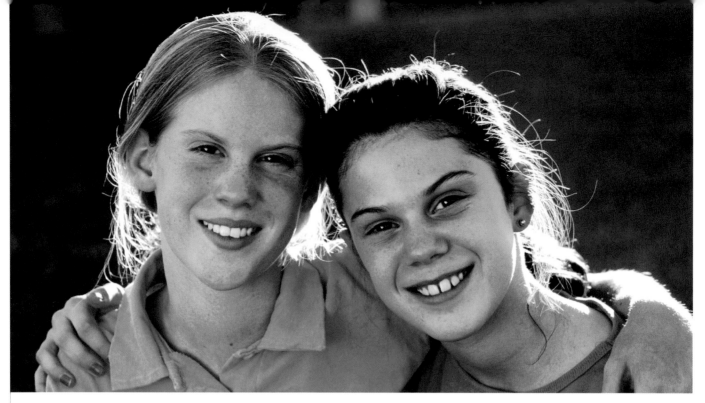

If you're relaxed, then your subjects will almost certainly be relaxed as well. Just be confident, act as if you know what you're doing, and your photo session will go like a dream.

▲▲ WHY IT WORKS

Many children adopt self-conscious poses in front of the camera, so the photographer has clearly done a good job here of relaxing these two young friends. The backlighting produces a lovely halo effect on their hair, while a reflector has been used to bounce light back into the girls' faces to make sure they are fully illuminated.

DOS AND DON'TS

- DO prepare everything before the session begins.
- DO make sure you understand your camera fully.
- DO have some idea of the poses you want to begin with.
- DON'T get flustered and start asking your subject what to do.
- DON'T get bossy and start ordering the person around.
- DON'T change pose or location every few seconds—let the person settle.

RELAXING YOUR SUBJECT

For expressions to be natural and attractive, you need to help your subject to relax, and while there are plenty of ways of building rapport, there are many ways to ruin it also! Just remember to think before you act.

Even when you know your subjects well, there's usually a hint of nervousness when you ask them to pose. Not unreasonably, they're worried about how they will come across. Will they look as attractive as they want to appear, or will the lens capture every flaw? If you don't find some way to relax them, chances are their fears will be realized, because feeling uncomfortable in front of the camera means they won't look their best.

SHIFTING ATTENTION

The secret is to shift your subject's attention from what you are doing to something with which the person feels at ease. An important part of this process is knowing your camera well and being able to operate it without fuss. Spend some time with the instruction manual and familiarize yourself with all of the

controls. If you don't appear confident, your subject is likely to feel edgy. When you are obviously in charge of the technicalities, he or she can relax.

STARTING ORDERS

Think about how you want to begin the session in terms of location, pose, lighting, and composition. Will you work indoors or out? Should your subject sit or stand? Facing which direction? How do you plan to crop the shot?

There is no need to spend a long time over these choices. If you have time, you can try out alternative approaches. But it's valuable to have a basic plan, so things don't falter in the beginning. Once you are off to a confident start, you'll find things start to flow, and one idea will develop into another.

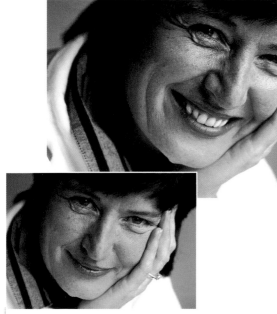

For the first few shots in this sequence, the sitter looked extremely serious. It was only when the photographer teased her a little that she relaxed and began to smile.

▲▲ **WHY IT WORKS**
While it's possible to force a smile on the lips, it's much harder to fake the lines you get around your eyes when you're about to laugh. The photographer used window light from the right aided by a reflector on the left, while the tight crop helped focus attention on the subject's face.

Chatting and directing

Having started to take some pictures, you need to keep your subject relaxed. The best method is to chat about shared concerns or the person's special interests. The better you know your subject, the easier this is. The aim is to get the person talking animatedly, so that he or she ignores what you are up to photographically—allowing you to click the shutter whenever you feel the moment is right.

Left to their own devices, most people stay in the same place and pose, so you need to give them directions. Try not to be bossy— "Would you mind just resting your hands in your lap?" is a better approach—but use your knowledge of the person to tailor your suggestions in the way you know will work best. Unless you are deliberately looking for a wide range of expressions (see pages 74–77), avoid a debate with your sitter. A pleasant conversation is all that's needed to produce some relaxed images.

By engaging people in conversation, you are far more likely to put people at ease and produce more interesting and animated poses.

FRAMING AND COMPOSITION

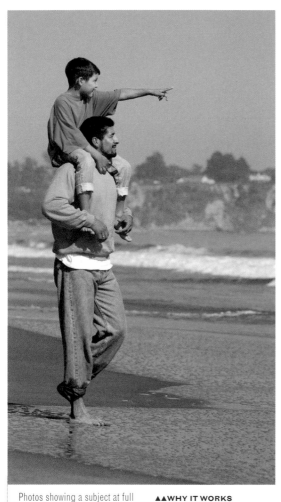

For some people composition is an intuitive process. They look at the scene, raise the camera to their eye, and take the picture. Somehow it seems obvious that the image should be framed in that particular way. But in reality there are many ways to compose a photograph, and the more conscious you are of the choices you make, the more successful your shot is likely to be. The most important considerations are where to position your subjects and how big they should be.

HOW BIG?

Do you want to capture character, shoot an environmental portrait—or create an unusual image? The picture you have in mind will help determine the size of the person in the frame. As a general rule, show more of the person where surroundings are important, and less of the person in shots that concentrate on the individual. But as ever, rules are made to be broken. Here are the main options, with the strengths and weaknesses of each.

Photos showing a subject at full length tend to make it appear small in the frame—even more so when there are two subjects! As a result, the image can lack impact compared to compositions where the subject fills the frame.

▲▲WHY IT WORKS
Placing the man and boy to one end of the frame produces an eye-catching composition that also allows room for the viewer's eye to "move into" the space into which the boy is pointing.

Top tip
With a digital camera, you can easily change the size and position of the subject by the way in which you crop the shot—but you will lose quality if you begin with the person small and then increase the size to fill more of the frame.

A three-quarter length composition, cropped just below the waist, can fill a frame nicely while still revealing enough background.

◄◄ WHY IT WORKS
This man is very much at ease as he leans on his stick midway through pruning. He is not too small in the picture and the background is attractive and gentle.

For more impact, try cropping to a head-and-shoulders composition. For the ideal compositional balance, leave a little space above the head and a few inches below the chin to place the eyes about two-thirds of the way up the picture.

◀◀ **WHY IT WORKS**

The photographer waited until his subject was relaxed and her expression happy and characteristic. The distant background appears out of focus, making her stand out almost three-dimensionally.

FULL LENGTH

Whatever the pose—sitting, lying, or standing—all of the person, from the tips of the toes to the top of the head, is included in the shot.

Strengths: You can convey a sense of the whole person, show the clothes, and reflect elements of body language. More of the background is included, putting the person in context.

Weaknesses: In regular-sized prints, the person can be small, so that his or her expression is unclear. Unless the background is interesting, the picture may lack impact.

THREE-QUARTERS

A tighter crop—typically to just above the knees—with some space above the head.

Strengths: This is a good choice for general picture taking, because you can see some of the body, and the face is not too small in the frame.

Weaknesses: None—unless the background is important, when a full-length composition is preferable.

HEAD AND SHOULDERS

An even tighter crop, which, as the description indicates, starts just above the head and takes in the tops of the shoulders, concentrating attention on the face.

Strengths: Maximum impact, with plenty of eye contact, and separation from the background.

Weaknesses: Most of the body and backdrop is excluded. The image can be too close for those with facial imperfections.

Placing the person

Where should you position your subject: at the center of the frame, to one side, top or bottom, or in a corner?

Center

This seems the obvious position in the middle of the frame.

STRENGTHS: The person is literally the center of attention, and you can usually see the surroundings.

WEAKNESSES: Can appear static, with the person some distance away.

To one side

The person is placed toward the left or the right of the frame.

STRENGTHS: Visually more interesting than a central position, and better if you want to show the person in a specific context.

WEAKNESSES: Can look a little off-balance, but generally a good compositional choice.

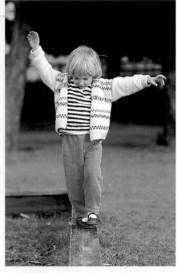

Placing your subject at the center of the frame creates a balanced composition.

Top or bottom

The figure is above or below the center of the frame.

STRENGTHS: Placing the subject extremely high or low in the frame creates tension and adds interest to the picture.

WEAKNESSES: When it fails, the picture looks unbalanced.

In a corner

The subject is placed in one of the four corners.

STRENGTHS: Eye-catching—certain to attract comment.

WEAKNESSES: A risky approach that can work well—or fail badly.

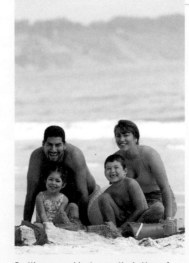

Position your subjects near the bottom of the frame for a more settled, stable effect.

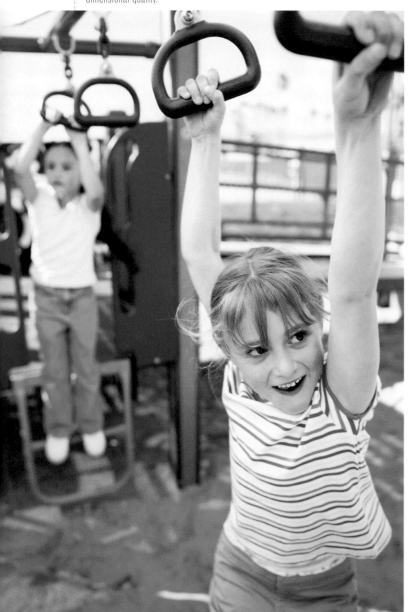

Shooting straight ahead gives you a regular perspective—but not one that is especially exciting. However, it is possible to add interest in other ways.

▼▼ WHY IT WORKS

The secret of this shot's success is the composition. The girl in the foreground is the obvious focus of attention, and because she's far from the background, she has come out sharp, with everything behind out of focus. This gives the shot a dynamic three-dimensional quality.

Points of View

It may seem natural to hold the camera at the same height as your subject—but does it produce the best results? Sometimes, yes. But altering your angle of view can bring some welcome variety to your pictures.

Changing your viewpoint is simply a matter of shooting from positions that are either higher or lower than your subject. It can mean crouching down, or asking the person to do so—or it can involve a more elaborate setup.

STRAIGHT AHEAD

There's nothing wrong with holding the camera straight in front of your face, with your feet planted on the ground, and your subject directly in front of you. A lot of the time that is the right way to proceed. The results have a natural perspective, and any background is included.

LOOKING UP

Here are some reasons for choosing a lower vantage point:
- Showing people at their best—disguising baldness or a large nose, for example (see pages 84–85 for more details).
- Avoiding a cluttered background, or relating the person to an attractive one. When you get lower, what you see behind the subject is usually sky or ceiling. A deep blue sky can make a sumptuous backdrop, especially if the person is wearing something red or yellow (see pages 50–51).
- Giving the subject dominance. Provided you don't go too low, this angle can make people appear more powerful.

WAYS OF LOOKING UP

The simplest way to shoot from below is to drop to one knee, or squat down, which reduces your height by two or three feet—more than enough to make a difference. If you want a lower position still, sit or lie down. This means, however, that the face is the farthest part of the person—a feature you could choose to exaggerate by using the widest setting of a zoom lens.

Don't enjoy all that kneeling and crouching? Then set your subject in a higher position. Ask the person to stand on a box, or shoot from below on a natural slope.

LOOKING DOWN

Why would you want to look down on someone? Here are some of the reasons:

- It can be extremely flattering—because the person is looking up at the camera, the neck is angled more elegantly and features are enhanced. (See the section on *Posing*, page 66, for more details.)
- A higher viewpoint enables you to include both the face and the clothes, and still crop in for a tight composition.
- You can use the ground as a backdrop, opening up a range of colors and tones—from grass to tiled flooring.

WAYS OF LOOKING DOWN

Many professional wedding and portrait photographers carry their equipment around in a hard case, to serve as a stand when they want a higher angle. But you will usually find a chair, step, or wall to serve the purpose when needed. If you want greater height, shoot from a second- or third-story window—an excellent way to show all the faces in a large group.

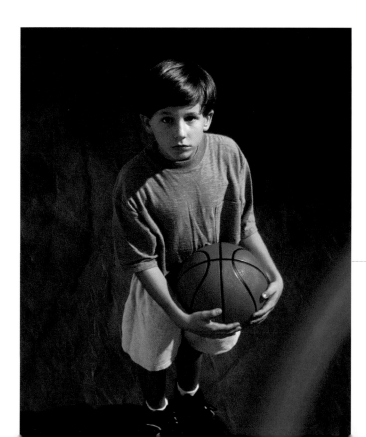

This picture shows how exciting things can get when you start changing your point of view. Photographing these girls on top of a climbing frame from below produces a dramatic perspective that adds to the subjects' sheer high spirits.

▼▼ WHY IT WORKS

The girls' evident sense of fun is part of what makes this a great shot. But it's the way the woodwork—framed by the camera's wide-angle lens—appears to point heavenward in line with the girls' legs, that gives the photo an extra boost.

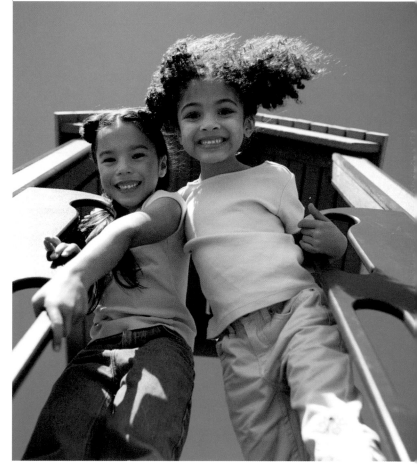

A photograph taken from an extreme high or low viewpoint not only creates unusual shapes, it can also make vertical objects appear more dominant or less important. That is why it is advised not to photograph children from a high viewpoint.

◄◄ WHY IT WORKS

But, as in any art, rules are made to be broken. This shot works precisely because it appears to diminish the little boy, thus illustrating the challenge of the game of basketball ahead of him very effectively.

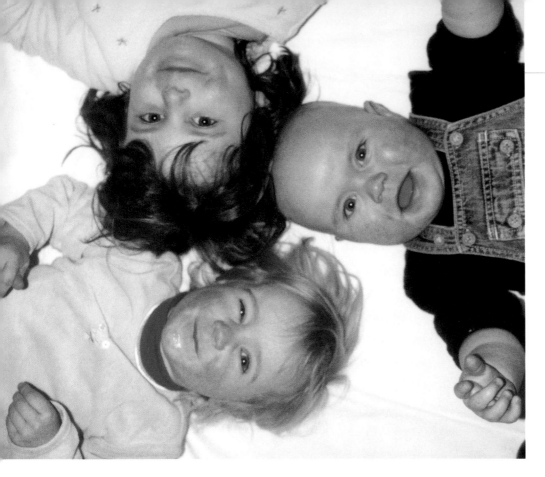

Adopting a different point of view almost always pays dividends. Asking three siblings to lie on their backs with their heads together produces an unsual and imaginative composition.

◄◄ WHY IT WORKS
The near-three-pointed star implied by the way in which the three heads come together is very attractive. It also makes the eye flick involuntarily from one face to the next in an effort to examine the children's facial likenesses and different expressions.

Shape, Line, Form, Texture

Composition is also about the way shape, line, form, and texture work together in a picture. Knowing how to use these elements can enhance your images.

SHAPE

Shape is one of the key ways in which we tell things apart. Most of the time we don't think about shapes, but unconsciously they can affect us. Shapes are also created by elements within a picture; a child holding two favorite dolls might form a triangle composed of her face and theirs. Other common shapes are circles, squares, and rectangles, which again can be actual or implied. Careful arrangement of the elements in the frame, and the choice of lens setting and lighting, can yield sophisticated results.

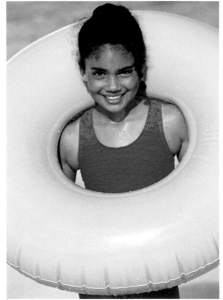

A circle and a stick together! Combining different shapes in a single shot grabs the viewer's interest even when he or she doesn't realize it.

▲▲ WHY IT WORKS
The bold, vivid colors are the first thing you notice about this photo. But it's the interaction of the line of the girl with the curve of the ring that produces a dynamite combination.

LINE

Lines often appear explicitly in a picture, and they are also implied by the shapes of the people and objects included. All lines have a direction—and that direction has an impact on the person viewing the photograph. Horizontal lines, such as the horizon in a landscape, tend to convey calm, while vertical lines appear stronger, like the walls of a house. Diagonal lines are dynamic, suggesting movement across or even out of the picture.

FORM

Form is like shape—but more so. It is what makes an object look three-dimensional. Since photographers deal in two-dimensional pictures, they must pay close attention to the tonal values created by lighting, as well as to shape and color, in order to express the appearance of an object. Variations in the quality and direction of illumination can have a significant impact on how people and their surroundings are perceived. Strong frontal lighting can flatten form, making it difficult to perceive bulk or structure. Soft side lighting is usually the best way to reveal form—the more varied patterns of light and dark it creates give clues about the body of an object. Color is also an important revealer of form because of the interplay between different colors in a picture.

TEXTURE

Texture is an important design element because it appeals to our tactile as well as our visual sense. Skin and hair, rough or reflective fabrics—these all help to make the picture seem real. The effect can be enhanced by the textures you choose and the way in which you light them.

HORIZONTAL AND VERTICAL COMPOSITIONS

A simple decision, but a crucial one, is whether to hold the camera horizontally, producing a picture that is wider than it is high, or to turn it on its side and take an upright shot. When photographing one person, the best choice is usually a vertical composition because people are much taller than they are wide. That is why the term "portrait" is often applied to vertical compositions. When photographing groups, or when you want to show more of the context, a horizontal, or "landscape," format can be more suitable.

As a general rule, horizontal shots work best for couples and groups and vertical shots for individuals.

▼▼ WHY IT WORKS
Because of the tight grouping created by the father's crouched position near his daughter, an upright composition is ideal for focusing attention on the subjects and emphasizing the depth of distance behind them. But a horizontal composition works far better if the intention is to capture the circles of light from their sparklers, which fill the frame from left to right.

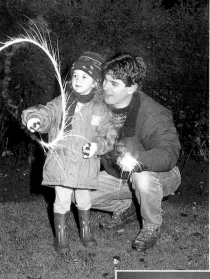

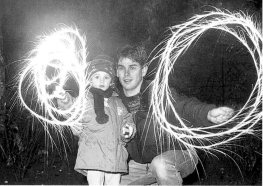

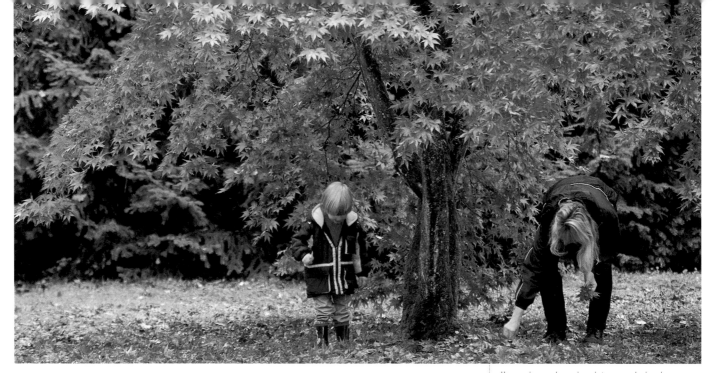

Color Composition

Color is one of the most important elements in a picture—and deliberate use of color can improve your portrait photography immensely. Always remember that color affects our emotions so strongly that it can create or destroy a mood.

Harmonious colors give pictures a gloriously integrated feel, especially when the overall tones are as warm and autumnal as they are here.

▲▲ WHY IT WORKS
The colors of the clothes blend naturally with the surrounding foliage, while the positioning of the tree off-center works well with the wide, horizontal crop.

As ever, your decisions will be largely determined by the kind of picture you want to take. Are you aiming for a bold, contemporary look? Or a mellow mood? You could, of course, dispense with color completely and produce an image in monochromatic tones.

HARMONIOUS COLORS

Our reaction to colors is subjective—Mom loves purple and Dad hates it, for example—but most people agree that certain colors harmonize better than others. So if you want to produce a pleasant picture, combining compatible colors is the best approach. Put red, orange, and yellow together, or juxtapose blue, purple, and green. Make sure that your subject's clothes harmonize with the background—a blue sweater can look good with foliage, for example.

CONTRASTING COLORS

If you want to produce a vibrant image, mix colors that contrast strongly, such as red and green, or blue and yellow. For a truly dramatic effect, ask your subject to don his or her brightest top, and choose a backdrop of the opposite hue. Color contrast is especially useful for emphasizing the main subject when the lighting is flat.

Vivid colors always help a picture stand out—like this mix of red, blue, and yellow.

▶▶ WHY IT WORKS
By crouching down to the boy's level, the photographer made the field the backdrop instead of the sky, heightening the impression of the boy being lost in an endless summer's day. The late afternoon sun has thrown an attractive golden light, creating long, soft shadows.

A SPLASH OF COLOR

It is not necessary to fill your image with color to create an impact. Including a splash of vivid red or blue can be more powerful than quantities of it—especially if the lighting is soft and low in contrast, causing the color to "jump out" three-dimensionally. So if you're photographing someone in dull conditions, and the picture looks a little ordinary, try using a hat, a scarf, or a pair of gloves to bring it to life.

MONOCHROMATIC COLOR

Pictures with a limited color range can evoke a mystical feeling. Often this results from the light: early morning or late evening sun, bathing your subject and the surroundings with golden light, conveys the impression that everything is made of the same material. In pictures taken in fog or mist, the world appears to have turned black and white.

BLACK AND WHITE

Atmospheric results can also be achieved without color. Shoot on black-and-white film, or turn color digital images into mono, and your image will be composed of shades of gray.

As any artist will tell you, when a small, highly colored object appears in a mainly gray scene, it can have a powerful influence on, and indeed dominate, the image.

▶▶ **WHY IT WORKS**
This picture was taken at dusk, creating a predominantly blue-gray coloring that intensifies the photo's wintry, romantic feel. However, the girl's complexion and hat bring an unexpected shot of bright, isolated color that lifts the whole picture.

Monochromatic images have a special quality about them, and most processing laboratories will produce black-and-white pictures from color originals—or you can do it yourself if you're working digitally.

▶▶ **WHY IT WORKS**
The beauty of this shot lies in the simplicity of the composition and the way in which the absence of color lends itself to the subject's shyness and innocence. The plant on the left echoes the wallpaper motif while the soft lighting brings out the different textures of the tiled floor and chair, and the girl's cotton dress.

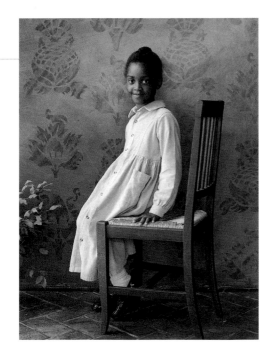

Dynamic Compositions

Rules are made to be broken. And although the suggestions given in the previous pages are extremely effective, they are not the only ways in which pictures can be composed.

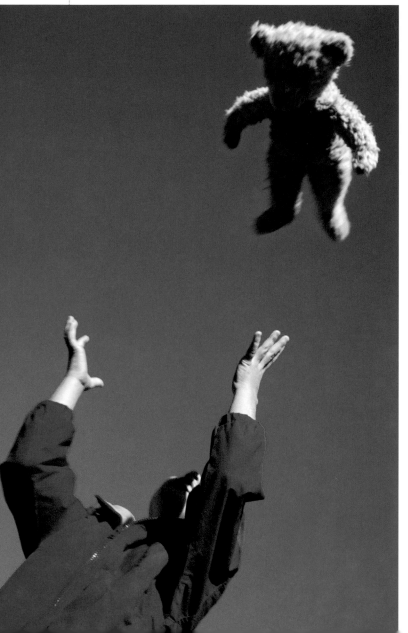

The secret is to experiment. Keep doing what produces the results you want, and discard the techniques that don't. Here are some ideas to help you stretch yourself further and give your portraits an extra edge.

DIAGONALS

Placing your subjects so that they form horizontal or vertical lines tends to produce pictures that are solid and stable. For more exciting images, choose compositions that feature diagonals.

The easiest way to do this is to tip the camera so that the person goes from one corner to the other instead of from top to bottom or side to side. Another option is to ask your subjects to tilt their heads—or to stretch out at an angle, if that fits the pose. The most effective diagonals usually start at the bottom left corner and extend to the top right. That's because we read from left to right, and the eye tends to travel through the picture that way. You can form the diagonal from bottom right to top left, but it is far less effective for most subjects.

CREATING DEPTH
WITH FOREGROUND INTEREST

All too often pictures lack depth, with the components seeming a long way off in the distance. One solution is to place an object in the foreground or at the side. Many subjects look a little lost on their own, especially if there's nothing of interest at the edges of the picture. Strengthening the edges helps to concentrate attention on the most important part of the picture—the person—while giving the entire image a much more three-dimensional appearance.

Placing a vase of flowers at the front of a portrait not only creates depth but also adds color. Outdoor shots can be framed with an overhanging tree or the arch of a gateway.

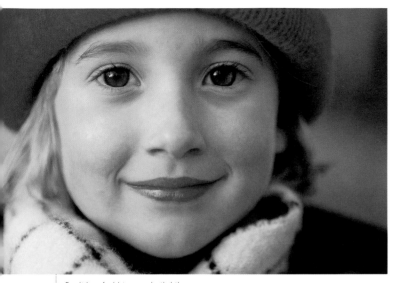

Don't be afraid to crop in tightly on your subject—but try to use a longer setting on the lens if you can, instead of going in close, as this can intimidate the subject and create an unflattering distortion of the face.

▲▲ WHY IT WORKS
The photo focuses attention on the girl's features, especially her eyes and lips, while the soft lighting enhances the picture's sublimely harmonious colors.

With imagination, virtually any strong upright or horizontal shape can be used to form part of a frame. Don't worry about getting the foreground sharp. The eye is more readily drawn to the main subject, and the sense of depth is increased when the foreground—though recognizable—is out of focus.

ULTRA-TIGHT CROP

A famous war photographer once remarked, "If your pictures aren't good enough, you're not close enough"—and that sentiment is also true of portrait photography. As a general rule, the more you crop in on the person, the more impact the shot will have.

So why not take that thought to its logical conclusion and crop in ultra-tight—chopping off the top of the head, the chin, or even the ears? No problem with receding hairlines then! Be bold. If you have a zoom lens, put it on its longest setting, and crop in as close as you can without the picture being out of the focusing range.

If you have an SLR (Single Lens Reflex) camera, you can combine selective focus (see page 143) with an aperture setting like f/4 to give a shallow depth of field, creating subtle and varied focusing effects.

◄◄ WHY IT WORKS
By including the mass of flowers as objects in the foreground and picking the couple as the main subject of focus, the photographer has filled the frame with interest.

The rule of thirds

One surefire way of composing your picture is according to the rule of thirds. Imagine the frame divided into three sections, both horizontally and vertically, with nine squares in all, like a tic-tac-toe grid. Place your main subject at any point where the lines intersect (see image below), and you'll achieve a pleasing composition.

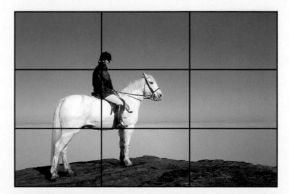

In this photo, the horse and the head of the rider have been positioned exactly on the intersection of thirds. The space left in front of the subject reinforces the picture's tranquil, solitary mood.

LIGHTING MATTERS

An understanding of the many moods of light is essential to make the most of the countless situations you'll encounter. Light is the single most important element in any picture—try taking a picture without it! No matter how attractive your subject is, if the lighting is unsuitable, the picture will disappoint. Yet it's astonishing how little attention many photographers pay to it.

Afternoon sun produces a warm, attractive glow that is perfect for portraits of all kinds. As the day progresses, the shadows lengthen and become less intense.

▼▼ WHY IT WORKS

Quiet beaches provide a clean, soothing background free from distractions. Avoiding midday sun means the light is more suitable for portraits—more golden and more diffuse. Although shot candidly, the group is well composed, and placing it off to the side is more interesting than having it in the center.

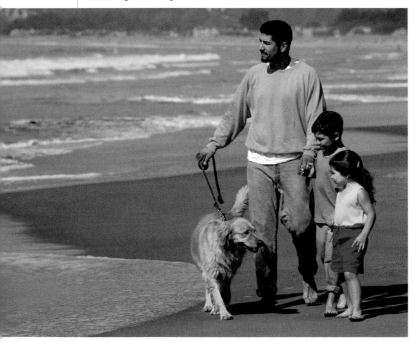

The most remarkable aspect of light is its diversity: sometimes harsh, sometimes soft; sometimes neutral, sometimes orange or blue; sometimes plentiful, sometimes scarce. Become familiar with the many moods of light and use it creatively to transform your portraits. Begin simply by monitoring the variations of daylight. Observe the pattern of light on the shady side of a building, the light piercing a small window, or dappled by foliage—and store the awareness for use when planning a shoot.

MORE DOESN'T MEAN BETTER

When it comes to light, don't confuse quantity with quality. The intense noon light outdoors on a sunny day, for example, is unsuitable for most portraits. More evocative results are generally achieved when light levels are lower. Early morning and late evening light is more atmospheric, and clouds—even rain or fog—provide subtler illumination. Indoors, there is usually less light, which is one reason why portraits there can be so beautiful—provided you use the ambient light and not the flash unit.

Photographing people in snowy conditions when it's sunny can be tricky—while areas that are illuminated look warm, parts of the scene in shadow often have a blue cast. As long as you make sure faces are fully lit, you should have no problem.

▶▶ WHY IT WORKS

The long shadows and the warmth of skin tone mean the sun is about to go down—creating a tranquil sense of mood. This, together with the expressions of father and daughter, make for a winning composition.

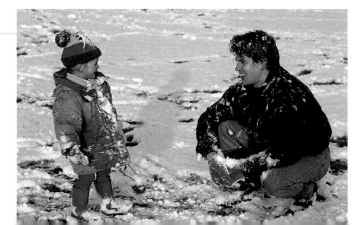

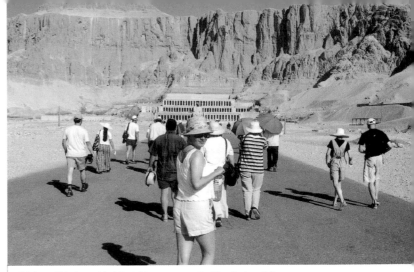

CONTROLLING THE CONTRAST

Sometimes light is harsh, with distinct shadows and sharp highlights. Outdoors in sunshine, the shadows are darker and shorter around noon, and softer and longer in the early and later parts of the day. Contrasty lighting can yield vivid images with rich, saturated tones, but care is needed to avoid losing important detail or producing a pale or over-heavy picture. Although there are exceptions, a contrasty treatment is rarely appropriate for portraits. The degree of contrast also depends upon the direction of the light (see pages 56–57).

Soft light is usually the best choice for portraits. It is more flattering because it creates fewer shadows. Soft lighting is most likely to be found indoors in rooms with large windows.

In every picture, light reveals something about the subject—and never more so than in portraits. So think carefully about the people you plan to photograph and what you want to convey about them—then organize the illumination to suit.

LIGHT ISN'T WHITE

We generally think of light as being neutral or white, but it varies considerably in color—think, for example, of the orange of a sunrise or the blue of twilight. Standard film is "daylight-balanced" and designed to be used in noon sunlight or with electronic flash. If you use regular film under artificial lighting without flash, your photo will have a "color cast": orange, if the light is a regular tungsten bulb; green, if it's a tungsten tube. Neither is attractive, and it is preferable to work with daylight.

Bright sunlight is not ideal for taking portraits, but sometimes you don't have a choice, especially when you are visiting a new place for a limited period of time.

▲▲ **WHY IT WORKS**
Although the light is harsh, the photographer has taken the shot so that the shadows fall away attractively. The wide-angle lens opens up the perspective, pulling the viewer's eye along the road to the center of the picture and emphasizing the drama and grandeur of the huge rocks in the distance.

▶▶ JARGON BUSTER

Contrast Lighting contrast is the difference between the amount of light reaching the darkest and brightest parts of a scene. One of the best ways of understanding contrast is by playing around with the controls of a television set. Take out all the color, leaving a totally black-and-white image. Then turn the contrast knob. At one end of the range, you'll have a picture with strong blacks and bright highlights and a little gray in between. This is akin to the results you get on an intense, sunny day. At the other end, all you will see are shades of gray. This is similar to the soft, shadowless light on an overcast day. While you can compensate for variations in the amount of light with the choice of film, nothing can change the degree of harshness or softness of the light or the direction from which it is coming.

Shooting at the extremes of the day—just after sunrise and just before sunset—when the light is much warmer in color, is a great way of adding mood to your portraits and preventing them from looking bland.

▶▶ **WHY IT WORKS**
This picture would have looked quite ordinary had it been taken at midday. But the golden light of the late afternoon sun has given the subject an instant tan—and a lively catchlight in the eye.

Light Outside

You'll probably achieve your best results shooting outdoors, but only if you make the most of the prevailing conditions. The easiest place to take portraits is outside, where there is plenty of space and light. But take care when shooting in bright sunlight, especially if you tend—as most of us do—to put the sun behind you. This arrangement casts unflattering shadows under the nose and eyes, especially in the middle of the day. It can also make your subject squint.

Positioning people so that the light is behind them is one way of avoiding unflattering shadows on the face.

▲▲ **WHY IT WORKS**

The light was behind this man when the photographer moved to his left to take this shot. This has given the subject's face an attractive glow without showing the kind of shadow and detail often revealed by harsh frontal lighting.

Standing sideways to the sun is better—but not much. The result is one side of the face brightly illuminated and the other in shadow. It can be the right light for a powerful depiction, but it is too harsh for most pictures, unless it is softened by using a reflector on the shadow side (see page 61).

The best approach is to shoot *contre jour*—into the sun (see page 103)—so that your subject's face is evenly lit and the person is not staring into a fireball. Take care, though, because if you allow the sun to hit the front of the lens, there's a risk of flare: that is, stray light that will make the picture hazy. Find a position where the camera is protected from direct light, perhaps by an overhanging tree.

There really is nothing to beat the light you get on a sunny day with clouds in the sky—shadows are soft and the light has a lovely quality to it.

◄◄ **WHY IT WORKS**

This picture was created when the girl wandered into a field of poppies and got lost in her own world picking them—allowing the photographer to shoot off a whole roll of film without her noticing. The field of poppies fills the frame with color without detracting from the subject at its center.

DOS AND DON'TS

- DO take portraits when the light is flat and gray—you'll be surprised how good they are.
- DO experiment with positioning your subject in relation to the sun.

In the middle of a sunny day, when the light is at its most harsh, it's a good idea to find a shaded area to take pictures of people. Light levels will normally be sufficient for you to work without flash, and the results will be much more attractive.

▶▶ **WHY IT WORKS**
The soft light created by shooting beneath a tree is very flattering to the little girl and suits her breezy, happy-go-lucky posture. And the fact that she is darker than the sunlit background makes her stand out very well in the photo.

HAZY DAYS

The best weather for outdoor portraits is slightly hazy, with fluffy clouds drifting across the sun. There are still shadows, but they're softer and more attractive ones that bring the face and body to life. When the sun is not too powerful, it is possible to have it behind you, producing a soft, even, frontal illumination with minimum shadow. If you can shoot early in the morning or in late afternoon, the light will be even softer.

In a sidelit composition, the contrast levels will be more acceptable and could be the perfect choice for a more incisive portrait. Hazy conditions are also preferable for into-the-light photography, because there is less chance of flare.

Most photographers pack up their equipment when they see overcast weather. But it provides one of the best lights for flattering portraits. With no shadows at all, detail is enhanced, and the lack of glare means that natural-looking expressions are easily achieved.

Time of day

The time of day is almost as important as the weather conditions. The sun sits lower in the sky in the early morning and late afternoon, and reaches its zenith around noon. Unless the day is dull, avoid the period from 10:00 A.M. to 2:00 P.M., when shadows are at their darkest.

The color of light also changes throughout the day: from warm orange in the morning through a neutral/blue in the middle of the day to a golden glow in the evening. The evening glow gives skin tones an instant radiance, which is why late afternoon on a summer's day is one of the best times for portrait photography.

Low sun throws long and interesting shadows, which the photographer has incorporated into the composition to great effect. Late evening light tends to be warm, bathing everything in a golden glow.

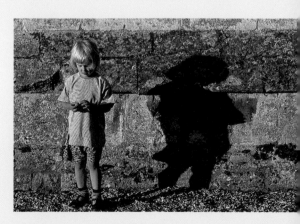

Using Window Light

Light streaming through a window is some of the most beautiful illumination available. Depending on the size of the window, its location, and the time of day, you can virtually "paint with light."

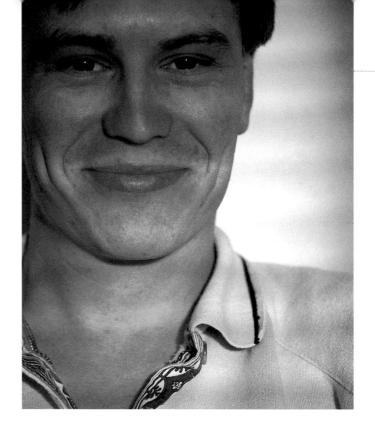

Light levels are lower indoors, but with the aid of a faster film or a tripod, you can keep on shooting portraits—and you might prefer the results. Follow a few simple guidelines and your indoor portraits can be immensely rewarding.

WHICH ROOM?

If you have a choice of rooms, think carefully about which to use. The key points to consider are the number of windows, their size, and the direction they face. Small windows give contrasting light, like that on a bright sunny day, although this can be softened with lace curtains or tracing paper. Large windows provide a very soft light, but contrast can be increased by masking areas with drapes or thick black cardboard. The more windows you have, the more the light will "wrap around" your subject. A room with a skylight is especially useful, because it gives an attractive top light that brings hair to life.

The direction of the window is crucial. A north-facing room enjoys the same light throughout the day, because the sun never passes it. Many professionals have "daylight studios" that face north, because of the soft, attractive, and constant light they give. But if the room faces any other direction, the light will vary in contrast, intensity, and color during a typical day as the sun passes by. In those cases, late afternoon on a sunny day is usually a good time to shoot portraits indoors.

PLACING THE SUBJECT

Putting the light behind you, so that it falls on your subject's face, works better indoors than out, because light levels are less intense. Side lighting can also be effective—especially if you use a reflector to fill in the shadow areas (see page 60).

SUPPORTING CAST

Some people automatically use flash for indoor pictures, because they fear the pictures will be too dark without it. But the range of shutter speeds and apertures on all but the most basic modern cameras means that it's generally possible to take pictures in extremely low levels of light, provided you support the camera to avoid shake and blurring. Use a tripod, or rest the camera on a table or shelf.

Top tip

If you have a camera that allows you control over the shutter speed and aperture, then it's possible to take pictures indoors without flash even when light levels are extremely low. You do this by setting the maximum aperture on the lens—that is, the aperture that lets as much light onto the film as possible. This may result in a long shutter speed, but in that case you can support the camera on a tripod.

Most windows have curtains or blinds. These can be used not only to modify the amount of light entering a room but to create the kind of shadows that make a picture's atmosphere.

◀◀ WHY IT WORKS

By allowing a Venetian blind to throw shadows from the afternoon sun onto his subject, the photographer was able to stage this photo's attractive, *film-noir* atmosphere. The angle of the blinds and the position of the subject were repeatedly adjusted until the desired effect was achieved. Only the man's warm, jocular smile gives the game away.

Top tip

The low light levels you get indoors mean that there's an ever-present risk of camera shake. Loading up with fast film (ISO 400-plus), or, if you're using a digitial camera, switching to the most sensitive setting, will allow the camera to set a higher shutter speed, making it more likely that the picture will come out sharp.

▶▶JARGON BUSTER

Flare When taking pictures outside on a bright day, take care that you don't include the sun in the picture. This can cause flare, in which the light bounces around in the lens and causes bright patches in the picture or sometimes an overall softness.

Place your subject carefully in the room, and the light you get can be magical. But take care when you include the window itself, as there's a risk of flare and under-exposure. Using blinds can help control the light.

▶▶ WHY IT WORKS

The illumination from the window on the left is flattering to the girl's face and brings to life the body of the cello. The subject's pensive, wistful pose suits the photo's mood perfectly.

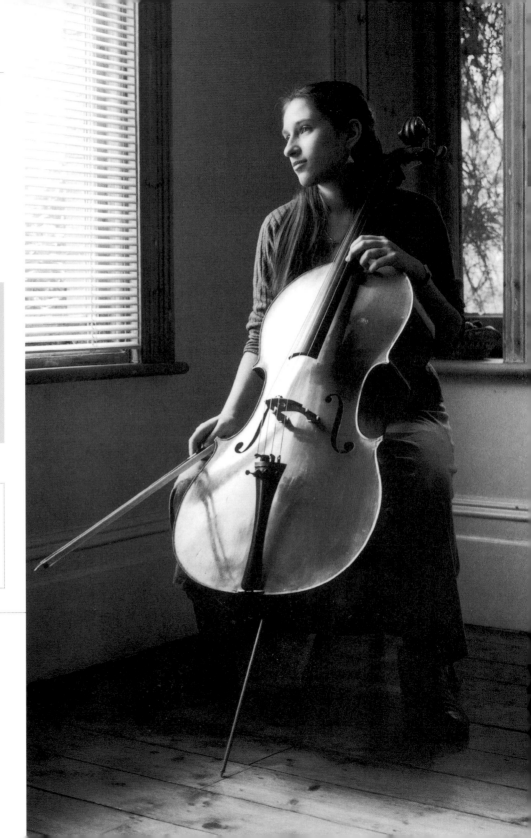

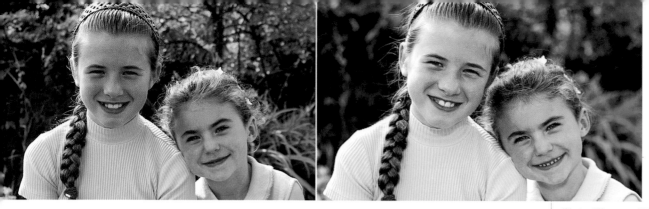

Improving Existing Light

Small steps can make a big difference in the quality of the ambient light. As we've seen, the most flattering light for portraits is directional but diffuse—subjects are fully illuminated but the shadows are soft. Conditions for photography are seldom ideal, however, and the results can often disappoint. Maybe the light was too strong or too flat.

Happily, there are simple but effective things you can do to improve the lighting in a picture.

DAY TRIPS

Suppose you're spending a day at the beach. The sun's blazing down, and naturally you want to take some pictures—but you know that conditions are potentially disastrous for good photography. What can you do?

One option is to locate your picture in a shady spot—under a beach umbrella, for example. Cutting out the top light avoids shadows under the eyes, nose, and chin. Instead, all of the light comes from the front and side, producing an attractive effect. Shade can be improvised, if necessary, by using a towel or a picnic rug as temporary overhead cover.

What a difference a little extra light makes! Although the two shots are virtually identical in composition, the winning smiles that really grab the viewer's attention are the ones that are fully lit.

▲▲ WHY IT WORKS

Shoot into the sun without any correction, and your subjects' faces can appear flat and a little dark. Using flash gives you an extra bit of light that helps brighten the subject, bringing life and vitality to the picture.

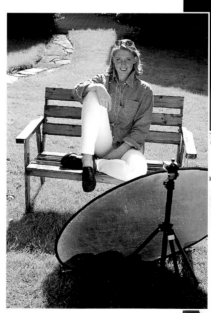

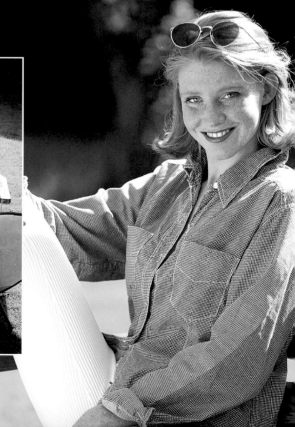

REFLECTED GLORY

A regular option is to use a reflector that bounces light back into the shadows. Professionals use folding reflectors that can be stored in their bags and opened in seconds, but anything that is mainly white can be pressed into service: a sheet, a shirt, or even a newspaper. Ask a companion to hold it for you, or prop it so that it bounces the maximum amount of light back onto the subject but doesn't appear in the picture. You'll be amazed how effective it can be.

Position your subject with his or her back to the sun, and use a reflector—or even two—to bounce light back onto the face. Or light the person from the side, and use a reflector to lighten the shadow side.

An advantage of reflectors is that you can see precisely what effect they're having. As you move your reflector around, going in closer and pulling away, lifting it up and down, and taking it to the side, you can see shadows change. Most often you want the reflector as close as possible to the subject without appearing in the picture. For portraits, the reflector is usually tipped back at an angle of 45 degrees. If you're taking head-and-shoulders portraits, ask your sitters to hold the reflector in their lap, just out of view. It also gives them something to do with their hands!

INSIDE JOB

The same principles apply when taking pictures indoors, using window light. Since you don't have to transport them, indoor reflectors can be much larger and therefore bounce more light. Make your own reflector by painting a piece of wood white—or cover it with aluminum foil—in preparation for a portrait session.

Carrying around a large sheet of cardboard is not always convenient, so consider investing in a collapsible reflector. The clever design means it folds down to a size that fits easily into a bag, yet opens in seconds to a semi-rigid circle with a diameter of 3 feet (1m).

◄◄ WHY IT WORKS

Putting the sun behind your subject on a bright day and then using a reflector gives you the best of all worlds—a face and body that are fully illuminated and a bright halo and hairlight around them.

Top tip

A black reflector might sound like a contradiction—how could it bounce back any light? But it's a useful accessory when the light is excessive and you want to take some away. Use two black reflectors—one on each side of a face—and notice how attention is drawn to the nose, eyes, and center of the face.

Shady places

Another option is to shoot your portrait behind a building or wall. The illumination in such areas is indirect, and therefore gentle, which makes it good for portraits of all kinds. Again, you can improvise a similar effect by screening an area alongside your subject. Be careful, though, to avoid a brightly colored screen, which could lend its hue to the skin tone.

In this picture, the tree behind the boy, and the other trees alongside it (which are not visible), provide natural screens that control and direct the light in the photo, producing illumination that is both directional—from the right—but also relatively soft.

Better Flash

Here's how to make the most of your flash unit—and when not to use it! If your camera has a built-in flash, only use it when there's no alternative—because the results are so often disappointing. Take a look at the last set of party pictures you took. Chances are they show overexposed faces backed by dark shadows. Red eyes are probably apparent also, where the blood vessels at the back of the eye reflected back the flash. That's why it's preferable to work with daylight whenever you can.

When you need to shoot at night, however, there are ways to improve results. The first is to make sure your subject is at least 3 feet (1m) away, and preferably about 6 feet (2m), so that the illumination is less harsh. The second is to use your camera's anti-red eye system, if it has one. If not, switching on the room lights before you shoot will minimize the risk of red eye. A built-in flash will never do much more than let you take snapshots—but you can make sure they are good-quality snapshots!

TAKE IT OFF

Built-in and inexpensive accessory flashguns are usually fixed in position, but more expensive, advanced add-on units often include "bounce heads" which can be adjusted to reflect the light from walls or ceilings for a softer, more flattering effect. If you're using an SLR (Single Lens Reflex) camera with a flash that has a bounce head, reflecting the flash from the wall or ceiling will improve the quality of the lighting and reduce the risk of red eye. To unlock the full potential of your flash unit, though, you need to move it away from the top of your camera. Fitting it on a bracket to one side of the camera can help, but moving it farther away and putting it on a proper lighting stand will achieve the best results.

If you're shooting digitally, you can spot out the red and improve the exposure in the computer—though it's still better to get it right the first time.

It's all too easy to stand your subject in front of a window or mirror and have the flash bounce back at you. In addition to an ugly reflection, the bounced light fools the camera into underexposing, and you end up with a picture that's too dark.

▲▲ WHY IT WORKS
Moving your subjects away from the window improves the light and at the same time improves the composition. Bringing the couple together creates a beautiful portrait that you will be proud of and they will cherish forever.

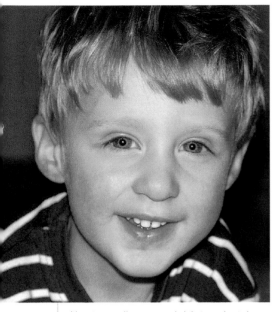

It's not generally recommended that you shoot close-ups with a flashgun, because the lighting is often harsh and unflattering. However, provided you put some distance between yourself and the subject, say 4–6 feet (1.3–1.9m), and use a telephoto setting, the results can be attractive.

▲▲ WHY IT WORKS

The piercing highlight in the center of the pupil from the flashgun encourages direct eye contact with the subject, while the light enhances the grades of color in his hair. That, together with the child's warm smile and the photo's tight crop, make for a terrific shot.

Top tip

Most cameras, even relatively inexpensive models, offer a range of controls over the flashgun. One of the most useful is "fill-in" flash, which balances the output with the existing light—so the subject is fully illuminated but still blends in well with the background.

Fill-in Flash Outdoors

Although built-in flash units have their limitations indoors, they can be useful when you need to brighten an outdoor shot. Heavy cloud cover, for example, can cause faces to appear flat, and the lack of contrast can make an insipid picture. Bouncing a little more light onto the subject with a reflector can bring some improvement, but what is often needed is some additional light—and nothing beats a flash at times like that. In fact, your built-in flash unit may be programmed to fire automatically in such situations. If not, you may have a "fill-flash" or "force-flash" setting that will make the flash fire every time and usually balances the output of the unit with the existing lighting. With an accessory flash on a reflex camera, it's relatively easy to reduce the amount of flash emitted to give a controlled fill-in flash effect.

The same approach can also pay dividends on bright days, when the flash acts to reduce the contrast in the scene generally.

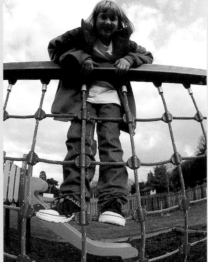

Without fill-in flash the young girl appears dark and murky.

Ilowing the flashgun to fire helps her to stand out from the sky.

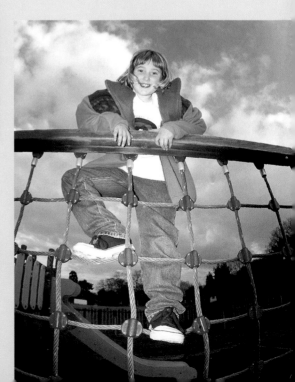

Unlike the outdoors, the studio gives you complete control over how your subject is illuminated.

▲▲ WHY IT WORKS

All these pictures work but each one was differently lit. The picture farthest left was illuminated with just one light to the left and is dark and moody. Adding a white reflector board to the right softened the shadow area (second image from left). The use of two lights, one on each side, resulted in a well-lit portrait (third image from left). In the fourth photo, a third light was added to produce a more "studio" type shot.

DOS AND DON'TS

- DO think carefully about whether you're interested enough in the technicalities of photography before investing in studio lighting.
- DON'T buy lights if you have a compact camera—you won't be able to connect to them and you won't have enough control.

Advanced Lighting

Want to get started in studio photography? Here's how. There are essentially two light sources available to the studio photographer—tungsten and electronic flash. Each light source has its advantages, and many professionals use both, depending on the kind of effects they want to achieve.

If you have an SLR (Single Lens Reflex) camera and want to take your portraits further, consider investing in studio lighting. Being able to place lights exactly where you want them, and modify them with accessories to give either diffuse or contrasty illumination, means you can create any effect you like. It also frees you from the elements—you don't need to stop when it gets dark or the light's not right.

CHOICES, CHOICES

First you must choose between two distinct types of lighting. The cheapest, and in some ways the easiest to use, are tungsten lights. They use similar but slightly brighter bulbs

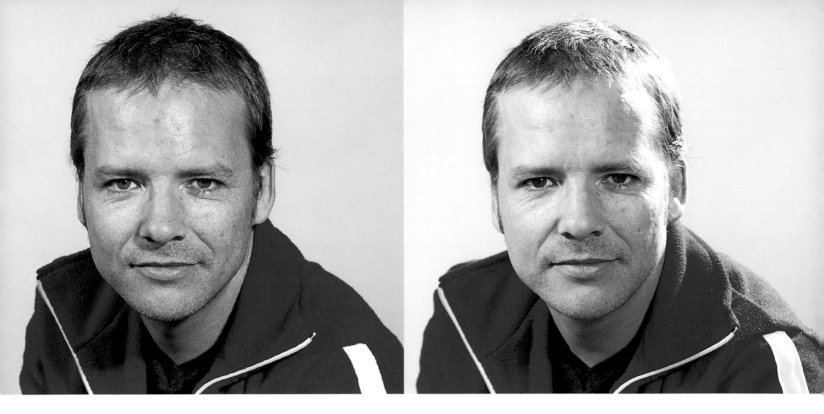

than those used in regular household lamps. They provide an uninterrupted flow of light, so you can see exactly what effect they're having. But the light they produce is orange, and they quickly become extremely hot. The color problem can be countered by fitting a blue filter over the lens, or by choosing the tungsten setting on a digital camera, and the heat can be managed by switching the lights off intermittently and not placing them too close to your subjects.

STUDIO HEADS

Most professionals, however, use electronic flash equipment, which works like a flash unit, emitting a brief but powerful burst of light when the shutter is released. Although flash equipment tends to be more expensive than tungsten, all you need to begin is a single flash head, a stand to put it on, and an "umbrella" or "softbox" diffuser to produce soft, even illumination. The only additional requirement is a handheld exposure meter to measure the amount of light falling on, or reflecting from, your subject.

POWER POSITION

If you start with just one light, where should you position it? Not directly in front of the subject, or the light will be harsh and flat. A better position is at 45 degrees to your subject, slightly above the person, and 3–5 feet (1–1.7m) away. Place a reflector on the other side, as close as possible, and you'll be able to produce some marvelous portraits from this very simple setup.

Adding a second light will give you many more choices, including control of the "lighting ratio." This involves placing one light on either side of your subject, and reducing the power of one of them to create just the right amount of shadow.

LEARNING CURVE

Using studio lighting opens up a new way of working. Instead of "taking" pictures, you're "making" pictures. You no longer rely entirely on the lighting that the universe provides—you have your own.

POSES AND POSITIONS

The ability to pose people effectively is one of the most important skills of portrait photography. The only sure way of developing it is to take lots of pictures, using as many approaches as possible, to find out what works and what doesn't.

Guiding your subjects to the pose you want

Photographers differ in the way they give directions, and subjects vary in their reactions. As you gain experience, you'll develop ways that work for you and the people you photograph. Here are some approaches to try:

- **Telling them:** A polite request ("Could you turn more to the camera?" "Would you mind pointing your toes a little more?") is more effective than an instruction ("Stand up straight!" "Don't fold your arms!").
- **Showing them:** Some people find it difficult to translate verbal descriptions into physical movement, and showing them is easier. If you want them to soften their hands or relax a shoulder, do this yourself and ask them to copy you. If the position of arms or legs needs changing, it's probably easier to go to the person and face the camera, so that the sitter is clear about which side to adjust.
- **Moving them:** Especially when you know your subject well, you can move him or her into the pose you want, as some professionals do.

Getting people to follow your directions takes skill and practice, especially if there are several people in the shot. But directing can also be tremendous fun and can produce unexpected compositional gems like this, where the photographer has captured another photographer in action!

One approach that doesn't work is leaving your subjects to their own devices—probably with their arms dangling and an apprehensive stare at the camera. People don't know how to pose—and for most it doesn't come naturally. If your photograph is to succeed, you must give your sitter some guidance about how to stand and where to look. Even professional models need some direction.

SQUARE ON

Many amateur portraits show their subjects standing square on (see opposite, top left) to the camera, that is, with their whole body facing the camera, because that's the position most people adopt without direction. Unless the person is slim and elegant, this can be most unflattering, because the full width of the waist and hips is visible. It is usually better to ask the subject to turn their body slightly so that one shoulder is closer to the camera than the other.

THREE-QUARTERS POSITION

The best position for most subjects is facing the camera at an angle of 45 degrees (see opposite, top right). Whether the person is sitting or standing, this pose is naturally slimming, because the rear hip is partly behind the front hip.

FACING SIDEWAYS

This pose (see opposite, bottom left) is suitable for a man or woman with a good figure, but it's not flattering for anyone with a bulging waistline, which will be all too prominent.

LOOKING OVER THE BACK

This pose (see opposite, bottom right) is useful for occasional use, when you want to try something different. It can be surprisingly effective.

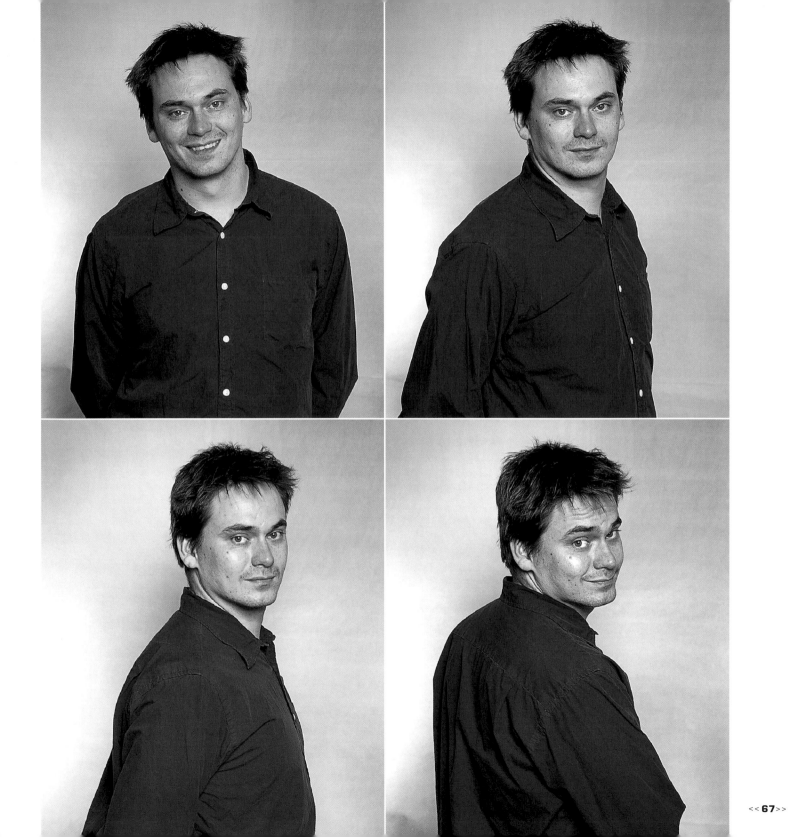

Chairs are a great way of including a subject's whole body in a picture without having to stand. They also help subjects feel more comfortable, which is particularly important if they are older.

▼▼ WHY IT WORKS

The child's sweetly awkward pose, with his hands between his knees, makes this a delightful portrait. The chair is an ideal prop as it both provides a frame and gives the picture its structure. Soft lighting from a window to the left adds the final, wistful touch.

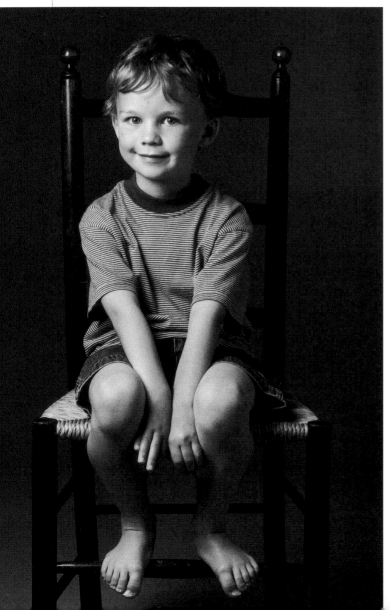

Standing, Sitting, Leaning, Lying

What's the best pose for a photograph: standing, sitting, leaning, or lying down? All can yield superb results, and the choice depends upon the person, the circumstances, and your aims for the photo.

Older folks are likely to feel more comfortable sitting, while youngsters can prefer an informal style. But whoever your subject, you'll probably want to check out a number of different approaches to see what seems most effective.

STANDING

Lots of pictures are taken with the person standing up, and this is a practical pose when you're out and about. It makes people long and thin, so be prepared either to crop in to a three-quarters composition or to include a fair amount of background in a full-length shot. It's usually preferable to position your subject at a slight angle to the camera. Check that the spine is upright and supported on the hips, that the knees and shoulders are relaxed, the neck is long and elegant, and the hands and feet don't detract from the shot (see page 72).

SITTING

Chairs offer people support, which many will welcome, especially if you're planning to take a number of pictures. An attractive chair also adds interest to the photograph. It's possible to turn a simple chair around and sit astride it. The chair back can be a distracting feature, however, and in most situations a stool is a better choice. Place the seat at a 45-degree angle to the camera for the most flattering shot, and be sure that the subject sits erectly but comfortably. Try seating your model on a desk, a step, behind the wheel of a car—or on any other suitable perch.

LEANING

For a natural look, find your subject something to lean on: the back of a chair, a banister, or a mantelpiece, for example. Outside, you could choose a wall, a tree, or the roof of a car.

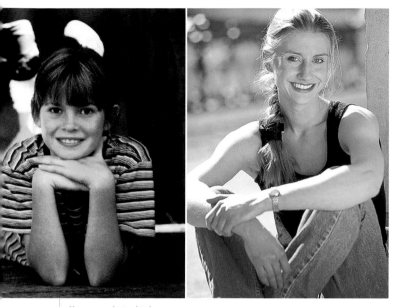

Leaning forward is a useful pose for a seated person. It looks more dynamic, improves posture, and avoids sagging chins and tight facial muscles. Alternatives include leaning over the arm of a couch. For some personalities, slouching poses can look good.

SITTING ON THE FLOOR

Subjects who like sitting on the floor will relax more, and the position offers the photographer a wider range of poses: arms draped around the knee, the back resting against a wall and the legs stretched to one side, for example. Looking up helps to tighten the neck and facial muscles, so with the photographer standing, a more flattering perspective is achieved. Floor poses also tend to fit the frame well.

LYING

You might not think of asking people to lie on the floor, but this can be very effective. Photograph your subjects lying flat on their back, with their hands splayed out; or lying on their front, propped up on their elbows; or with their head resting on their arms. This last pose can look especially attractive, with the feet and body stretched out behind the subject, out of focus, and the face in full focus.

Young people tend to be more open to poses that involve lying or sitting on the floor. This can open up a range of compositional possibilities, and produce more relaxed images. Try and choose a pose that is characteristic of your subject.

▲▲ **WHY IT WORKS**
When people are on the ground, they instinctively use their arms and hands for support. The same applies to legs and feet. This solves the problem of what to do with the subjects' hands and feet, and produces natural poses like these.

Soften the joints

People often hold tension in their shoulders. Ask them specifically to relax that part and they'll look a lot better. Encourage them to soften every joint. Nothing should be straight or stiff. Limbs and joints should be curled and easy.

Beware of bulges

Lumps of any kind can ruin a potential masterpiece, so check carefully before clicking the shutter. Men, in particular, are inclined to put lots of items in their pockets, and if you think they will show, ask your subject to empty his pockets temporarily. A formal jacket with the buttons fastened can develop a bulge just behind the neck. Go behind your subject and gently pull on the tail of the jacket to solve the problem.

How not to do it! For the best results, getting people to relax their arms and shoulders results in fewer bulges.

Photographs with the face square to the camera can all too easily look like passport shots—so it's a good idea to shoot a range of pictures with the same subject looking in different directions.

▲▲ WHY IT WORKS

To avoid the "passport shot" problem, the photographer cropped in tight to concentrate attention on this man's strong face. More pictures were taken when a third party engaged the subject in conversation, producing this animated, but nevertheless controlled, profile image.

▶▶JARGON BUSTER

Catchlight This is the highlight in a person's eyes that reflects the light. Outdoors on a sunny day, the catchlight is a sharp circle of light caused by the sun; on a hazy day, it is a larger but less bright band of white. Similarly indoors, a small window gives an intense catchlight, and a large window a more spreading one. Catchlights can help bring portraits to life, and using a reflector close to the camera is one way of adding them if they are not already there.

Direction of Gaze

Should people look at the camera or away from it? Gazing into the camera indicates an awareness that the picture is being taken. Looking away suggests that a more private moment was captured.

Most portraits show people looking at the camera, which is a good reason to have your subjects avert their gaze sometimes. But in either approach, certain head positions are more effective than others.

FACE FULL-ON

This can all too easily look like a passport photograph and be correspondingly dull. It's unsuitable for people with rounded faces, because it shows the full width. There is strong eye contact, however, which can be effective for people with distinctive faces. A full-on view can establish a powerful connection with the viewer, especially if there's a "catchlight" in the eye.

The best modification of a full-on pose is to angle the body at 45 degrees to the camera and then turn the head toward the camera, but not fully. This is flattering for most people.

In a full-on view, it is rare for the person's gaze to avoid the camera, unless he happens to be glancing down. Prompt your subject to look up or down, however, and the pose can appear to be a deliberate joke.

THREE-QUARTER VIEWS

These are a good choice if you want your subject looking off into space, apparently lost in thought. They can also work well if the person looks at the camera, provided the torso is turned to face the same angle. But turning the head square-on to the camera with the body angled doesn't work at all.

As a general rule, do not allow the end of the nose to extend beyond the line of the cheek behind it, or the shot will look weak.

PROFILE SHOTS

Pictures with the head facing directly to the side need careful handling. The person must have strong features, because the nose and chin are exposed for scrutiny. There's also no eye contact, which makes it more difficult to engage with the sitter. With the right person in the right setting, however, profile shots can be striking, and you should certainly explore them in your portrait photography.

Tilting the head

Tilting the head adds variety to your poses—but take care. If the head tilts too far, it looks unnatural (as if the neck is broken) and can make the chin look ugly.

Chin tuck

Ask people to tuck their chin down slightly—it makes the eyes more attractive. If they tip their head backward even a little, they appear to be looking down their nose in a superior manner.

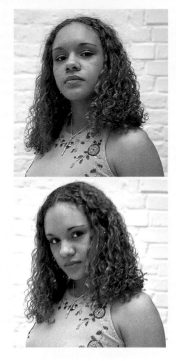

If you allow your subject to tip her head back, her chin will jut out and she will appear to look down at you in a haughty way.

Asking your subject to tuck her chin into her neck helps her look her best and produces a more flattering result.

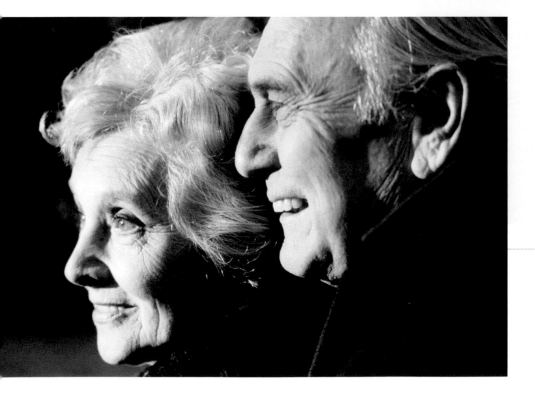

Be careful when shooting profiles because many people are sensitive about the shape or length of their nose.

◄◄ WHY IT WORKS

Whether or not the couple were directed by the photographer to gaze off in the distance, the effect here is of a candid photograph. The slight backlighting catches the profiles perfectly.

Hands and Feet

Hands and feet need lots of attention. They betray at a glance whether someone is relaxed or tense, and awkward placement can undermine an otherwise attractive shot.

Unless you're taking a tight head shot, arms and hands will appear in the picture. Most people are self-conscious about them and will need your guidance about placing them. Here are some suggestions:

ARMS

Don't allow your subjects to fold their arms in front of the body, unless you want a bored or rebellious pose (which can sometimes be fun with children). A standing pose with arms dangling is rarely successful either. Instead, ask your subjects to clasp their arms in front, one hand holding the other wrist, or to slip their fingers into their pockets (see below). Hands on the hips can be effective, but this isn't a suitable pose for everybody. Give your subjects something to hold, such as a book, a drink, or an item related to their job or hobby.

HANDS AND FINGERS

Once someone is seated, the hands stop being a hindrance and can become a useful prop. Place subjects behind a table and ask them to rest their head in their hands—first with the fingers loosely supporting the cheekbone, and then under the chin. But don't allow the hands to form a fist, which will look like a punch in the face! Here are some additional suggestions:
* Place hands on a surface, but not resting flat. Have them balanced on the tips of the fingers, or with the index finger pointing slightly.
* Slip hands into pockets for a relaxed pose, but not completely. Leave the thumb out, or hook just the thumb into the pocket.
* When arms are hanging, don't allow the fingers to dangle limply. Ask the person to curl them in slightly.
* Hands that are resting in a person's lap should not be separate—arrange one hand gently over the other wrist.

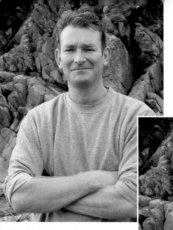

You don't have to be an expert on body language to know that having arms folded across the chest is a defensive gesture—and not very flattering.

▲▲ **WHY IT WORKS**
People visibly relax when they unfold their arms, and you can see it here in the shoulders and the smile.

LEGS AND FEET

Pay attention to legs and feet, even if you do not plan to show them, because they can have a subtle effect on the rest of the body. Where legs are part of the picture, careful arrangement is essential. In a standing pose, make sure people are well balanced, with the feet about shoulder-width apart. Putting one leg slightly forward and pointing it, like a ballet dancer, will enhance the appearance of adults in formal shots. A similar effect can be achieved more naturally by raising one of the legs slightly—resting it on a step, perhaps. In seated poses, ankles and feet can look "solid." Crossing the ankles (but not the legs) can make them more attractive.

People often don't know what to do with their hands, so one solution is to incorporate them into the pose. They provide a natural cradle for the head, and make the composition much more interesting.

▶▶ **WHY IT WORKS**
The contrasting tones of this photo give it impact while the child's slightly bored expression accentuates its wistful quality. The basket weave on which she rests adds texture and definition to the composition.

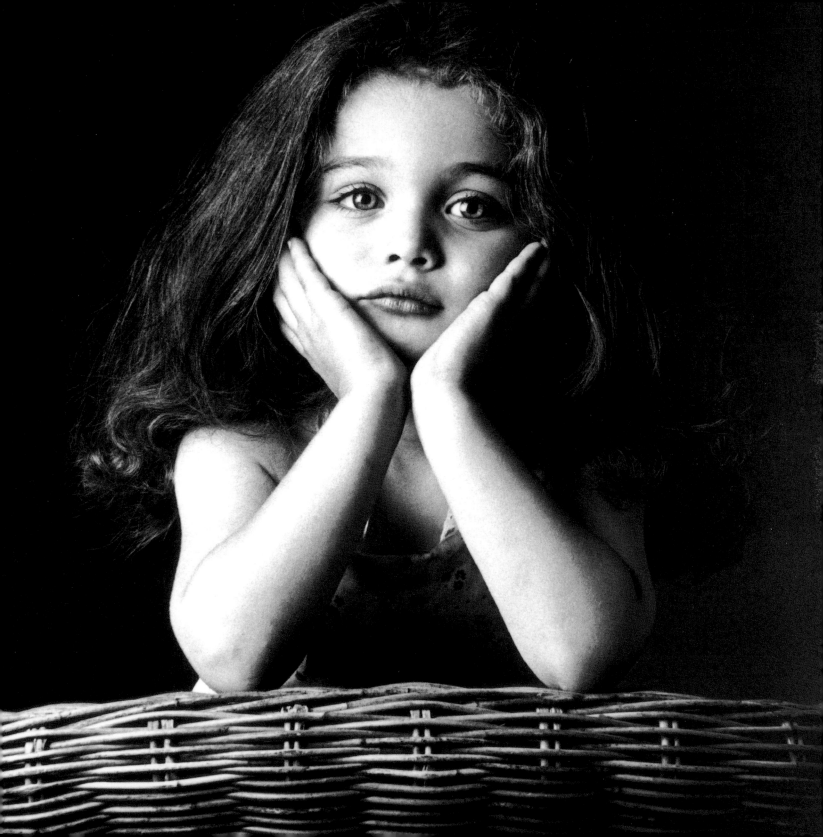

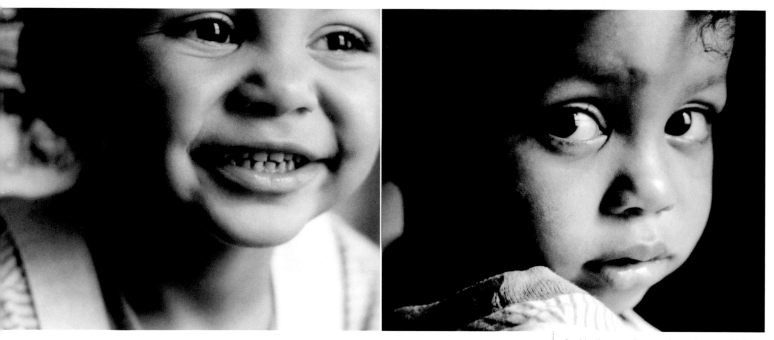

FACIAL EXPRESSIONS

One of the most memorable pictures of British wartime leader Winston Churchill shows him scowling at the camera. The photographer, Yusuf Karsh of Ottowa, Canada, is said to have achieved the shot by grabbing the great man's cigar from his hand just before releasing the shutter. Whether that is true or not, the picture's enduring success shows that subjects don't always need to smile.

A subject's expression can change in a mere blink of an eye, so you need to be ready to capture every nuance of smile and expression.

▲▲ WHY IT WORKS

The photographer was drawn to this girl's large eyes and decided that a tight crop would emphasize them. Within minutes he had captured two different faces of the same person—one lively and gleeful, the other shy and thoughtful, but both a true record of her personality.

EMOTIONAL INTELLIGENCE

One of the ways we know we're alive is by experiencing emotions—and these are most clearly expressed on the face. In the course of a minute, a face can register an extraordinary array of emotional states. Call on a relative you didn't visit for a while: she's surprised to see you; delighted you came; embarrassed that you found her in old clothes; sorry if you bring sad news; excited about how you might spend your time together; curious about your new job; envious of your new car; thoughtful about the weather. Some of these expressions

DOS AND DON'TS

- DO have your camera ready to capture that elusive expression at a moment's notice.
- DON'T work so hard at eliciting expressions that they seem forced—act natural.
- DO encourage people to talk about their experiences—to "connect" with you.

flash across the face for a second or less. But a photographer who is alert enough to capture some such fleeting glances will produce a much wider range of portraits than the conventional smile to the camera.

GENUINE SMILES

How to begin? Well, don't ask people to say "cheese." Some people might say it anyway, because it's a traditional response to having their picture taken. In that case, go ahead and take a couple of shots—it can help them relax and might give a pleasant result.

Other words are better at producing a genuine smile. One photographer asks people to shout "payday," which leaves the mouth in a cheery grin. Another likes the word "whiskey," which pushes the mouth open a little wider. Practice words and phrases in front of a mirror, and note which ones produce a happy expression—whether because of the way the mouth moves or the feeling they evoke, which is reflected on the face.

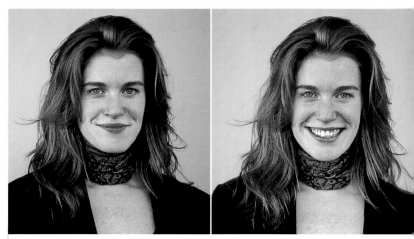

It's the twinkle in the eyes that tells you if a smile is real or false—and it doesn't matter whether the person has a little turn of the lips or the mouth opens wide. A smile isn't something you can force. It just comes naturally. The trick is to learn when to take your shots.

▲▲ **WHY IT WORKS**
These pictures were taken in the shade of a wall on a sunny day. The subject's expression changed from one of faint amusement to a broad grin as she relaxed. The soft lighting and backdrop give the shots a palpably "studio" feel.

FADING SMILES

The secret of success is capturing the smile as it fades. Encourage your subjects to open their lips wide—even to laugh—and click the shutter just before the lips close fully. This looks genuine—unlike so many shots in which people are pretending to be happy.

How do you get people to smile and laugh? Telling jokes is one way, or recounting something amusing that happened to you. Better still, have people tell you something funny that happened to them. While they're busy remembering the story, they're not thinking about the camera.

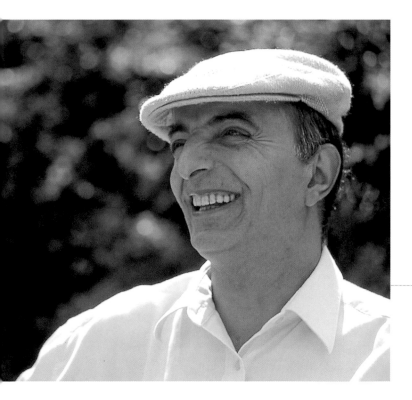

One of the best ways of capturing expressions is to shoot candidly, as this will give you a full range of expressions, all of them completely natural.

◀◀ **WHY IT WORKS**
This man was talking to a member of his family as the pictures were taken with a telephoto zoom on an SLR (Single Lens Reflex) camera. This allowed the photographer to stand about 12 feet (4 m) away and capture a range of expressions over a mere couple of minutes.

Being playful

Suggest your subjects adopt a funny expression, such as crossing their eyes or making a silly face. It will probably not be long before they collapse into giggles. Then you have two types of images for the price of one: a range of unusual expressions and a wonderful smile at the end.

A similar approach is to ask your subject to act out a sequence of emotions: miserable, happy, mysterious, haughty. But you don't need to be the life and soul of the party to get the best out of people. Chatting to them about their interests and events in their lives can be equally successful. Share some gossip. Find out their news. As your rapport with them builds, they'll become more comfortable with you. With your nearest and dearest, of course, you should soon be at ease.

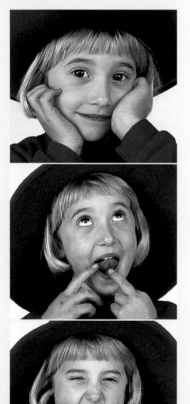

This young girl was trying to be a good "model" for her father by trying out different poses, but quickly got bored, as children often do.

Rather than fight a losing battle, the photographer encouraged his daughter to "act up" for the camera, giving him free rein to take a large number of photographs.

As the subject got into the swing of things, she became more animated, acting out as many expressions as she could think of—and then decided she didn't want to pose any more.

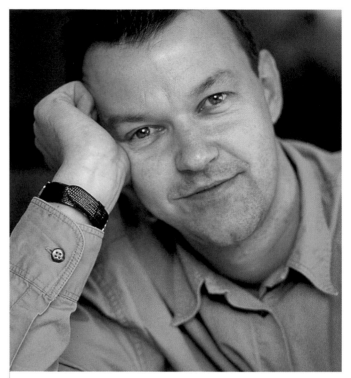

Natural smiles are often much easier to live with than broad, goofy grins, especially if you plan to put the photo of your loved one in a frame. So if you try to get your subject engaged and interested, you're more likely to come up with something of lasting appeal.

▲▲ WHY IT WORKS

The photographer took this picture of his friend while they were in mid-conversation. The angle of the man's head, resting lightly on his hand, and his gently animated expression manage to capture something of his personality.

ELICITING EXPRESSION

The aim is to elicit as wide a range of expressions as possible. As you talk, observe the myriad fleeting looks that pass across the face—and all you need do is be ready with your camera.

Some of the most interesting portraits come from moments when people seem lost in thought. Asking people to pose like that can produce unconvincing results. Suggest instead that they think about something that's important to them—an ambition, a magical vacation, a coming grandchild—and be ready to record their expression.

REVEALING LOOKS

And what about feisty, seductive, curious, sad, or questioning looks? You know your family well. What emotion sums up each member best? See if you can capture it!

Of course, you need to tread with sensitivity. Most people would feel it inappropriate to photograph family members crying, for example. You're not a newspaper journalist, after all, and you'll probably want to give them a hug instead. You might also think twice if they're angry—unless you believe that taking a picture could break the tension.

BEYOND CORNY GRINS

The aim is to vary the endless pictures of people smiling. A lot of the time they will be, because you're photographing happy times, but there are so many more emotions to capture than a corny grin.

Most people think only of taking "happy" photos of their children, but other expressions are often more captivating and enduring.

▶▶ **WHY IT WORKS**
It's the smudges of dirt on the nose and cheek that make this picture—and the child's tremulous expression. Although it was an overcast day, the photographer avoided the use of flash as it would have spoiled the picture's mood.

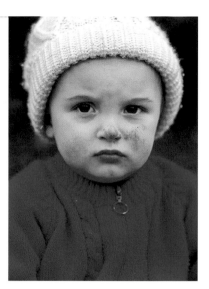

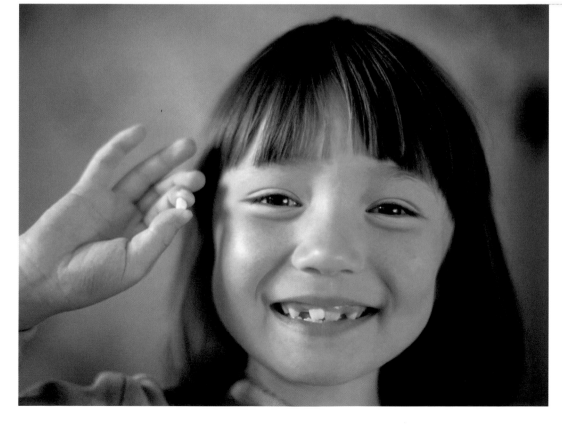

When photography becomes a part of everyday life, and not simply the reserve of special occasions, the photographer learns to see and capture a wide range of expressions when the right moments arise.

◀◀ **WHY IT WORKS**
"Look Mom, my tooth's come out!" By grabbing her camera at the right moment, the photographer was able to capture this moment for posterity as her daughter talked about the tooth fairy and showed off her gap-toothed grin.

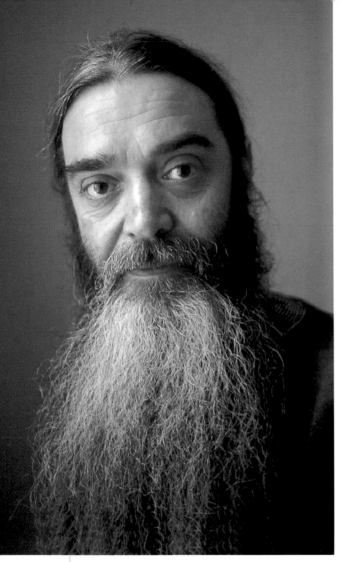

CHARACTER STUDIES

We all know people who are "larger than life," who exude character. You see it in their faces and in their body language, and you might think you only need to point the camera at them to get a good result. To a certain extent, that's true—but it can lead to disappointment, because there's a considerable difference between a superficial snapshot and a picture that captures an essential part of a person's character.

ELUSIVE COMMODITY

A shyer subject is a more obvious challenge, but whether exuberant or modest, each person has inner qualities that a photo can help to reveal. How do you recognize that elusive element we know as character? And how do you capture it on film?

Character is not about how people dress; it's not how tall or short they are; it's not what they own, or where they live—although all those things can give some information about them. Character is about the way they are inside. It shows in words and actions, but it can also manifest itself in people's expressions or in the way they carry themselves: a glance, a nod, or a lively gesture.

Some people have faces that suggest a great deal about them, an assumption used to enormous advantage by generations of Hollywood typecasters. Some characters can be too shy to pose, but with a little persuasion they will warm to the camera.

▲▲ WHY IT WORKS
To capture this individual's thoughtful and eccentric character, the photographer excluded all distracting elements from the shot. The picture was taken indoors using light from a window on the left, and the subject was positioned away from the walls, rendering them out of focus. A tight crop concentrated attention on the man's eyes and beard.

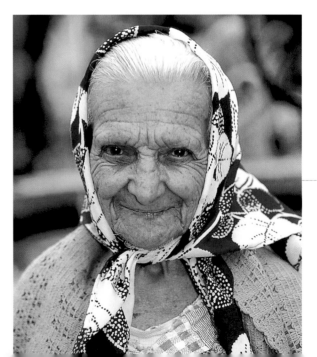

Every family has at least one "character" —irrepressible, the life-and-soul-of-the-party—and generally you won't have any difficulty getting them to pose. If anything, you'll find it hard to make them stop! That makes your life easy, because it means you can take all the pictures you want.

▶▶ **WHY IT WORKS**
This shot captures perfectly the wonderful character of this fiddling grandpa with his dancing feet. The outdoors porch setting works well, while the angle of the shot shows the background but allows it to disappear out of view.

DOS AND DON'TS

- DO keep it simple—in character photos, more is less.
- DON'T try to be clever; there's a time and place for that, but this isn't it.
- DO allow people to be themselves, honestly and openly.
- DON'T do anything that distracts attention from your subject.

KEEP IT SIMPLE

When your subject has character aplenty, remember the old adage: keep it simple. Focus all attention on the person, and do not add anything. Choose a plain background—even black or white. Find a location where the lighting is sympathetic, and possibly a little dramatic: coming from a single window, for example. Crop in close, so that nothing distracts from your subject's special qualities.

Then all you need to do is to get the person to rivet attention on the camera. Hold your subject's gaze so that he or she really connects with you, the photographer—and with anyone else who looks at the picture.

The beauty of taking character shots is that you often don't have to try hard to achieve good results. In fact, if you do, you probably risk ruining everything.

◀◀ **WHY IT WORKS**
The photographer cropped out any distracting background, using the longest setting of a zoom lens, and chose to photograph his subject face on, her eyes looking straight into the camera. Her eyes are piercing and her smile kindly, suggesting a stern yet feisty character.

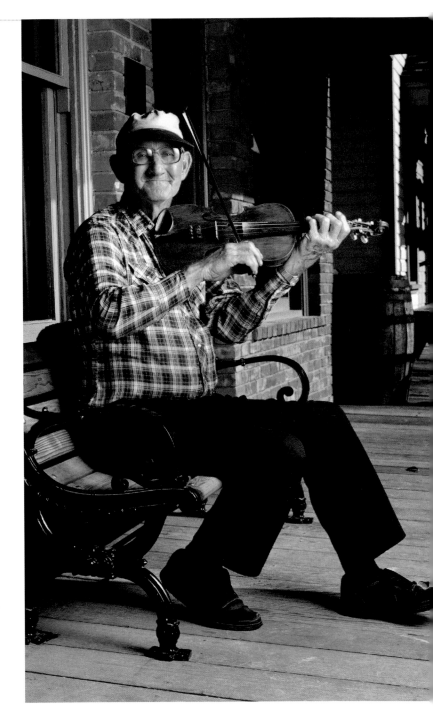

CLOTHES, PROPS, AND ACCESSORIES

Clothes are an important part of the way we express ourselves. Imagine swapping clothes with your parents or children, or exchanging them with a neighbor who has a different lifestyle. It would certainly feel strange walking down the street in their clothes—you might not even feel like yourself any more!

DUE RESPECT

When taking pictures of your family and friends, you'll obviously respect the fact that clothes are part of their identity, and most of the time you'll photograph people in what they're wearing. But that doesn't mean ignoring clothes, especially when you aim to produce a flattering portrait.

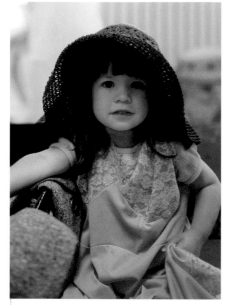

Young children love to dress up to have their photo taken. This can add fun to the photo session, and prevent children from getting bored too soon. If you want your pictures to have lasting appeal, it's worth going to the trouble to create the right shot.

▲▲ WHY IT WORKS

All the details have been thought out—the hat, the dress, the chair, the regal pose—making this little girl literally "as pretty as a picture." She's proud to be photographed in a grown-up pose, but so relaxed as to complete this photo's delightful, old-fashioned look.

If you want to produce pictures that will endure, ask your subject to wear clothes that are unlikely to become dated, and avoid backgrounds or accessories that are too specific to a particular time period.

▶▶ WHY IT WORKS

This woman is dressed in classic yet attractive attire. Her spectacles bring interesting character to her face while the use of the rule of thirds (see page 53) to place the face at an intersection of thirds draws attention to her eyes and her wistful expression.

CHECKPOINTS

Unless you are shooting in a candid style, a little "neatening" is generally acceptable. Maybe a necktie isn't straight, a strand of hair is awry, or a blouse is untucked. It takes only a few seconds to notice and rectify such things, but they can make all the difference.

Check that your subject's clothes go with the setting. If the person is wearing a red shirt and the walls of the house are pink, you might want to switch the background. A patterned garment will not look good against heavily decorated drapes. And a white blouse will "disappear" into a white backdrop.

Consider your location also. Urban clothes tend to look odd in a rural setting, and country attire would look out of place in a big city.

FASHION STATEMENT

Fashions come and go, and it can be amusing to look back at the flared pants and tie-dyed T-shirts of a past decade. But when you want to produce a picture that will endure for its own sake, suggest that your subject wear clothes that are unlikely to date—casual clothes in a classic style, for example.

The clothes people choose to wear can tell us a great deal about their character. Provided they don't clash with the surroundings, bright colors and vivacious patterns can bring a photograph to life.

▼▼ WHY IT WORKS
Bold Hawaiian shirts are this man's sartorial trademark and a match for his extrovert personality. By capturing him here in a thoughtful moment, the photographer has brought interesting contrast to the photo.

Our many selves

There is not just one "us," of course. Most of us play many parts and have a range of clothes to match. You wouldn't exercise at the gym in your office clothes. A uniform tells you at a glance what a person's job is. Why not set up a project for yourself: to photograph the people in your life at work, rest, and play, in all their varied outfits?

ACCESSORIES

Jobs and hobbies all require different accessories, and these can be incorporated into your pictures to help "tell the story." A fishing rod for an angler or a piano for a musician are obvious choices. Don't overdo the accessories and surround the person with everything that seems relevant. Although there are exceptions, it's usually more effective to select one or two items that spell their message unambiguously: a camera, a wrench, or a laptop computer, for example.

PRIDE AND JOY

Some people identify closely with certain possessions. Automobiles are a prime example—and most devotees will happily pose alongside their pride and joy. Countless other objects that people care about can be used in a composition: a family heirloom, books, jewelry, a childhood toy, photographs, and also pets (see pages 118–123 and 126–131).

A musical instrument provides the perfect prop for a photograph. Start by finding an uncluttered area with a plain background for your shot.

▲▲ WHY IT WORKS
The strong diagonal composition created by the violin and bow, and the boy's solemn, hesitant expression give this picture its appeal. The use of flash would have thrown a shadow onto the background, so light from a window to the left was used instead.

Hobbies, interests, and professions provide natural accessories that can be incorporated into your photographs, and people are usually proud to pose with items that in some way represent their lifestyle.

◄◄ WHY IT WORKS
The photographer, photographed. The bright but hazy light conditions are ideal for this shot, bringing the colors to life and producing a strong, crisp image.

DOS AND DON'TS

- DO check that the clothes and accessories are suitable for the setting and style of shot.
- DON'T introduce props just because they look interesting.
- DO check that everything looks neat and tidy.
- DON'T be afraid to suggest a change of clothes if you think it's crucial.

Props are items that don't belong to the person but add something to the photograph. They need to be chosen carefully and with the subject's help. But if the person always liked the idea of trying a different look, here's a chance for both of you to have fun—and shoot some interesting photographs along the way.

How about a floppy hat, or an extravagant scarf? A big gold chain? Or a blouse that the person would never normally wear? Let your imagination run wild. And then start shooting.

Some people have a strong sense of their own style, which they carry off with flair. Others welcome the opportunity to dress up for the camera.

▶▶ **WHY IT WORKS**

Here the photographer set up a studio shot using a single light to produce a bold image of this subject in Western dress. A painted canvas backdrop was used for dramatic emphasis. The man's direct gaze, the position of his hands on the stick, and the shot's warm, rustic colors make for an extremely attractive portrait.

Automobiles play a large part in our lives and many people—especially men—identify with a particular brand, model, or style.

◀◀ **WHY IT WORKS**

The photo has been taken at a beautiful, coastal location rather than the standard home and garage. Instead of trying to fit the full body of the car in the shot, the photographer has included only part of it to prevent the owner from appearing small in the frame.

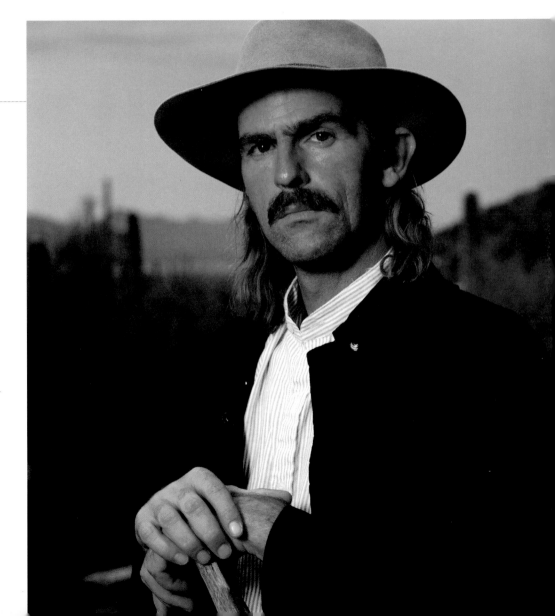

CAPTURING SUBJECTS AT THEIR BEST

Top tip
As a rule, you will get more flattering pictures of your subjects if you photograph them from a distance with a telephoto lens.

One of the most wonderful things about the world is the enormous diversity of the people in it. But while we delight in human variety, we can feel ill at ease about our own looks when someone points a camera at us. A skilled portrait photographer will know how to show his or her sitters at their best, especially if they are concerned about a particular aspect of their appearance.

You'll almost certainly be aware of any such sensitivities in family members and close friends and will handle them with tact. The following suggestions will help you produce flattering portraits of subjects with varying physical characteristics.

EARS

Most women—and some men—whose ears protrude hide them with long hair, so all you need do is check that the hair is in place. Do not take head-on shots of people whose protruding ears are visible; that is the angle that throws the ears into greatest prominence. Choose a three-quarters pose, so that one ear is hidden. Then check that the lighting puts the exposed ear in shadow.

NOSE

An unusually prominent nose can be enhanced by shooting from a slightly lower angle, or by asking the person to tip the head back a little. If you have a zoom lens, set it to its longest position and work from farther away. Do the opposite for a stubby nose: shoot from above, ask the person to lean forward, and go in closer, with your zoom lens at the bottom of its range. If subjects are self-conscious about their noses, profile shots are taboo.

A few changes to your subject's pose, or the position of his head, can make a world of difference to how the camera "sees" them. It is your responsibility as photographer to ensure that the shots are as flattering as possible.

◄◄ WHY IT WORKS
In the first (smaller) shot, the man is facing the camera head on, which draws attention to his ears. In the second more flattering shot, his head is turned away slightly, throwing one ear into shadow.

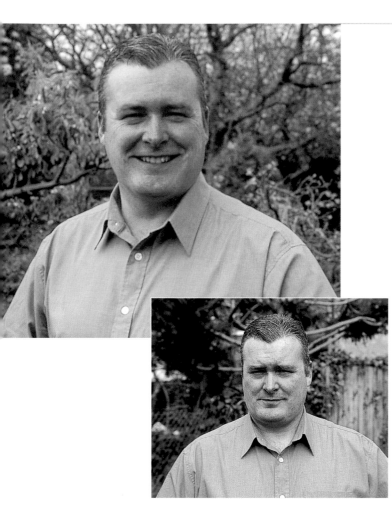

Shooting from a low viewpoint doesn't do any favors to subjects with a slightly fuller figure as it makes them look larger than they really are and draws attention to any hint of a double chin.

◀◀ **WHY IT WORKS**

In the first (smaller) shot, the photographer took the picture of the man from a slightly lower viewpoint, emphasizing his size. The second shot was taken from a slightly higher viewpoint, enabling the photographer to slim the man down as well as draw attention away from his chin.

TEETH

People who are unhappy about their teeth usually won't reveal them. You must accept smiles, not laughter, and manage with a more limited range of expressions. This should still provide the variety for some nice shots. Working digitally, you can brighten teeth in a few seconds, if necessary.

CHINS

A sagging chin is diminished by shooting from above head height. Ask the sitter to lean forward, which lengthens the neck and tightens loose skin. A receding chin can be enhanced by shooting from underneath.

HAIR

Play down a receding hairline or bald spot by positioning your camera below the person's eye height. That will make the hairline less visible. Minimize the amount of light shining on the person from above, so that the face is the lightest part of the picture and the forehead a little darker. Stand the person under a tree, for example, and crouch down to take the photo. If gray hair is perceived as a problem, find a spot where the light doesn't draw attention to it.

CHEEKS

If your subject has full cheeks, avoid going in too close. Shoot three-quarter compositions rather than tight head shots, and use the telephoto setting of a zoom lens. For sallow, concave cheeks, choose a setting that is not lit from the side. For dark-haired men, early-day sessions will reduce the risk of a five o'clock shadow.

Top tip

Tact and sensitivity are important qualities in any portrait photographer. When you ask people to adjust their pose, be sure to use the right words and manner. Don't say things like "Your nose is too big, so I'd like you to tip your head back." Simply judge or anticipate problem areas and ask your subject to move position accordingly, without necessarily telling them why you are taking the picture in a particular way. If you have prepared your equipment in advance and managed to put your subject at ease, this will make your task a great deal easier.

We all develop a few wrinkles with the passing years, but we don't necessarily like to be reminded of this when looking at photographs of ourselves. So try to portray older subjects in what is literally the best light, bearing in mind that the absence of the physical attributes of youth will be more than made up for by the subject's character and experience.

▼▼ WHY IT WORKS
In the first picture (left), contrasty light is falling across the woman's face, drawing stark attention to her wrinkles. In the second shot, her entire face has been placed in the shade, producing a much softer, more flattering result.

WRINKLES

Wrinkles can be an unwanted reminder of the passage of time. To minimize them, keep the illumination as soft as possible—shoot on a cloudy day, for example—and place people so that the light is coming from behind them, not from the side. If you are working digitally, the image can be softened using the image manipulation sofware on the computer.

EYES

Many people wear eyeglasses, and you must avoid reflections in them, because otherwise it can be difficult to see the person's eyes. Tipping the head down slightly is the answer—but not too far or it can look awkward. Leaning forward, with the arms resting on a table, is an excellent approach.

When outdoors, you should obviously avoid people with glasses looking directly into the sun. In fact, the best time to shoot is when there's no direct sunlight. Indoors, choose a room with only one window, and place your subject at 45 degrees to it. Don't use direct flash—it will be reflected straight back at you.

Make sure your glasses-wearer does not gaze on anything else that's highly reflective. That includes you—so wear dark tones rather than a white T-shirt or sneakers.

If the eyes are indeed the "windows of the soul," then spectacles can sometimes act like shutters that stop you from seeing the eyes—because of awkward reflections.

▶▶ WHY IT WORKS
In the first shot (near right), the picture of the woman has been marred by the reflections in her spectacles. The photographer produced the second improved shot (far right) when he asked the woman to tilt her head forward slightly, eliminating the reflections.

Size matters

When taking pictures of people who are tall, short, thin, or large, it is important to pay attention to camera angle and to whether the subject is sitting or standing as this can make all the difference between a flattering photo and a less attractive one.

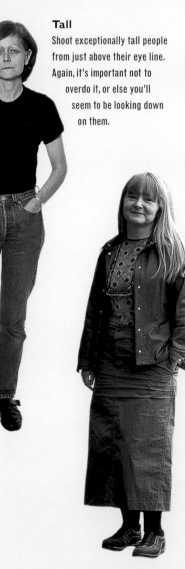

Tall
Shoot exceptionally tall people from just above their eye line. Again, it's important not to overdo it, or else you'll seem to be looking down on them.

Groups
When photographing groups, you will need to compromise between the physical characteristics of the different individuals.

Large
The more people are squared off to the camera, the wider they look. So larger individuals should be placed at an angle to the camera—and standing rather than sitting.

Short
If you want to make a person look taller, shoot from a slightly lower angle—but not so low that you start to exaggerate the perspective.

Thin
Thin people can be successfully positioned square to the camera, if required.

AVOIDING DISTRACTING ELEMENTS

Many photographers become so engrossed in their main subject that they don't notice what's around it—with unfortunate results. That's how you end up with the classic shot of power lines sprouting from your subject's head!

Always check around the edge of the frame for distracting elements before you press the shutter. Areas of bright color, even if they are out of focus, can catch the eye and create an unbalanced composition. Scraps of litter in an outdoor photo look messy, and unnecessary clutter disturbs the equilibrium of an image.

Such items can be cropped out of a digital photo, of course, but they are better avoided in the first place. Spending a few minutes cleaning up the clutter will pay dividends in making your finished photographs look smarter. Professional photographers often refer to this as "gardening," and they do it as a matter of course.

Beware of extraneous background elements, such as fellow tourists walking behind your subject or an unattractive street sign. Check the area behind your subject before you shoot, or you may find a lamppost on top of the person's head.

Sometimes you will achieve better results by relocating to a place with a backdrop more conducive to the shot you are trying to create.

▼▼ **WHY IT WORKS**

The three-quarters shot of this lady is a pleasant environmental portrait, but the background is rather messy and distracting. Her backyard, though, had lots of hedging and provided the ideal location for an attractive head-and-shoulders shot.

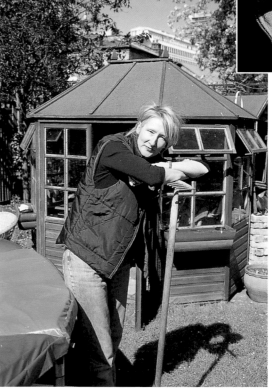

One of the easiest ways to improve your portraits is to look around the frame before you press the shutter, to see if there are any distracting elements—and if so, re-frame the shot.

◄◄ **WHY IT DOESN'T WORK**

This photo is a classic example of what can go wrong when you're so focused on the subject that you don't pay proper attention to the background. A very funny shot anyhow!

TAKING ACTION

Does the background complement the subject or detract from it? When framing a shot, spend a moment evaluating the best vantage point—and that includes noting the surrounding area. Moving a couple of paces to one side can often produce a significantly better backdrop. Alternatively, crouch down to show your subject against a clear sky, or shoot from a higher position to give a background of crisp lawn.

REARRANGING THINGS

In indoor photography especially, you can move items around to get the effect that you want. Take superfluous furniture out of the shot, or position an item to one side. Think about where the subject should be in relation to the light, and position the furniture accordingly.

WHAT THE CAMERA SEES

Remember that what the camera sees is not always the same as what the eye perceives, so get into the habit of checking the composition through the viewfinder as you adjust the elements in the scene. Before you commit anything to film, take a final look behind and around the subject to make sure everything is just as it should be. If something's even slightly amiss, take a moment to adjust it. This simple procedure alone will make an enormous difference to your success rate.

It can be a nightmare taking attractive pictures of families at mealtimes because people have to twist around to face the camera, and surrounding clutter can get in the way. This is what happened in the first shot (above, right).

▲▲ **WHY IT WORKS**
For the second shot (above, left) the photographer waited until after the meal to gather everyone in a group around the table, creating a much more appealing and coherent composition.

Focusing Attention on the Subject

Simple but effective techniques will enable you to make the subject stand out from the background almost three-dimensionally. A sound knowledge of the creative controls available to you is the first step toward making this happen.

Sometimes the foreground and background are essential elements of the shot, providing valuable information about where and when it was taken, so you want to render them as clearly as the main subject. Other times, when you want to focus on the person, you must think carefully about what else to include and how to set up the shot.

If your camera has a zoom lens or interchangeable lenses, the settings you choose are important. A wide-angled perspective will include more foreground and background, and unless you go in close, the subject will lack impact. A more powerful zoom setting or lens—at the telephoto end of the range—means the person is more likely to dominate the picture, especially if you crop in tight.

A wide-angle lens setting is ideal if you want to include as much as possible of a scene in your picture. But this can leave the subject relatively small in the frame. Often, therefore, unless what you're photographing is close to you, a long (telephoto) lens setting is preferable.

▼▼ WHY IT WORKS
In the smaller shot, the use of a wide-angle lens has successfully captured much of the park, but left the two women looking insignificant. The switch to a telephoto lens in the larger shot places them quite literally at the center of the picture.

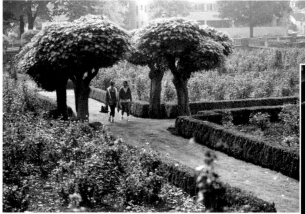

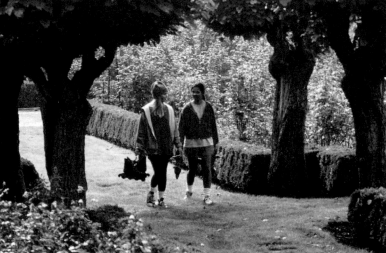

ENHANCING THE EFFECT

This effect is enhanced by the subject's distance from the background. Increasing that distance tends to blur the backdrop, so if that's the effect you want, ask your subject to walk forward a little way, while you stay where you are. The ultimate such effect occurs when all you see is a distant horizon behind your sitter. Bright clothes will cause your subject to stand out from drab surroundings. And a well-illuminated subject will project from a backdrop in shade. Use these techniques to your best advantage, and your subject will stand out three-dimensionally from the background.

The farther your subject is from the background, the more out of focus the background will be. So if you want someone to stand out, ask him to step forward until you have the effect you want.

▶▶ WHY IT WORKS

This fresh, spontaneous photo works well because the boy and his tackle stand out brightly from the background, which is very far behind him. His expression and wind-blown hair also enhance the picture.

Depth of field

The photograher used a small aperture to take this picture, which yielded extensive depth of field.

The switch to a wider aperture in this shot allowed the subject to stand out from the background.

If your camera gives you direct control over the aperture, you can determine how much of the finished picture will appear in sharp focus—technically known as depth of field. Photographs that have a large zone of sharpness are said to have extensive depth of field, while images only part of which are in focus are described as having limited depth of field.

The principal factor that determines depth of field—along with the lens setting and the distance to the background—is the aperture. This is the opening in the lens that lets the light through onto the film or, in the case of a digital camera, the CCD (see page 18).

Varying the aperture, along with the shutter speed, is what makes correct exposure possible—in addition to providing much of the creative potential in photography.

Small apertures—which have large numbers, such as f/16 and f/22—give extensive depth of field, especially when combined with wide-angle lens settings and placing the subject close to the background. But to make the subject stand out, choose a large aperture—determined by a small number, such as f/4 or f/5.6. Use a longer lens setting, and place the subject farther away from the background.

Background Story

You need not depend upon the background that's there—you can choose or create your own. An effective backdrop can make the difference between an ordinary photo and a compelling one, but be careful to ensure that the background is not so distracting that it swamps the portrait.

The background of a picture is important: if you use it well, it will complement the main subject, while a poor background can spoil your shot.

If you're shooting an environmental portrait, use a location that says something about the person—such as a golfer on the green. Or minimize a distracting background by your choice of lens setting and the distance of the subject from the backdrop (see page 91).

CHOOSING A BACKGROUND

You can also choose a background for your subject. At its simplest, this can be an existing area that works well with the composition. Plain, painted walls are effective, especially for character studies, where you want all of the attention to be focused upon the person. Pure white projects the person forward, and pastel shades can also be effective. But be cautious with bold colors, which can easily overwhelm or clash with your subject.

Subtle wallpaper can also be an excellent choice, especially if you bring the person away from the wall so that the backdrop is slightly out of focus. Heavily patterned designs need care, because they can be overpowering, but with the right subject they can inject a shot of color that lifts the picture out of the ordinary.

Drapes can be pulled to produce an improvised backdrop, but be sure they hang straight or they look messy. The more neutral effect of shades or Venetian blinds is attractive. Natural materials, such as wood and stone, can provide excellent backdrops. Or create the effect you want with the aid of waste ends of material or wallpaper.

Great care must be taken when photographing people against brightly colored or heavily patterned backgrounds, particularly when the subject himself is dressed in clothes that have a strong color, pattern, or design.

▲▲ WHY IT WORKS
In the first (smaller) shot, the background pattern battles for attention with the man's checked shirt, leaving the viewer's eye confused and bewildered. Relocating to a plain white background (larger shot) solves the problem.

DOS AND DON'TS
- DO keep your eyes peeled for suitable backdrops.
- DON'T just use what's there—be imaginative.
- DO try making your own backgrounds—it's easier than you think.
- DON'T use garish colors unless the composition demands it.

COLORED PAPERS

A sheet of paper or cardboard can act as a backdrop to a head-and-shoulders portrait. Tape the sheet to the wall, or ask someone to hold it for you. Arts and crafts stores carry large-sized sheets in a range of tones and colors—the larger the sheet, the more of the person you can include. Professionals use background rolls that are typically around 30 feet (10m) long and 4½ feet (1.5m) or 9 feet (3m) wide, which permit full-length studies and can be used indoors and out. A specialist camera store should carry these, along with stands that are made to support them.

Also available, but considerably more expensive, are "old master" backgrounds, painted with mottled colors. Make your own instead from an old sheet of wood and some leftover household paint.

You don't have to buy specialist backgrounds to improve your portraits. A large sheet of white cardboard from an art store is all you need—plus either a willing "assistant" to hold it behind your subject or some tape or putty to secure it to a wall.

▼▼ WHY IT WORKS

This cluttered office environment made for a messy shot, but by introducing a background sheet of white cardboard, a much neater portrait was created. The tight crop fills the frame, and the light comes from windows on the right.

If you want to take your portraits to the next level, it's worth investing in some special background rolls and a support system to hold them. While they are normally used in a studio environment by professionals, they can easily be used outside in daylight.

▲▲ WHY IT WORKS

The area at the back of this house was very messy, but by draping this blue cotton background over a support system, a professional-looking portrait of this young boy was achieved, using only hazy daylight illumination.

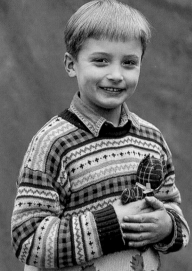

Top tip

One of the great advantages of working digitally is that you can modify elements of the picture with relative ease—and that's especially true of the background. Once you develop the skills of cutting out and cropping, you can delete a distracting background and replace it with another. Simplify the task by shooting against a colored background—usually blue—which is easier to select and remove. (See *Digital Dialogues*, page 166, for more details.)

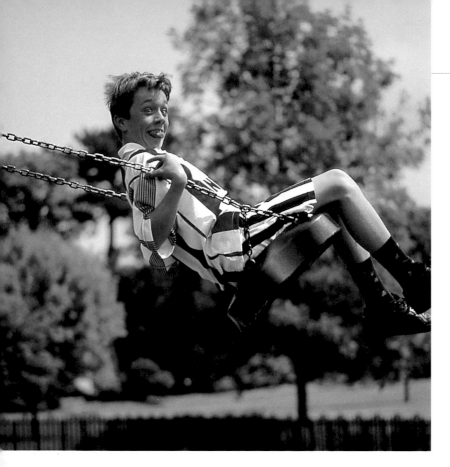

You don't have to go to exotic locations for active portrait shots. Take your children along to your local park, and you'll discover plenty of opportunities right there.

◄◄ WHY IT WORKS

The young boy appears suspended in midair, the expression of delight on his face adding to the photograph's high spirits. The photographer used a compact camera, with no direct control over the shutter speed. But by using a fast film and shooting on a bright day, he was able to freeze this exhilarating movement in time.

Opportunities for active portraits can turn up at the most unexpected moments, so keep your camera ready to capture things as and when they happen.

▼▼ WHY IT WORKS

This vibrant photo of a young woman showering at a beach is a good example of versatile portrait-making. The "candids with permission" style allowed the photographer to use a telephoto lens setting from a distance to separate her from the background.

ACTIVE PORTRAITS

Photographing people as they go about their activities can produce much more realistic pictures—and introduce a sense of movement. So don't just settle for static poses. Get out and shoot while something is happening.

WORK AND PLAY

This doesn't necessarily mean just taking pictures of your loved ones when they're playing basketball or roller-skating. It is about making even everyday activities look exciting by capturing them in a more energetic manner.

This is easier if your camera offers direct control over the shutter speed, but it's not impossible with models that have fully automated exposure systems—provided they have shutter speeds that vary according to the lighting conditions.

Even mundane activities can take on a new complexion when you use this technique. Children playing on a swing, Uncle Bob juggling apples from the fruit

bowl, or Dad kicking a ball around—all make perfect action subjects. Family members who enjoy sports will be happy for you to go along and take some pictures. Although it may be possible to shoot during a match, you'll find it easier at a practice session—when you can get closer to the action—and even ask your subject to repeat a particular movement a few times until you line it up as you want it. Whatever action you decide to capture, you'll find it invigorates your photography.

FREEZING MOVEMENT

A much-loved shot shows the subject frozen in mid-action—jumping for joy at exam results, for example. This effect can be captured with all but the cheapest cameras, which tend to have a fixed shutter speed of around 1/125 second—too slow for high-speed action. Here's how to do it.

Compact camera: Although you can't set a fast shutter speed directly, you can make sure that the camera does it for you. Use a high-speed film (ISO 400 or even 800), or set the

Sport-loving family members can easily be photographed as they enjoy their favorite pursuit —and since their attention will be focused elsewhere, you'll be free to frame and compose your shot as you like.

▶▶ WHY IT WORKS

This picture of a man on a quad bike works because the frame is filled with action. Although there is nothing obvious to indicate movement, the concentration on the subject's face leaves no doubt that there is a great deal going on.

Panning: The ultimate movement technique

Wouldn't it be great to blur the surroundings and freeze the movement at the same time? Sounds impossible? Not if you use a technique known as panning. Set a relatively slow shutter speed, or put yourself in a situation where the camera will do that for you (see "Freezing Movement" above,) and then follow the movement with the lens—swinging your body in a smooth arc, rotating at the hip, and releasing the shutter as you do so. The technique works best with subjects that are passing in front of you, such as runners or cyclists, but once you develop the technique, you can extend it to other areas. Your aim is a streaked background with the subject mainly in focus. The key variables are matching the speed of the subject and not moving too jerkily. A typical speed is between 1/2 second and 1/30 second. Practice, practice, and more practice are required to get this right, so you may need to persuade a family member to repeat an action, such as running past you, to help you master it.

Moving the camera horizontally while the shutter is open freezes the cyclist but streaks the background.

With some types of sports, especially
water sports, you can't get in close,
so making use of an SLR (Single
Lens Reflex) camera with a powerful
telephoto lens is essential if you are
to fill the frame with, and freeze or
blur, the subject.

◄◄ WHY IT WORKS
By using an SLR, the photographer had
control over the shutter speed and set
a brief exposure of 1/2000 second to
freeze the movement of both jet skier
and water, even though the skier was
traveling at a high speed.

"High" sensitivity on a digital camera, and shoot in
bright conditions. Typically you will get a shutter speed
of 1/500 second, which is fast enough for many action
subjects—though not for the highest-speed sports, such
as skiing.

SLR (Single Lens Reflex) camera: Almost all reflex
cameras offer shutter speeds of up to 1/1000 second;
most current models go up to 1/2000 or 1/4000 second;
and one top-of-the-line camera goes up to 1/12,000
second. Provided there's enough light, and you have a
reasonably fast film loaded, you can select whatever
speed you want—though you will rarely need to go above
1/2000 second. Using an SLR also means that you can fit
a telephoto zoom, which will take you into the heart of
the action—perfect for situations where you can't get
physically close.

BLURRING MOVEMENT

A photograph of a moving subject needs to show who
the subject is and what he's doing, but with some or all
of the scene blurred to enhance the feeling of movement.
Getting the balance right can be tricky—if you blur it
too much, the picture will be an impressionistic mess—
so you may need to take lots of pictures for a handful of
successes. With some subjects, it's better to use a tripod
so that the subject is moving but the surroundings are
stable; with others, it is more effective to hold the camera
to add to the general blurring.

Compact camera: This technique is more difficult to
achieve with a camera that doesn't allow you to control
the shutter speed—but not impossible. Take the pictures

Many people are into jogging and running these days, and chances are that you know some. Whether they're training or competing in a race, joggers make great subjects for active portraits.

▲▲ WHY IT WORKS
The photographer waited until the jogger was running slowly and the background was relatively undistracting. A telephoto lens setting was used to fill the frame.

when light levels are low, using a relatively slow film (such as ISO 100), or the "Low" sensitivity setting on a digital camera. This forces the metering system to set a longer shutter speed to ensure enough light for a correct exposure. In the right circumstances, it will set a shutter speed of 1/4 second to 1/30 second—perfect for blurring movement.

SLR (Single Lens Reflex) camera: Simply choose the shutter speed you want and click away. Try out a range of speeds to find out which gives the results you like, make a note of them, and you will soon be able to predict the outcome of your pictures more accurately.

COMPUTER ENHANCEMENT

If you're working digitally, it's easy to add creative blur (although it's not yet possible to freeze subjects using software!). Most programs offer a range of automated options that allow you to blur movement in predetermined ways or manual alternatives that let you apply a freer style.

Using flash with a long shutter speed

Another way to capture movement is to combine a long exposure with flash, a technique usually known as synchro-flash. Because flash has a limited range—rarely more than 12 feet (4m)—it only affects what's in the foreground of the picture. And because the illumination from a flash is so brief, it freezes virtually anything. Set a long shutter speed and use it with flash, moving the camera as you take the picture, and the background (provided it's less than 12 feet [4m] away) will be blurred and the foreground subject sharp. The trick lies in getting the exposure of the flash and the existing lighting balanced accurately, which is largely a matter of calculation and experimentation.

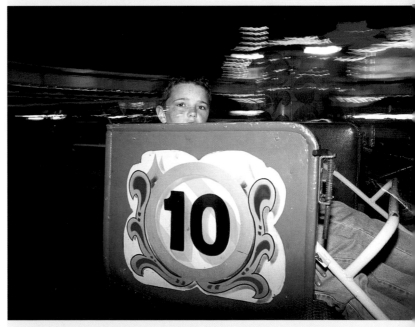

When you use a camera that gives you direct control over shutter speed and aperture (see page 12), you can set a long shutter speed with flash to create an impressionist-style "streaked" effect. Here the photographer set a shutter speed of 1/4 second and moved the camera as he took the picture—thereby blurring the background. The subject, however, who is illuminated by the burst of flash, is frozen and sharp against the background.

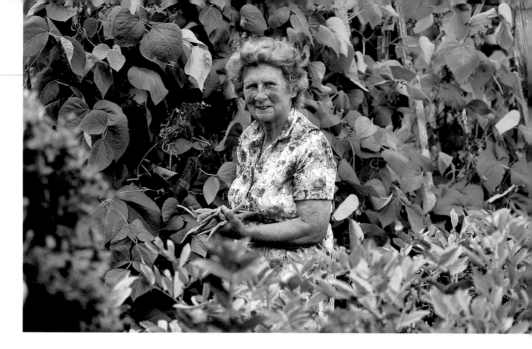

Many older folks are as active as younger people—even more so. If you photograph them doing something they enjoy, you'll produce a much more engaging shot than if you simply make them pose for the camera.

▶▶ **WHY IT WORKS**

There's nothing false or stylized about this picture. An elderly lady is captured collecting vegetables in her garden. Shooting over the bush so that it is out of focus creates a sense of depth, while the soft lighting is sympathetic to the subject's skin.

PHOTOGRAPHING MATURE SUBJECTS

Images of older people all too often stress their age above all else. When you photograph senior family members, you can produce pictures of the individuals they really are.

BENEFITS OF AGING

While growing older offers the benefits of knowledge and experience, aging brings the gradual loss of some of the physical attributes that are widely considered attractive. Skin sags, eyes lose some of their luster, and hair may be less abundant than it once was. But senior members of the family—who may include yourself—don't want to see themselves as "over the hill." So how can you create positive images of people in the fall or winter of their lives?

PRACTICAL STEPS

As we saw in earlier sections, soft lighting minimizes the visibility of wrinkles; careful posing disguises flaws; and relaxation before the camera is important. But the "frame" you put around your subject is also crucial. Pictures that show seniors sitting in a chair with a blanket over their knees, or staring into space, conform to a classic stereotype.

Close-ups with a tight crop can have an acute psychological impact because they convey a strong sense of the subject's mood and character.

▲▲ **WHY IT WORKS**

The photographer has captured the finest details of the subject's skin and hands. The photo's sepia coloring gently draws attention to the lines, tones, and textures of skin, while the man's long, sensitive fingers convey his introspection as no expression ever could. The result is an intimate shot that poses many questions for the viewer.

Whatever your subjects' ages, getting them to do something will allow them to be themselves. And there's no need to get hung up on technicalities. Just wait for the right moment and go for it.

CHOOSE LIFE

Instead, seek situations that show the elders of your family living life to the fullest. Since many are doing just that, it's simply a matter of being in the right place at the right time, and recording it as it happens—preferably in a candid or semi-candid style. Lots of retired people walk the dog, play tennis, or enjoy gardening. These are opportunities for dynamic and fascinating photos that say more about the person than his or her age.

LIGHTING MATTERS

Lighting is also important. Light that helps to enliven a subject, and that flatters older people, is "backlighting," where you shoot toward the sun. This is especially true later in the day, when the light is enhanced by a wonderful warmth. The face is softly lit to minimize lines, with a halo of light around it. Use a reflector board to bounce a little of the light back to create a catchlight in the eye—and your job is done.

Older faces are flattered by soft lighting, so try to place mature subjects in the shade, and avoid direct sunlight or window light from the side that could accentuate lines and wrinkles. Soft frontal lighting is often the most flattering to lined skin.

◀◀ **WHY IT WORKS**
The diffused lighting in the doorway shows this man at his best, while his folded arms and pose make him look relaxed rather than defensive. The wooden door provides a suitably neutral but solid and reassuring background.

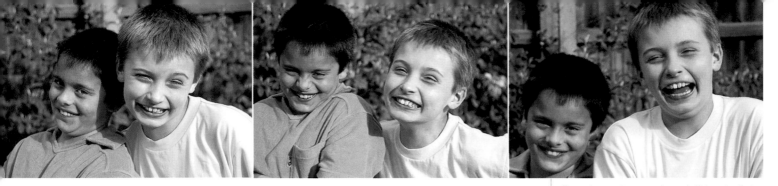

SEQUENCES

One picture can capture a moment, but a sequence can tell a story—with a beginning, a middle, and an end—producing a series that is often a lot more interesting and informative than a single shot. And all you have to do is keep your finger on the shutter release.

EVER READY

Shooting a sequence is relatively easy, since all but the most basic film-based cameras have a built-in motor. No sooner do you take one picture than the film advances, ready for the next shot. The speed of integral winders varies, but it is generally at least one frame per second, which is perfectly adequate for normal shooting. Advanced SLR (Single Lens Reflex) cameras, designed with sports photography in mind, can take pictures at up to 12 frames per second—which means you can complete a 36-exposure roll of film in just three seconds! In most portrait situations, that's a waste of film, since expressions rarely change quickly enough to justify so many pictures—and the sequence might show no difference at all.

STORAGE TIME

With a digital camera, there's no film to advance, since images are recorded on removable memory cards. However, the speed at which the images are stored can vary considerably, and it can be several seconds before you are able to take another shot. In the latest models, however, capture is close to instantaneous.

FLASH LIMITATIONS

Shooting a sequence is straightforward in suitable light, but it's a different story when you're using flash. Depending upon

the state of the batteries and the efficiency of the system, the flash can take up to eight seconds to recharge—most cameras take four to six seconds. So you can't simply keep your finger pressed on the shutter release as you might with a daylight series. Either some pictures will be taken without flash, and be underexposed, or the camera will lock until the flash is ready to fire again.

CHOOSING THE MOMENT

A digital camera enables you to shoot as many pictures as you want and then make your selection later. With a film-based camera, you need to be more discriminating. Think about the story you want to tell—and choose your moments accordingly. To record a series of expressions—as your subjects play in the backyard, for example—you'll need to take your pictures in fairly quick succession. But if you want to show the building of a snowman, a beginner's skating lesson, or preparations for a party, there could be several minutes—or even hours—between images.

A sequence of shots can record many different narratives including a conversation or argument between two or more people, the progress of a journey, the changes in a person's expression, or the unfolding of an event.

▶▶ **WHY IT WORKS**

These three photos have clearly captured a linear sequence of events. By maintaining the same viewpoint throughout, the photographer focused attention on the differences between the photos—namely the girl's act of throwing the leaves in the air. Although the grandfather is in the same position in all three shots, he is a crucial link between the photos as well as an important part of the narrative.

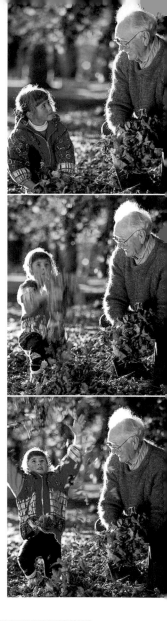

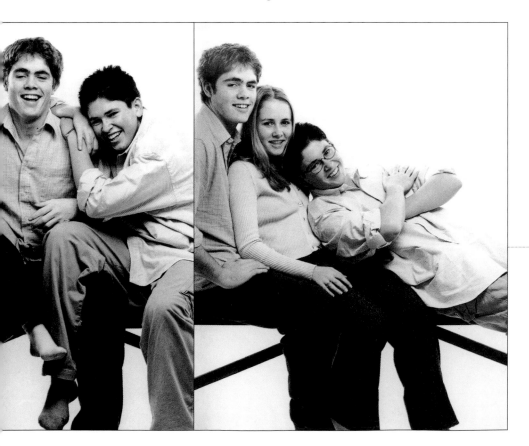

Older children are often more open to trying different poses. This means that you will at the very least get one shot that works well and may even end up with a nice sequence.

◀◀ **WHY IT WORKS**

The three different compositions create pace and interest, while a sequence of shots conveys the siblings' camaraderie and infectious sense of fun.

ALTERNATIVE PORTRAITS

Don't keep shooting the same old thing—try some more creative interpretations, such as getting people to dress up, wear a mask, or use mirrors. Just use your imagination, and remember, the sky's the limit!

What do you do when you have photographed everyone you know several times over and seem to be in a rut photographically? Instead of trying for a flattering likeness of your subject, get your inspiration flowing with some wackier experimentation.

UP FOR IT

There are 100 more interesting ways of being photographed than sitting still, staring into the lens of a camera. A lot of people, especially children, love to have fun—so why not give them the chance? Perhaps they'd like to dress up, wear a mask, or act out a fantasy. Ask people how they would really like to be photographed, and see if you can make it happen—or use your imagination to prompt theirs.

The following pages contain some suggestions for portraits with a difference. Use them as a springboard for ideas of your own.

DRESSING UP

The enduring popularity of fancy dress parties testifies to people's love of dressing up and expressing different parts of their personalities. Maybe your subject would like to be a historical figure, an athlete, a comic book hero, a pop star, or a character from *The Lord of the Rings*. Why not encourage that, and capture the results with your camera? Use the opportunity to try some new approaches yourself—throw caution to the wind and experiment with composition, lighting, and perspective.

People of all ages love to dress up, whether for a fancy dress party or just for fun. So don't be too literal with your picture taking. Encourage people to shed their inhibitions and act out a fantasy role for the camera.

▼▼ WHY IT WORKS
This "princess" had a wonderful time dressing up and acting out her role in a fairy tale. The dress, the crown, and the wand all create the perfect image, and the simplicity of the lighting and the backdrop make her very much the center of attention.

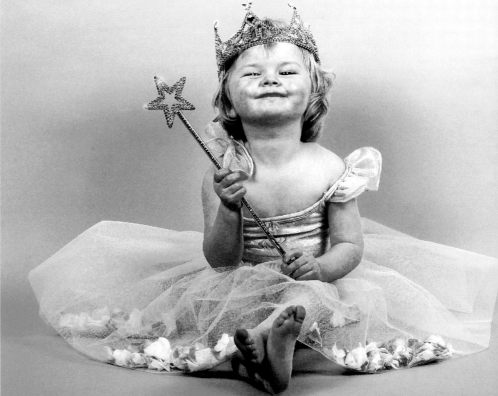

MASKS

Some people love to wear masks, which can be bought in fancy dress stores or made at home. Donning a mask can change not only people's countenance but also their entire demeanor, as they imagine dancing at the Rio carnival, flirting at the court of King Louis XIV, or marching down Bourbon Street during Mardi Gras.

REFLECTIONS

For a subtler but intriguing effect, encourage people to play with their reflections. Use a handheld or a wall-mounted mirror, and include the person and the reflection, or just one of them—or a part of each.

SHOOTING SILHOUETTES

The secret of shooting successful silhouettes is to find or create a scene in which the background is much brighter than the main subject. Most *contre-jour* situations are suitable, especially if the person is indoors standing in front of a window on a bright day. Water and white walls can also make good backdrops, especially if they are lit by the sun and the foreground subject is in the shade.

In the studio, silhouettes are easily set up by illuminating a white background, preferably with two lights—one on each side—and leaving the person unlit. Then all you need to do is take the picture. Because the background is bright, the person is recorded without detail—as a silhouette.

Putting on a mask or having your face painted is one way of completely changing your appearance—and it can be extremely photogenic. Masks can also remove subjects' inhibitions and encourage them to adopt more dramatic poses.

▲▲ WHY IT WORKS
The photographer made use of the camera flash to ensure that this subject's face was fully lit, and to darken the background. A long lens setting was also used to crop in tightly to her features.

▶▶ JARGON BUSTER

Contre jour This is French for "against the light." It describes the lighting conditions that exist when a photograph is taken with the camera pointing directly at the light source, making the main subject back-lit.

This shot was taken inside an office building with the subject in front of a window. The much higher light levels outside produced a semi-silhouette.

◀◀ WHY IT WORKS
Silhouettes have a hypnotic simplicity as the subject communicates itself by means of shape with the faintest trace of detail.

Parts of the Body

While a portrait most often depicts someone's face, you can produce the likeness of a person without showing the face at all—or by including just a little of it. This can be a more descriptive and intriguing way of depicting someone. Just begin by thinking what's special about them physically.

Parts of the body can be just as revealing as the whole—sometimes more so—and the challenge of cropping in tight and concentrating on a detail can be stimulating.

Examine your family members closely. If you excluded the face, which part of them would be most interesting to photograph, and why? How could you reveal something about them to a stranger through the medium of photography?

FEET FIRST

Most people give little thought to their feet, but since they carry you around for a lifetime, feet develop characteristics of their own. Each person's feet are unique. This is especially apparent when they are used in different ways: compare a ballet dancer's feet with those of an office worker, for example.

FACIAL ATTRACTION

A face photographed in part is tantalizing, causing the viewer to try to fill in the missing features. In most people, the lips and eyes are especially appealing, but every part of the face is worth considering: from chins to ears—or why not the back of the head?

A person's feet may not be the most obvious things to photograph, but in the right context the results can be remarkably effective—and memorable.

◀◀ **WHY IT WORKS**
This intimate shot works because of the tiniest details. The neat nail polish, the kittenish sandals, the subject's elegantly crossed legs and shoe-on/shoe-off pose all suggest a relaxed, glamorous personality at ease with herself and her surroundings.

If you have a young baby, bringing hands together—tiny fingers held gently in Mom or Dad's grasp—will create a picture you'll treasure forever. It's simple to do, but very rewarding.

◄◄ WHY IT WORKS
Everything is kept soft and loose. The plain background means nothing competes with the hands, and the soft lighting maximizes detail.

SHOWING YOUR HAND

Hands are rich in potential, especially when they wrinkle with age, or exhibit the effects of manual work. Clearly some people will not want bits of themselves presented for close scrutiny, so you must broach the subject tactfully. Careful lighting from the side is essential to reveal the texture.

Supple young hands are also interesting—and imagine the compositions and contrasts you could create if you brought the old and the new together.

ABSTRACT COMPOSITIONS

Take your pictures into a new dimension with a virtually abstract interpretation. Photograph the body as if it were a statue—concentrating on the line, shape, and form instead of the subject matter.

TATTOOS AND PIERCINGS

People are increasingly choosing to adorn their bodies with tattoos and piercings, and these can be the focus of fascinating studies.

Top tip
Many modern cameras offer a close-up or "macro" option, which allows you to crop in close and fill the frame with details. Check the manual for guidance on using this feature. Most digital cameras have excellent close focusing—and what you see on the electronic monitor is exactly what you'll get in the finished picture.

Bearing in mind that ultra-tight crops bring dramatic abstraction to portrait shots, you might want to experiment and go in even closer to concentrate on just a part of the body or face, for an alternative treatment. This is possible with most cameras, especially if you have one with a zoom lens.

▲▲ WHY IT WORKS
The eyes are the "portals of the soul." Here, cropping almost everything else away and focusing on just one eye—but with the fingers framing it—results in a very different kind of portrait. The subject was asked to look toward a window, creating a strong catchlight in the eye.

Many people have something that's particularly interesting about them— maybe it's the way they do their hair, the muscles in their arms, or the color of their eyes. Isolating that can result in a fascinating and personal study.

◄◄ WHY IT WORKS
Here, the photographer's eye was drawn to the way in which the subject's hair was braided—and decided to crop in close to take the kind of shot that literally turns its back on tradition.

Some digital cameras have screens that swivel around, allowing you to see yourself when taking a self-portrait and to frame your shot exactly as you want to.

▼▼ WHY IT WORKS

Having planned the composition and pose using the screen of his digital camera, this photographer-cum-subject released the shutter using the self-timer. The result is a slightly moody character shot.

SELF-PORTRAITS

When you tire of photographing your family and friends, there's a new challenge to consider: photographing yourself. Don't be self-conscious, and try to photograph yourself in whatever mood comes to mind.

The self-portrait is a long-established tradition in art, as the paintings of Rembrandt and van Gogh can testify. The main problem with photographic self-portraits is the impossibility (with most cameras) of looking through the viewfinder while also being the subject—so framing the picture can be a chancy affair. But this can add to the fun, and you'll soon find ways of making such pictures work.

How inventive can you get? Once you've tried all the obvious poses, you can start to be more innovative—creating images instead of simply capturing them. It's a whole new ball game!

▲▲ WHY IT WORKS

This is a clever shot. The photographer took the picture by placing the camera in a golf hole and clicking the shutter by means of the self-timer. You could almost certainly do something similar, depending on what your interests are.

Mirrors and windows offer fabulous opportunities for taking quirky and interesting self-portraits. It is obviously easier to predict what will be in the portrait if you intend to include your camera in the shot than if you do not.

◄◄ WHY IT WORKS
By standing in front of a window and taking a picture of his reflection from it, this man has also captured the details of a café interior, creating a chaotic but haunting and unusual self-portrait.

FOCUS MATTERS

If your camera needs focusing manually, you must measure—or estimate with reasonable accuracy—your distance from it. This is not a problem with an autofocus camera, provided you position yourself toward the center of the frame. Don't become embroiled in technicalities, though—risk-taking is the essence of creative self-portraits.

The easiest way to support and position the camera is with a tripod. Think about what backdrop you want, and where the light is coming from, and locate the camera accordingly. In the absence of a tripod, use a convenient surface, such as a table or the roof of a car.

Most modern cameras have a self-timer to click the shutter. This typically gives you twelve seconds to compose yourself. If necessary, you can set up a mirror behind the camera to check your pose and expression. Digital cameras that are equipped with a swiveling monitor provide instant feedback on what the camera is seeing.

SERIOUS, SILLY, SMART...

So much for the technicalities. But the key aspect of self-portraits is deciding how you want to depict yourself. Sensible, funny, sad—it's up to you. Dress up, try different poses, experiment with expressions. This is an opportunity to let your imagination run free and see what results.

The immediate feedback of the digital camera is obviously useful here, because you can amend or delete the shots that don't succeed. But even with a film-based camera, the most you risk is a few frames of film—and the results can be worth the wait. Since you're the photographer as well as the subject, there's no reason to be nervous, and you may achieve the most relaxed pictures you ever saw of yourself.

Top tip
Whatever your age, why not set up a project for yourself to take a self-portrait on your birthday each year? These will build into a fascinating record of the ways in which you change over time.

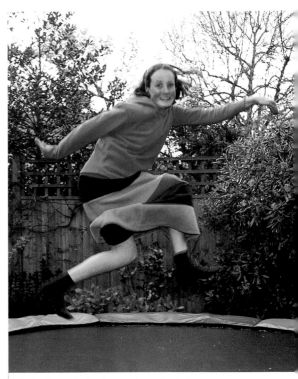

While she was having fun on a trampoline in her backyard, this young woman decided to capture her feeling of exuberance on camera. She placed the camera on a wall and gave herself just twelve seconds to get to the trampoline and jump in the air.

▲▲ WHY IT WORKS
Full of life, this wonderful photo shows the value of photographing oneself when no one else is around.

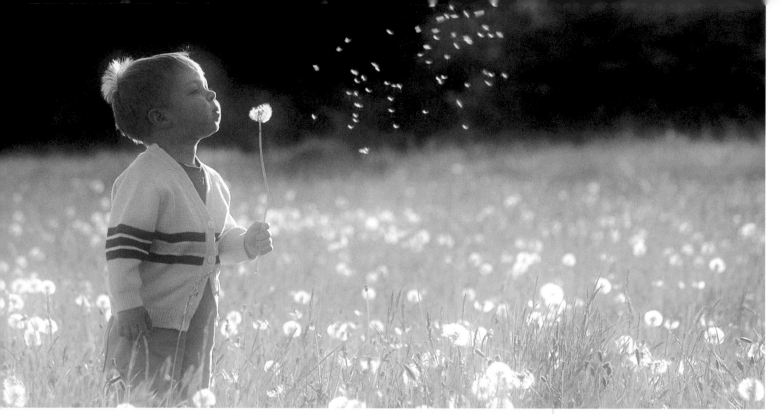

CONTROLLING THE MOOD

Sometimes you get everything right technically, yet the portrait looks dull. What could be lacking is mood—the magic ingredient that can transform a mediocre picture into a masterpiece.

Mood is an elusive thing. It's easy to recognize when you see it, but harder to generate. Expressing mood in your portraits is not just a matter of what you shoot, but of how you set it up and shoot it. Mood gives a picture an extra dimension—one that arouses an emotional response in the viewer. And skilled photographers can use a variety of techniques to introduce mood into almost any shot they take.

LIGHTING FOR MOOD

First and possibly most important is light. If you want to elicit a positive response, bathe your subject in the warming light of the evening sun. For a more detached, melancholic mood, use the cool blue of twilight. Indoors, adding a candle or a lamp can induce a romantic mood.

Contre-jour (back-lighting) and side-lighting, which produce shimmering halos and beautiful shadows, are more effective at generating mood than shooting with the

The long, lazy days of summer are perfect for creating photos that are simply drenched in mood—especially early in the morning and just before sundown.

▲▲ WHY IT WORKS

This impressionist-painting–style shot arises as much from the light as from the subject, with the *contre-jour* illumination bathing the subject to create an evocative dream-like mood. The photographer timed the shot perfectly, clicking the shutter at the moment when the little boy blew the dandelion seeds.

Location and time of year have a profound effect on a picture's atmosphere, and the colors of fall can always be relied upon to play their part.

▼▼ **WHY IT WORKS**
The shot is strongly composed, the commanding heights of the trees running parallel to the vertical bodies of the men, and the wooden fence and road leading the eye into the distant blue horizon. The late afternoon light warms the blazing colors of the trees, leaving the viewer with an unmistakable sense of nature's splendor and power.

sun behind you. Light filtered through leaves or a Venetian blind throws dappled shadows across your subjects and makes them appear more mysterious.

PERFECT SETTING

Location has a profound effect upon mood. Imagine photographing your favorite person in a busy living room surrounded by clutter or outdoors on a lovely spring day, with the sun filtering through the trees. The moods could not be more different.

So think carefully about the mood of your settings, and keep an eye out for locations with special atmosphere that you can utilize in the future.

FINAL FRONTIER

Adding props is another way of conjuring a mood. A piece of fine porcelain could hint at elegance, or an old-style highboy suggest a bygone age. In many ways, mood is the final frontier in portrait photography. Once you've developed lighting, posing, and compositional skills, make mood the focus of your attention.

DIGITAL MOOD

Although computer manipulation is no substitute for taking the picture well in the first place, it provides a wonderful opportunity to enhance the mood of a picture—or to add mood where it is lacking. In a couple of minutes you could make the shot more orange or blue, add diffusion for a romantic look, or introduce a grainy effect—or all three! Try turning the picture black and white, or experiment with sepia for a look of the past. It's all there at the click of a mouse, as shown in the *Digital Dialogues* section, pages 154–169).

BABIES AND CHILDREN

A baby in the family is one of the most common reasons why people decide to invest in a camera or start to take lots of pictures again. However young your children or grandchildren are, you'll want to photograph them growing up. The secret of success is using different approaches at different stages in their development. A handful of expert tips and techniques can lead to big improvements in your photography.

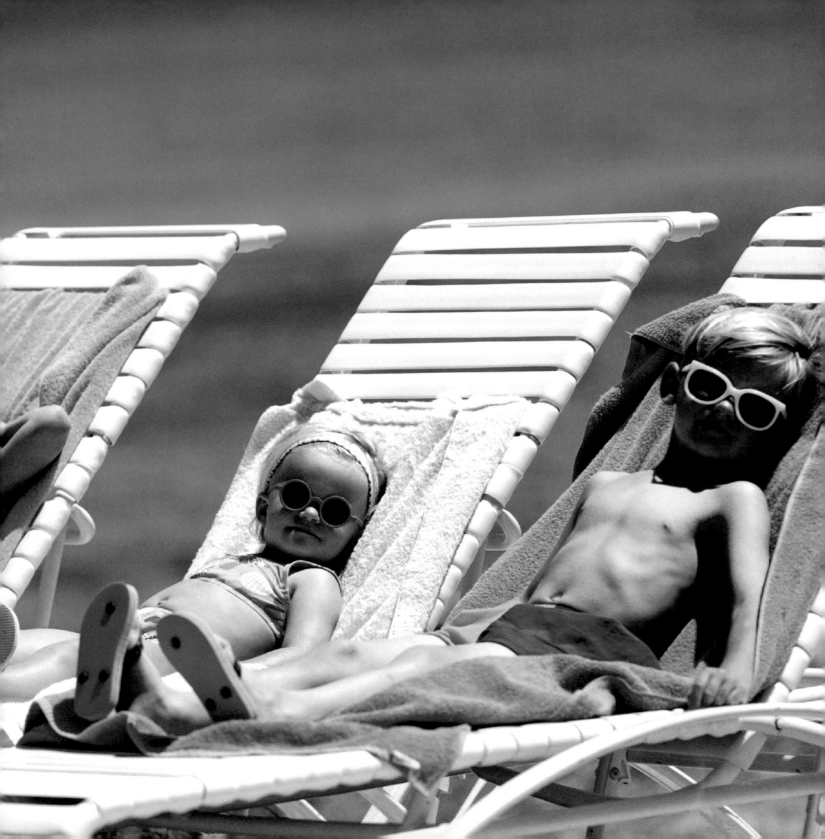

KIDS' ESSENTIALS

More photographs are taken of children than of any other family member. Children can often be challenging subjects, but they offer deeply rewarding photo opportunities—provided you take the right approach.

Having a baby or grandchild is often the reason for buying a camera in the first place. You want to record every stage of a child's life, from cradle to college—and beyond.

The secret to taking pictures of children is to become a child yourself. Stop being serious for a couple of hours and let your playful side take over. Make sure the children have fun: do crazy things, tell some jokes, and enjoy yourself. At the end of the day, you'll have succeeded in getting some great pictures of happy, smiling children.

The wrong approach is to be bossy and impatient. Once you begin telling children what to do—or worse, get mad at them—your chances of achieving successful photographs are close to zero.

ON THE LEVEL

Children lack most of the inhibitions displayed by adults, and their spontaneous behavior will give you the chance to capture some relaxed compositions. The key to success is to be on their level, physically and mentally. Shooting from

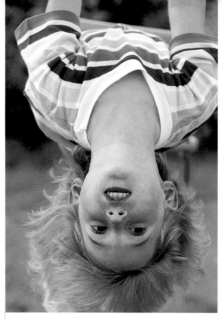

The more you allow children to be themselves, the more you will be rewarded with spontaneous images.

▲▲ **WHY IT WORKS**
Watching his daughter playing on a climbing frame, the photographer saw the potential for something different as she was hanging upside down, and he grabbed his camera. Her billowing hair and unusual expression created this appealing candid shot.

Kids are so photogenic, you may be tempted to spend all of your income on film! But if you choose your moment carefully, or use a digital camera, then you can get some great shots at minimal cost.

▶▶ **WHY IT WORKS**
Almost everything about this picture is perfect: the vivid colors, the children's identical and wonderfully comical poses, the plastic thongs, and the sunglasses. Sometimes strong, hard midday light works very well, as it has here, giving everything a crisp, sharp edge.

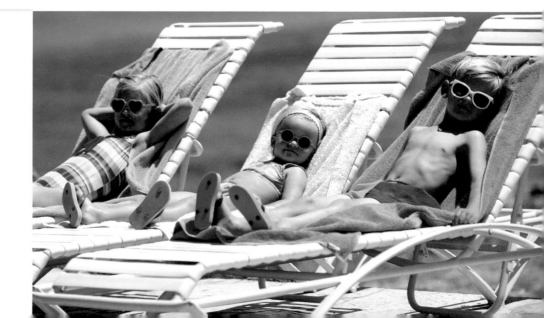

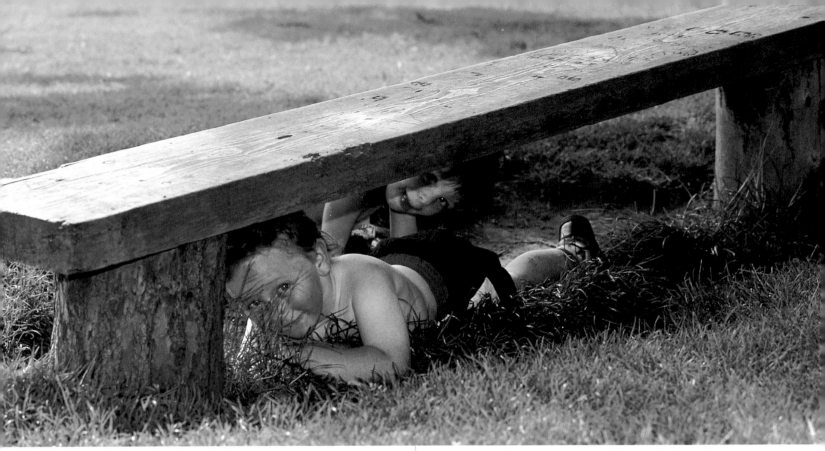

above produces an unnatural perspective, with the children's heads much larger than their bodies, and talking down to children creates a stilted atmosphere. So crouch down to a child's level, and treat your subjects as equals.

CANDID OR POSED?

As with adults, there are two basic methods of photographing children: candid and posed. With younger children, who are often rushing around, the candid approach is the best—and sometimes the only—option. As children grow up, they are generally more able and more willing to pose, which gives you greater control.

Of course, it's only worth photographing children when they're in an amenable mood—a forced expression is a failed photo. Even then, you must act fast before they become bored.

Whenever possible, spend a couple of minutes cleaning up the children before you take pictures. Although you may not notice them while shooting, dribbles, runny noses, and scraggly hair will stand out in the finished print.

Because children are by nature curious and restless, it makes sense to try to beat them at their own game by capturing them when they are busy at play.

▲▲ WHY IT WORKS

Children delight in playing hide-and-seek, so try to stay aware of their activities. Here, the photographer has managed to crouch down and capture his children's thrill at being "found." Because the subjects were in the shade, the camera automatically fired a burst of balancing "fill-in" flash to ensure that they were fully illuminated.

Top tip

You can't take too many pictures of your own children. They only grow up once, and it's wonderful when you get older to have all those memories to look back on.

One of the easiest times to photograph babies is when they're asleep. And that's when they're often at their most beautiful and photogenic.

▲▲ **WHY IT WORKS**
This sprawling pose that babies adopt when they fall asleep is beautiful—and perfect for photography. The soft natural light from a window to the left provided suitably gentle lighting.

BABY FACE

Babies aren't babies for long—and those early memories are precious. You'll need to use your camera nearly every day to keep up with their lives.

BIRTHDAY PHOTOS

That all-important first picture of mother and baby is one you'll treasure forever. And don't miss a shot of both parents with the new arrival, if that can be organized.

Hospitals often have fluorescent lights, so a conventional camera will need a flash. A digital camera may have a setting that adjusts the color balance automatically. Don't worry about damaging the baby's eyes—you won't, although you may notice them jump at the sudden brightness.

Babies change even during their first hours of life. This is no time to skimp on the film—take lots of shots from every possible angle, and you'll be certain of capturing some wonderful memories.

KEEP IT HANDY

Once at home, make photography part of your daily routine. Keep the camera handy, and photograph everyday events, such as crying and feeding, as well as the historic first smile and first step. As babies become more alert, you can record their curiosity and wonder at everything around them.

Babies start to learn from the moment they're born, and a great deal of what they pick up comes from their parents—so it's great to capture shots of them interacting right from the start.

▶▶ **WHY IT WORKS**
The great sense of love and vitality conveyed by Mom and baby having fun together makes this a wonderful shot. The feeling of joy and freedom is enhanced by the outdoor setting.

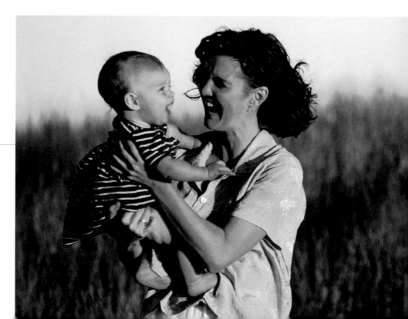

Babies are all too often pictured with just one parent—because the other is holding the camera. But if you're the parents, you'll want to make sure you get a shot including the two of you.

▼▼ WHY IT WORKS

The tight framing, with Dad resting his chin gently on Mom's shoulder instead of standing apart to one side, results in a very intimate grouping. Having both parents look at the child instead of the camera focuses attention on the baby.

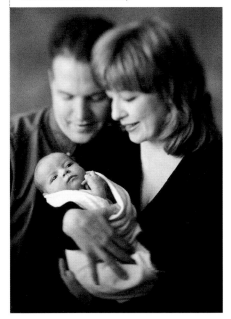

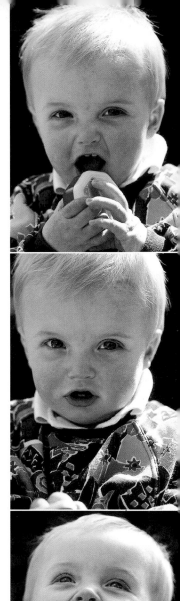

CAPTIVE AUDIENCE

One of the wonderful things about photographing babies is that they can't run away from you, as toddlers can. That doesn't mean that taking pictures of babies is easy. They still have ways of spoiling a photo—by a bout of inconsolable crying, for example. But if you pick your time carefully—after they have been fed, changed, and rested—you'll have a greater chance of success.

You can also photograph when they're asleep—when even the most temperamental baby looks radiant. Once they've nodded off, most babies don't even realize it if they're moved, enabling you to find a location where the light is soft and attractive—such as outdoors on a fine but hazy day.

WINNING WAYS

Babies look cute lying on their stomachs on a large white pillow and peeking over the top. With the light behind you and a sympathetic background, this picture can be a winner.

Pictures of the baby being held by different members of the family are a must, but add to the familiar shots by being creative. You needn't include everything—details can be just as effective. How about photographing the baby's tiny smooth fingers nestling in grandfather's large, mottled hands?

Once the baby can sit up, you have even more options. Prop pillows around newly sitting babies, who tend to tumble over. Going for a walk in the stroller or cuddling a favorite teddy bear make charming pictures. Once you start photographing babies, there's no end to the opportunities for memorable shots.

DOS AND DON'TS

- DO make sure the baby is protected at all times by another adult, in case you become distracted by the photography.
- DON'T choose a time when babies are likely to be miserable. Early in the morning, after being fed and changed, is often a time when babies are brightest.

As babies get a little older they can sit up, although some may still require the support of a cushion or two. A wider range of poses therefore becomes possible.

▶▶ WHY IT WORKS

Seated outside in the spring sunshine, this baby boy, just on the threshold of becoming a toddler, reeled off a wide range of happy expressions—all in the space of a couple of minutes—sometimes looking at the camera and sometimes looking away.

TODDLER TIME

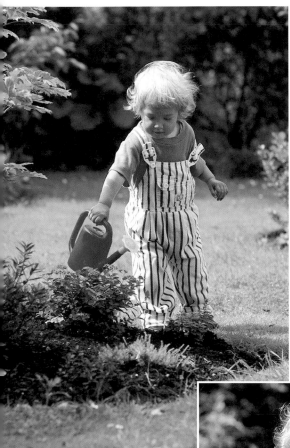

From the time they learn to walk, children seem to be in constant motion. So go with the flow, and capture their vitality in a candid style. What you lose in control you will gain in spontaneous enthusiasm.

MOBILE FACES

Take the children outdoors on a fine, clear day, give them something to do and, once they become engrossed, start snapping. Fast reactions are all you need to capture the moment forever.

Children's faces are much more animated than those of adults, and their expressions can change in a flash. Fortunately, most modern cameras wind the film automatically or operate digitally, so you can be ready for your next shot. You can keep firing away, shoot a sequence, and choose your favorite picture later.

To fill the frame well, you'll probably need a zoom lens. Young children are much smaller than adults, so you need to go in closer or use a more powerful lens than you would for adults in the same situation.

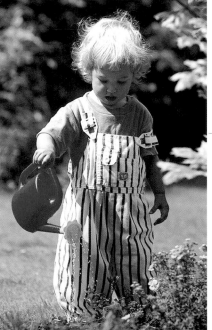

Top tip
Children can be coaxed to stay in one place if you ask them to step on a spider or other pattern drawn on the floor.

The long (telephoto) setting on a zoom lens is ideal when you are photographing children, as it allows you to take pictures of the whole scene and then crop in tighter for more frame-filling impact.

◄◄ **WHY IT WORKS**
There's an endearing innocence about this picture of a young girl copying something she had seen her Mom doing. Dad, meanwhile, had captured everything on film—first a scene-setting shot that shows more of the garden, and then, using the zoom, a tighter composition that focuses almost exclusively on the girl.

Toddlers don't have to be doing anything special when you photograph them. Simply picturing them in their own world is one very effective way of capturing the wonder of childhood.

▶▶ **WHY IT WORKS**

Although nothing out of the ordinary is happening here—the shot simply shows two girls playing with clothes pegs on a line—there's a magical charm to this picture, helped by the fact that the children are obviously unaware of the camera.

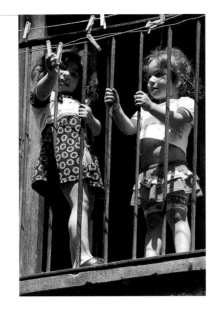

Headlong rush

While the candid approach offers the best chance of getting some good pictures, you may find that younger children run headlong toward you whenever you point the camera at them. Even if the camera's autofocus copes with their rapid movement—and many won't—you'll find it hard to frame the shot.

If you have plenty of time, wait and see if the children become accustomed to the camera. Alternatively, ask another adult to hold their attention, or provide them with an especially interesting activity.

Of course, children are not active all the time, so you may wish to plan your photography around the occasional quieter moments. Wait until the children are resting after a particularly vigorous game, or they're growing tired toward the end of the day, to improve your chance of success.

As toddlers grow older, it becomes easier to get them to pose. So make sure they are dressed in attractive clothes and find a suitable location.

◀◀ **WHY IT WORKS**

The chunky sweater, fashionable jeans, and cute haircut all add up to create a gorgeous picture. The subject's clothes are suitably neutral for a black-and-white photo and complement the photo's naturalistic, outdoor look. The gate acts as a perfect frame-within-a-frame.

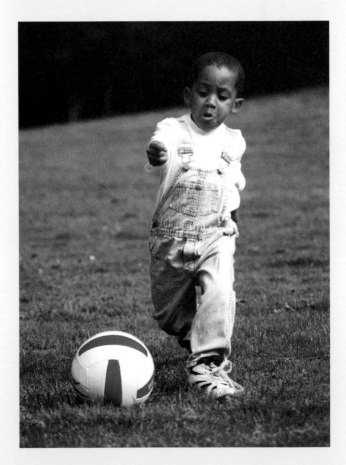

Sometimes, instead of merely observing your
children, get involved in what they're doing.
You'll be surprised at the results you get.

▼▼ **WHY IT WORKS**

Instead of standing back to wait for his son to come
out of the tunnel, the photographer stuck his head
inside, clicking the shutter just as the boy entered
to create this fantastic "space odyssey" shot.

PHOTOS THROUGH PLAY

Young children, in particular, have a limited attention span—so don't delay!
Check all of the technical details before the session begins, provide an activity,
and start shooting immediately.

One sure way of holding children's attention for a while is to
give them something to do. Involved in play, they'll forget
about you and your camera, and you can snap away to your
heart's content. An interesting toy can double or triple your
shooting time—and the more pictures taken almost certainly
means more good ones to choose from for your album.

PET THEORY

When children and pets come together, everyone says "Ahhh!"
So seize the opportunity to set up this winning combination.
Ask the child to hold the family pet—that way, they should
both keep still!—or take advantage of a visit to a pet-owning
relative or friend.

Team a child with a cat, dog, hamster, rabbit, pony—even
a goldfish—and you'll find taking pictures easier.

MAKING MUSIC

Many children play musical instruments, so what better way
to photograph them than showing off their talent? Plan the
light and background, then allow the child to become
engrossed in the playing before taking your shot.

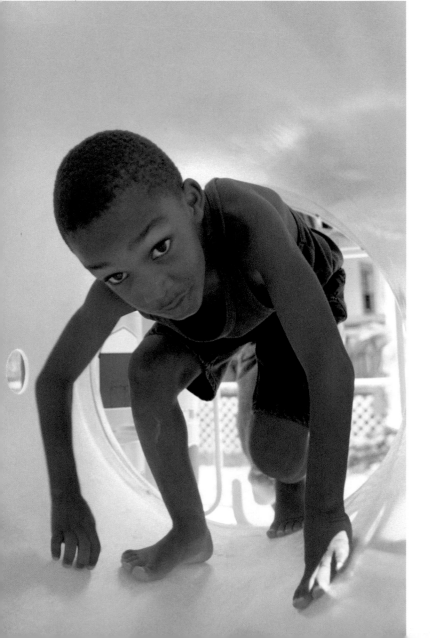

Children and pets go together very naturally, so
if you don't have any pets yourself, you can always
"borrow" one from the neighbors.

▶▶ **WHY IT WORKS**

Early evening sun is the magical ingredient that
makes this picture special as it just catches the
side of the girl's face and dapples the foliage
behind her. You can see from the pose how
special the pet is to her.

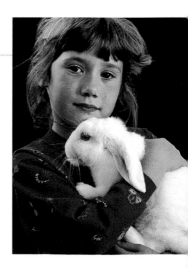

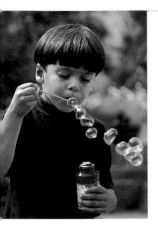

Anything you can give children to play with will distract their attention from you and so make your life easier. It will also add variety to the pictures you take of them.

◄◄ **WHY IT WORKS**
A bottle of bubble mix doesn't cost too much, but will keep a child occupied for a long time. The intent expression on this boy's face shows he's completely lost in play, while the use of a zoom lens lifts him away from the potentially distracting garden setting.

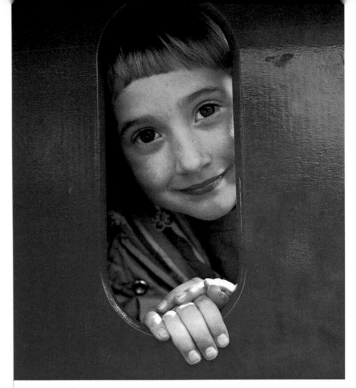

Children also like to dance, skateboard, read, or play ball. Encourage them to engage in their favorite activity. The secret of successfully photographing children—whether your own or someone else's—is to let them do something they enjoy rather than what you want them to do.

DRESSING-UP GAMES

Most children love to play make-believe. Families with young children often keep a dress-up box filled with discarded clothes, shoes, and pieces of material. Open the lid, and you have a world of possibilities. Ask a little girl to imagine she's a princess or a boy that he's a firefighter, and be ready with the camera as they act out their fantasies.

Be prepared for anything when you're photographing children. During a visit to the playground, the photographer saw his daughter climb into a train and anticipated she would look out of the window—and he made sure he was ready to capture this shot as she did so.

▲▲ **WHY IT WORKS**
The child is not posing, and her expression is fresh and natural. The red of the train provides a bright, attractive frame that focuses attention on the girl's face and wide brown eyes, which are lit by soft daylight.

There are no halfway measures when children start playing make-believe. They just throw themselves into it wholeheartedly.

▶▶ **WHY IT WORKS**
In this hilarious shot, the young policeman is also a clown and something of a jack-in-the-box. Because of the hard, high noon light, Dad switched the camera to fire a burst of flash to ensure the boy's face was fully illuminated.

THE CHILD'S WORLD

Once they start school, children suddenly have a lot more happening in their lives—new friends, new interests, and school events that offer not-to-be-missed photo opportunities.

One memory you will surely want to capture is a child's first day at school. Be sure to allow enough time to take pictures—leaving home, boarding the bus, getting ready, arriving at school. Don't forget to have your camera ready at the end of the day as well. Take some that show the entire scene, and some more tightly cropped for impact.

SCHOOL LIFE

For the next decade or more, school will no doubt be a major part of a child's universe, yet in many homes school life is often sparsely represented in photo albums. It's important to seize opportunities to photograph your children in this environment. Exhibits in the classroom, end-of-year affairs, musical and theatrical events, and school fairs are good venues for photos. Just a few shots of the classroom, perhaps—with the child sitting at his or her desk or of teacher and friends—will evoke a host of recollections for your child in later years.

Starting school is a major event in a child's life, and one that should most definitely be recorded for posterity. So make sure you leave a few minutes in your schedule to take a variety of shots.

▲▲ **WHY IT WORKS**
Immaculately dressed, and with his bag on his back, this young boy is fully prepared to take his first big step into the world of school. Mom asked him to stand in an area with no distracting elements, and placed him so that the light was coming from behind, leaving his face softly and evenly lit.

School plays provide an ideal opportunity for budding stars and starlets to show off on stage. In most situations you'll need to get close to the action and use flash for successful results.

◄◄ **WHY IT WORKS**
The rich colors and textures of the homemade clothes stand out strongly from the painted backdrop. The parents arrived early to grab a front-row seat, and fast film was used to maximize the range of the flashgun.

If you have a good relationship with your child's school teacher, she may let you in to take some classroom shots— a wonderful chance to record a part of a child's life that is seldom documented.

▲▲ WHY IT WORKS
A wide-angle lens setting opened up the perspective on this shot, while the box of colored pencils provided the photo with foreground interest and depth.

A trip to a local farm can provide many opportunities for excellent photos.

▲▲ WHY IT WORKS
Shooting candidly at the child's level has produced a lovely study of this young girl and the hen.

Conversation time

Another advantage of school-aged children is that you can carry on a conversation with them—and do they love to talk! Chatting with children about their favorite television show always elicits an animated response. It's also good to have a repertoire of jokes and amusing anecdotes that will get them giggling, relaxed, and unaware of the camera.

There's nothing like a good story to get children animated.

OUTDOOR EVENTS AND SCHOOL PLAYS

A sports day is a great chance to take some dynamic pictures of children and their friends. Find a suitable vantage point, and wait for the perfect moment to release the shutter. If necessary, keep moving around. Bear in mind the direction of the light and the area behind the subject. If you're shooting traditionally, load up with a fast-speed film (ISO 400 to 800), to freeze any subject movement (see page 95).

That's also a useful precaution when photographing school plays and other indoor events. You'll almost certainly need flash, and the faster the film, the greater the flash range. Arrive early and secure the best spot for photography— normally the front row, so that the flash doesn't have too far to reach. Set your camera to its longest zoom setting to fill the frame with action. Don't shoot all the way through the play— it's disturbing for others, so choose your moments carefully.

UNINHIBITED AGE

School-aged children are still young enough to be uninhibited, but they are sufficiently mature to pose for you. Make the most of this twin advantage and enjoy photographing them at every opportunity. Children are also likely to be more willing to pose for the camera if they have friends with them.

TEEN TIME

As children reach their teen years, they become increasingly involved in independent interests and activities. The good news is that this provides many new picture opportunities.

As any parent of a teenager knows, telling teens what to do is not a recipe for success. The more you treat them like the young adults they are, the more positively they will respond. Getting them actively involved in a photographic session can be interesting for both of you—teens generally have a lot to contribute, and if their suggestions are valued, they are more likely to cooperate when you want to take a few shots. But if they refuse to be photographed, don't try to persuade them.

SELF-CONSCIOUS

Of course, the physical upheavals of adolescence can make teenagers self-conscious and sulky for no obvious reason. They may not want to be photographed, especially if a pimple or two is affecting their self-image—so you might be tempted to pack the camera away for a few years until they're through the teenage phase. But you'll still want some shots to record these years, so the most successful approach is to bide your time until your son or daughter seems more receptive.

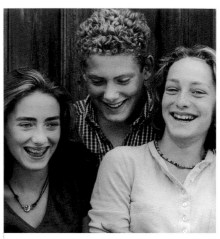

Teens may not want to look at the camera, especially when they're with friends, so try to be flexible in your approach.

▲▲ **WHY IT WORKS**
Not one of the three subjects is looking in the same direction, suggesting action and movement, but they are held together by their laughter.

DOS AND DON'TS

- DO keep up to date with teen styles and interests.
- DON'T tell teenagers what to do.
- DO involve them in the photography.
- DON'T force the issue if they refuse to be photographed.

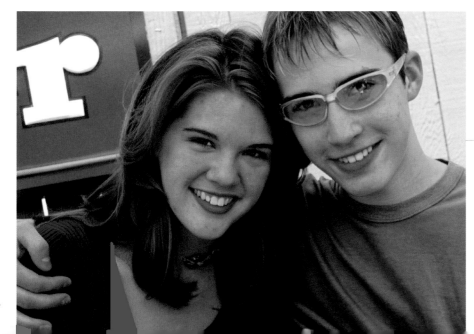

Young love is a wonderful thing, and if your teenage kids let you, you can take shots of them with their girlfriend or boyfriend.

◀◀ **WHY IT WORKS**
The classic heads-together pose, with the boy's arm wrapped around his girlfriend's shoulder, has produced this warm, sensitive image, shot in a modern, relaxed style.

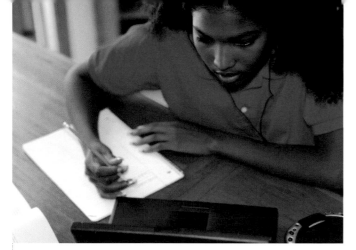

The easiest thing with many teens is to shoot candids. They may not always welcome your attention, especially if they're concentrating on something else, but a shot here and a shot there will soon fill an album.

▲▲ WHY IT WORKS
The girl is engrossed in her work, and isn't really aware of the camera. If she complains after the first shot, then you can always stop, knowing one picture is already in the bag.

STRIKING A POSE

When you do catch your teenager in a positive frame of mind, take the opportunity to shoot a posed portrait—but one that's a million miles from the formal graduation photograph. Look at the magazines your teen reads, and see if together you can re-create some of the styles that are featured. Check out the poses, the locations, the camera angles, and the lighting. Even if you don't duplicate the result exactly, it will certainly be more interesting than a traditional shot.

A RELAXED LOOK

Teenagers are often more awkward in the presence of Mom and Dad. Finding a spot to photograph them away from the family, where you can talk about things that interest them, will give you an opportunity to capture some true-to-life images. As always, smooth camera work and a keen sense of timing will help put your subjects at ease.

Top tip
Ask your teen subject to suggest some ideas and locations for photos. He or she will be more likely to cooperate.

Anyone with a teen son or daughter knows they don't want to conform to adult styles and norms. So it's good to try and capture that style—especially when you know it could change radically a year or two later!

▶▶ WHY IT WORKS
These six friends were walking hand in hand when one of the moms snapped them from a distance—only the girl at the end was aware of the photo. The result is a wonderful, offbeat record of teenagehood.

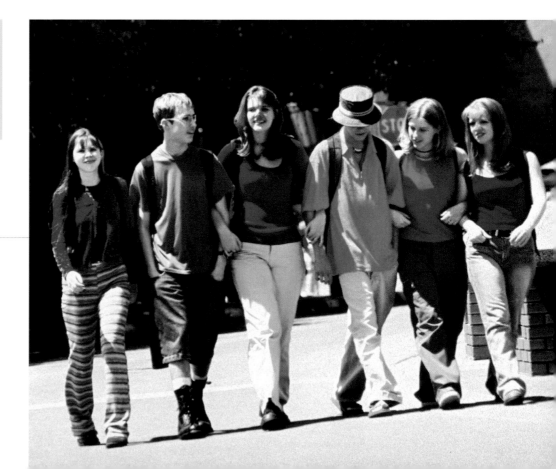

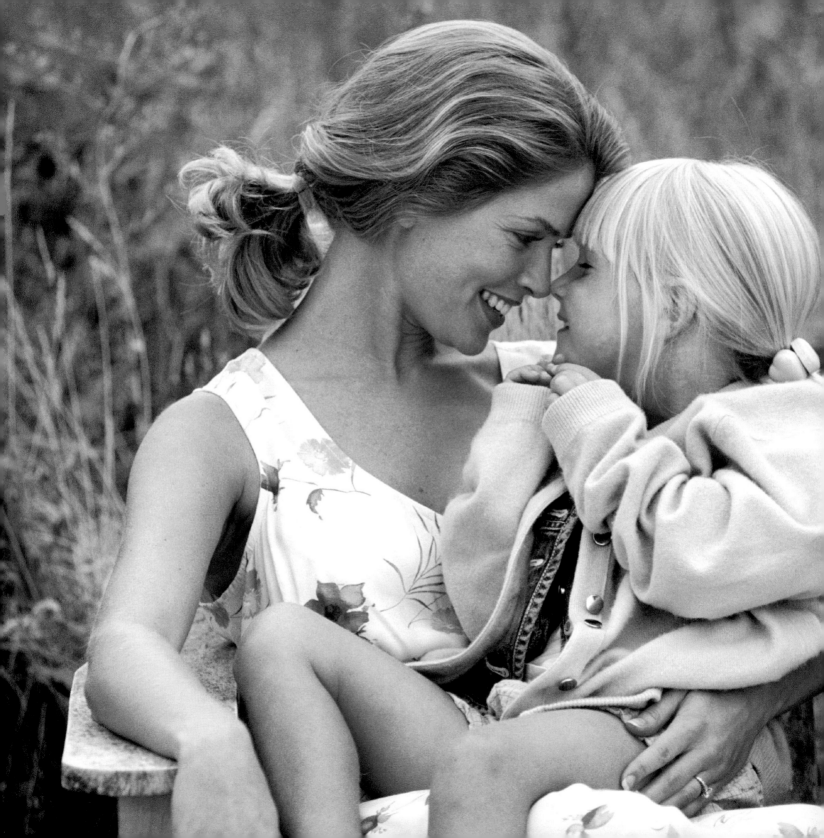

COUPLES
AND GROUPS

It's relatively easy to photograph individuals because there's only one person to think about. Couples and groups are a lot more demanding, however, because there's so much more that you have to attend to. There are lots of different ways in which people can be arranged, for instance, and more faces to watch to make sure no one has turned away or blinked. Happily, there are tried-and-true techniques for this area of portrait photography that will quickly set you on the road to success.

COMPOSING COUPLES

Husband and wife, parent and child, sister and brother, uncle and niece, first and second cousins, grandparents and grandchildren—families are full of "couples" whose relationships you can portray.

Putting pairs together in a picture often implies a relationship between them; you can enhance that sense through posing and lighting.

PLASTIC POSES

Take a moment now to flick through your photo album, and notice how you usually arrange two people. Are they mostly standing side by side, in the middle of the frame, looking at

There are no "rules" about how to photograph couples—either a picture works or it doesn't. So judge each situation on its merit.

▲▲ WHY IT WORKS

On the face of it, the way these two girls are seated—apart, and with their arms on their knees—shouldn't really work. But in fact the near-identical body language and their smiles show just how happy they are together. The gentle side lighting and the location in what seems to be a secret hiding place add the final magical touches.

Married couples often look best when they're in close physical contact, so try to get them closer.

▶▶ WHY IT WORKS

In the first picture, the two subjects are not only far apart but out of focus. By simply inviting them to move closer, put their arms around one another, and touch their heads together, the photographer made a vast improvement to the photo. He also used the focusing lock (see page 128) to bring them into focus.

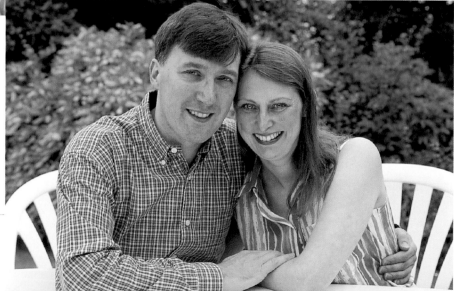

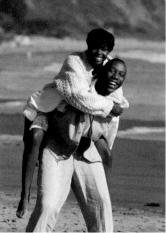

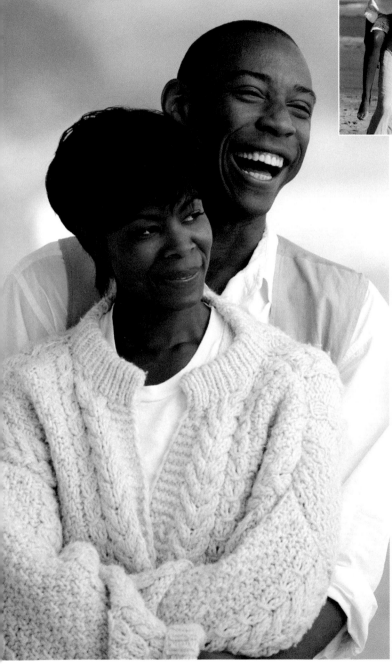

A classic way of posing a man and a woman is to make him stand behind her with his arms around her waist.

◀◀ **WHY IT WORKS**

The photographer first composed a three-quarter shot based on this principle, but created a more contemporary look by inviting the couple to look into the distance. The second shot resulted when the couple was allowed to relax a little more and the woman jumped onto her partner's back.

the camera? If so, you are not alone. That's how most pictures of couples are arranged. Or more accurately, not arranged. The photographer simply said, "I'd like to take your picture," and the two people positioned themselves in the time-honored way. The result is often uninspiring.

GETTING BETTER SHOTS

Occasionally couples respond with flair when asked to pose, but generally the photographer must give some direction. The following pages demonstrate many ways of composing photos of couples effectively—with detailed information about how they were created and why they succeed in terms of lighting, posing, location, focusing, background, and so on.

There are no absolute rules of posing—sometimes you can defy all of the guidelines and produce a winning shot. So be prepared to experiment. The more mistakes you make, the more you will learn.

Having two people in a picture instead of one gives you more options, so keep your eyes open for different compositions.

▶▶ **WHY IT WORKS**

By having this woman pose behind, instead of next to, her nephew, the photographer has created a tighter and more interesting composition as well as allowing the aunt some control over the foreground action.

Focusing lock

One mistake to avoid is to have your subjects out of focus. This can happen if you allow the focusing sensor of the camera (usually indicated by a circle or square in the center of the viewfinder) to go between the heads and focus on the background. This happens because the sensor automatically falls in the center of the picture.

But happily, all but the most basic cameras feature a focusing lock, which allows you to lock the focus on the area you want in focus, and then reframe the picture. This usually means focusing the sensor over one of the people, and partially depressing the shutter release to lock the focus. The focus locks on everything that is the same distance as that person from the photographer. Hold it there while you compose the shot. For example, you may reframe the shot with the person at the side of the frame, not the middle. Then fully depress the release to take the picture.

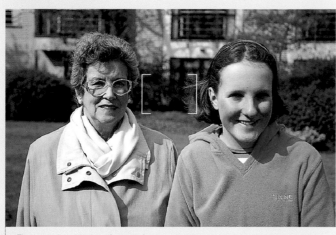

The central positioning of an autofocus camera's sensor means that the camera may focus on a distant background instead of the subjects. This happened in the first picture (top) where the two subjects are out of focus and the background in focus. To correct his error, the photographer positioned the sensor over one of the subjects, pressed the shutter-release button halfway, and kept it held down. This locked the focus on everything in the girl's plane (center). He then recomposed the picture (bottom) and pressed the shutter right down to take the picture with the subjects in focus.

Getting two people to put their arms around each other is a surefire way of creating a visual connection between them. In a parent-and-child portrait, ask Mom or Dad to pick their children up or wrap their arms around their waist in a protective gesture.

▼▼ WHY IT WORKS
The way the father has his arms around his son as they share a conversation gives the picture an immediately heartwarming feel. The man's crouched position makes it easier to produce a strong composition.

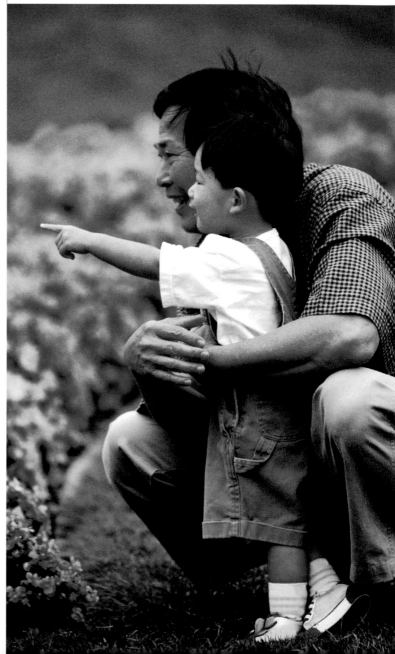

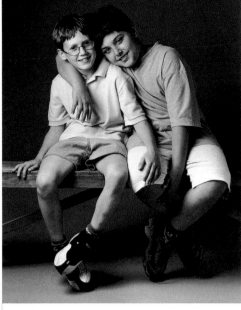

When taking pictures of friends or relatives, you need them to express their friendship in some way—and if you're lucky they'll do so without any prompting.

▲▲ WHY IT WORKS

The boys instinctively created a great composition, so the photographer had to make only a few tiny adjustments to tidy up the picture. The loose vertical lines of their arms and legs describe their closeness, and happy, relaxed mood.

If people don't know each other all that well, it may seem inappropriate for them to be too close to each other in a photo—but there are still ways in which you can make them seem more "together."

▼▼ WHY IT WORKS

By asking these women to angle their legs toward each other, the photographer achieved a visual connection between them even though they are not in fact touching.

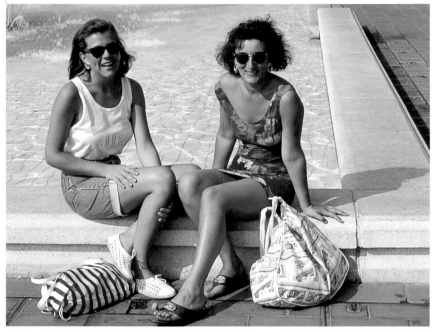

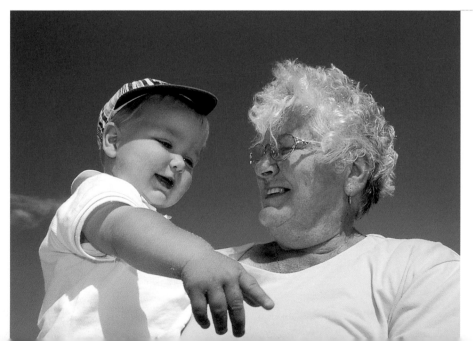

When photographing younger children with a parent or grandparent, having them held can be effective—plus it deals with the potential problem of enormous height differences.

◄◄ WHY IT WORKS

Grandma and grandson are having a great time together—it's immediately apparent from their expressions. The sun is rather harsh but has been softened with a burst of fill-in flash. Taking a lower viewpoint has allowed the sky to be used as a backdrop.

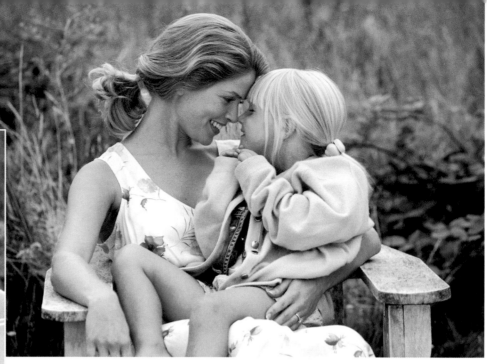

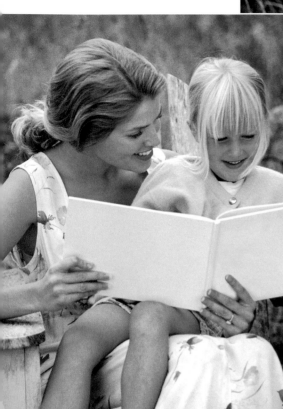

Capturing the special relationship between mother and daughter requires a delicate touch from the photographer, and a certain amount of imagination. You need to think of ways in which they can express the love they have for each other.

▲▲ WHY IT WORKS

The photographer tried a variety of different poses before shooting the ones he liked best. This also allowed the subjects to relax and feel at ease. The picture which works best is probably the one where they're rubbing one another's noses.

Creating a sense of intimacy

With some simple posing techniques and thoughtful composition, it's easy to create a sense of closeness.

TOUCHING MOMENT

Many photographers find couples tricky to photograph. All too often their pictures show two people standing awkwardly side by side, almost like strangers. To convey a sense of togetherness, it is important to have the two people touching in some way. How you do this depends upon the relationship between the couple and the kind of people they are. Lovers and spouses are likely to express their closeness in a different way from family members and friends, and people who are reserved will not behave in the same way as extroverts.

Whatever the relationship, arrange the pair so their bodies are touching. This creates a nice, tight composition. Getting them to point their feet at an angle toward the camera, instead of straight ahead, immediately improves the picture.

Enhance this basic pose by asking the couple to tilt their heads together, so that either the temples or the cheeks touch. Suggest they put their arms around each other—and you'll be well on the way to a wonderful photograph.

HAVING FUN

Some couples need no coaxing—they'll automatically play up for the camera. If, for example, the pair are horsing around, just bide your time and capture the fun when it reaches its peak. Other couples may feel a little awkward at first, but with encouragement they, too, will begin to relax and enter into the spirit of things.

One person's arms can wrap around the waist or the shoulder of the other. It's advisable for only one person to do this—if the two subjects put their arms around each other, the stances can become awkward. Alternatively, invite them to hold hands—an intimate touch that can speak volumes in a photograph.

HEIGHT DIFFERENCE

Always seek alternatives to posing people side by side. If there's a height difference, or a natural way to position one person higher, place the taller one behind—perhaps with arms cradled around the other's waist. Heads can be alongside or above each other. Photograph couples when they're busy with shared activities to capture moments of unselfconscious intimacy. People in close relationships continually exchange loving touches. Having your camera on hand means you can capture those personal moments without the artifice of formal posing. You'll also picture a variety of expressions, since the two people will be looking at each other instead of at the camera.

Many pictures are weak because the subject is too small in the frame. Taking one or two steps forward can make an enormous difference, allowing you to virtually eliminate the backdrop.

▶▶ **WHY IT WORKS**
By using the slide as a prop, the photographer was able to get the heads on top of each other for a more interesting composition.

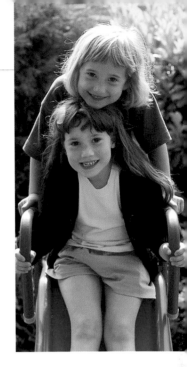

The longer people have been together, the easier it is to capture shots of them that show real feeling.

▼▼ **WHY IT WORKS**
A wonderfully spontaneous shot—a man, his head nestled in his wife's neck, gazes adoringly at her. The gesture is simple and uncontrived and the affection they feel for one another almost tangible.

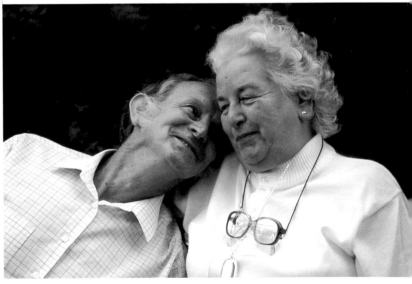

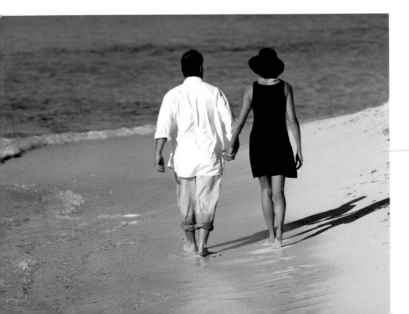

Holding hands is one of the most intimate ways of relating to someone, and ideal—from the photographer's point of view—for expressing a romantic relationship.

◀◀ **WHY IT WORKS**
The couple is all alone on the beach, hand in hand, their backs turned to the viewer. The long, evocative evening shadows add to the romantic mood.

When fine-tuning your techniques for photographing groups, it's best to start small—with three people—and then build from there. The more individuals there are, the harder it becomes.

▼▼ WHY IT WORKS

The photographer found it relatively easy to maintain a rapport with just three children and to ensure that they were all looking at the camera when the shot was taken. Simply having them put their arms around each other was enough to produce a strong composition.

ARRANGING GROUPS

Photographing groups is one of the most challenging areas of portrait photography, because of the organization involved. Each person needs to be visible, well posed, and looking at the camera when the shutter is released. That can be a tall order, especially with children and large groups—but a little planning can give you the right results.

SMALL AND MANAGEABLE

Unless there's an upcoming family occasion that you must photograph, the best way to begin is by practicing with small, manageable groups. Then gradually raise your sights as your experience grows. Arranging even three people is more complicated than arranging two, and there are many different ways of posing them. So why not ask some of the adult family members to assist you in improving your group-posing skills?

HEADS, YOU WIN

Success in posing groups is largely a matter of where you position the heads, which are almost always the picture's focal points. No one must obscure the person behind.

Take care to avoid the mistake of scattering people across the frame without any discernible arrangement. The most obvious way of posing three people is to have them standing in a row, with the heads effectively linked by a horizontal line. Make sure that everybody is touching shoulder to shoulder, or

DOS AND DON'TS
- DO shoot twice as much film of groups than of other subjects, because there's much more room for error.
- DON'T get uptight if young children begin to fret. Call a temporary halt, take them out of the group, or continue and make the best of it.
- DO remember to ask people to curl their hands slightly to make them more elegant.
- DON'T forget to check around the frame to ensure that nothing will distract from the finished picture.

If the people in a group are of different heights, asking them to sit down on a sofa is one good way of making their heads appear more in line.

▼▼ WHY IT WORKS

In the first (smaller) picture, the man on the right is clearly not engaged in the conversation, so the photo lacks a coherent composition. The second (larger) photo is a big improvement—the woman has her arms around both men, and they are both looking in her direction. The photographer has also cropped in for a tighter shot.

they can look like a firing squad! Done well, this pose is satisfactory, but it is fairly static and soon becomes dull if used repeatedly.

A taller person is usually placed in the middle, creating a triangle effect. This can be enhanced by standing the tallest person behind, so that he or she looks over the shoulders of the other two. If the height differential isn't great enough, the person at the back can stand on a makeshift support, such as a couple of old books. The aim is to prevent all of the eyes from being at the same height and to increase the impression of depth. Take your time to try out different alternatives.

KEEPING IT IN FOCUS

Unless there is a lot of light, you need to place everyone at roughly the same distance from the camera to keep them all in focus. There is more latitude when using a wide-angle lens with the group positioned farther away, but when you get close, the group must not be too deep.

Other arrangements include having the middle person in front, seating one person in a chair with the other two standing behind, and positioning all three on a sofa.

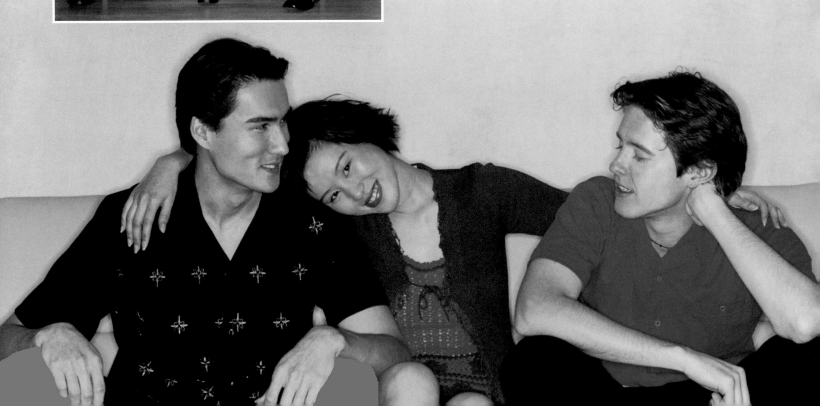

A tried-and-true approach to photographing four people involves having two of them at the back, either standing or sitting, and two people at the front, either sitting or kneeling.

▼▼ **WHY IT WORKS**
This arrangement ensures that everyone's head can be seen. The linked arms and legs between back and front hold everything together nicely.

FOUR!

Once you graduate to photographing four people, you can have two in front and two behind, two sitting and two standing, or a variety of other formations. As group numbers increase, so do the options. This can be daunting, so begin with one or two arrangements that give you pleasing results and continue using those until you feel confident about expanding your repertoire. Try an arrangement from the following pages, or copy a pose from the group portraits in celebrity and lifestyle magazines.

BIGGER GROUPS

Avoid lining big groups up like a sports team—it looks too regimented. If space makes this formation essential, ask the people on the outside to turn their bodies in toward the camera, with their front feet slightly forward and pointed, to improve the effect.

Instead of putting taller people at the back of a group and the shorter ones at the front, use some imaginative ways to "layer" the group. Outdoors, a low wall, steps, or some patio chairs can vary the levels. Indoors, you can use the furniture, with children on laps and some people crouching, or arrange your group on a flight of stairs. If the group is too large for you to see all of the faces, stand on a chair or a ladder yourself to get a higher viewpoint.

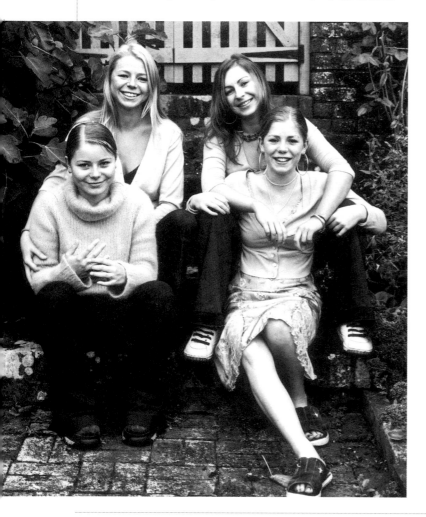

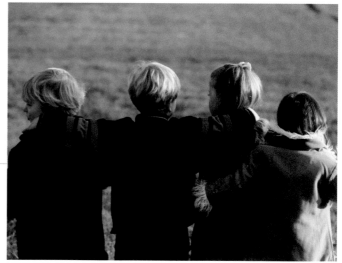

While pictures taken from behind can often lack interest because the faces are not visible, there are circumstances where it can work really well. So don't rule out any possibilities, and keep your eyes peeled for the right moment.

▶▶ **WHY IT WORKS**
By focusing on the subjects' arms instead of their faces, this photo gives a fresh perspective on this group of children—one that would have been lost in a more conventional shot.

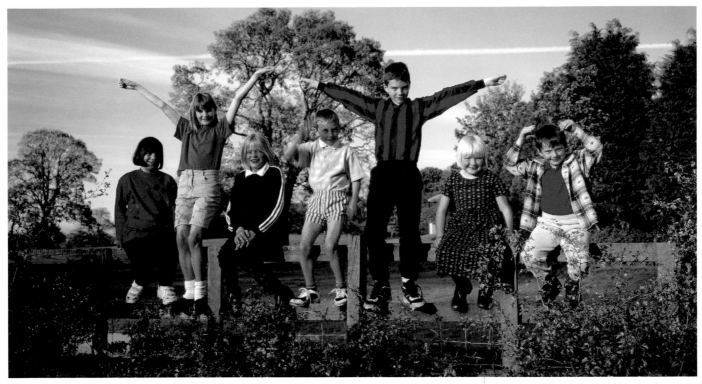

LIGHTING FOR GROUPS

Choose a time of day that puts the group in the best light. If people are looking directly into the sun, they'll squint, and if the sun is shining from one side, everyone will cast a shadow on the person next to them. On a bright day, there are two choices: shoot into the light, or find a shaded area where the illumination is softer—against a wall or under a tree, for example. In both cases, you can soften the shadows more by draping an old sheet out of sight on the ground, to bounce light back up into the shadows.

Indoors, the perfect lighting comes from a large window that everyone can face, so that illumination is equal across the frame. If light levels are low, you'll need flash, and everyone must be a similar distance from the camera. If they're not, those at the front will be too light and those at the back too dark—and that isn't easy to rectify, even with a digital camera.

If you have studio lights, it is important to obtain even coverage. Fire the lights into umbrellas: one on each side of the group, and, if possible, a third in the middle.

Arranging people in a line is another classic way of photographing groups, although the practical limit for a lineup is about six to eight people.

▲▲ WHY IT WORKS
The photographer has gone beyond the obvious by perching the children on the fence, and then breaking the line by asking three members to jump in unison as the picture was taken.

Top tip
You need to alert the members of a large group when you're ready to take the picture. One well-known professional blows a referee's whistle—a surefire way to make everyone look at the camera simultaneously.

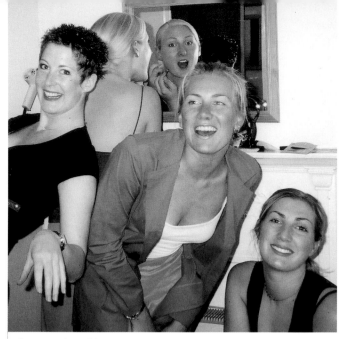

As you grow in confidence at photographing groups, you can flex your creative muscles even more. Be adventurous and try lots of different arrangements—you never know what will work until you try it.

▲▲ WHY IT WORKS
The photographer has been very creative here, even incorporating a mirror into the picture. The photo's composition is deliberately chaotic, adding to the shot's "girls having a good time" feel.

Top tip
Don't forget to include yourself in the picture. As you plan the shot, think about where you are going to be. Support the camera—on a tripod, if possible—and use the camera's self-timer as you sprint into place.

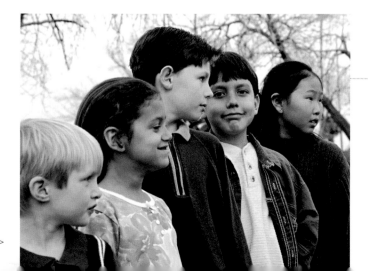

One group technique you must try is to lie on your back and get everyone to lean over you and put their heads together. Choose the widest lens position you've got, set the flash to fire, and you'll be rewarded with a strong, exciting image.

▶▶ WHY IT WORKS
This picture is full of fun and vitality. The exaggerated expressions came as a result of the photographer asking the subjects to shout "hooray!" while a burst of flash made sure they were fully illuminated.

FITTING IT ALL IN

As groups become larger, not only do you need a bigger space but you also need a lens sufficiently wide to fit everything in. Fortunately, most "compact" film and digital cameras feature a wide-angle lens whose angle of view is adequate for all but the largest gatherings, provided you have enough space in which to step back. A long (telephoto) lens is very useful outside, allowing you to be farther from the group and still produce a tight composition.

CLOTHING ISSUES

The color of people's clothes is also important. Don't put a person in red next to someone in pink or orange, but place them as far apart as you can. Position people wearing pale colors in front of those in dark colors—or vice versa—so that each stands out. If possible, offer suggestions beforehand about the tones and colors people should wear.

NEAT AND CLEAN

You want to show your group at their best, so while you're arranging them, be alert for such details as crooked neckties, undone buttons, untucked shirts, smudged makeup, lipstick on teeth, or hair out of place.

Try to think of new ways of arranging your subjects. Instead of lining people up like a sports team, try arranging them so that some are closer to the camera than others. Use a wide-angle setting if you can to increase the depth of field, or you'll find that some of the faces are out of focus.

◀◀ WHY IT WORKS
The fact that just one person is looking at the camera, while the others are staring away, is what makes this shot work. Your eye moves instinctively to the boy facing you—and returns to him, no matter how much you look around the image.

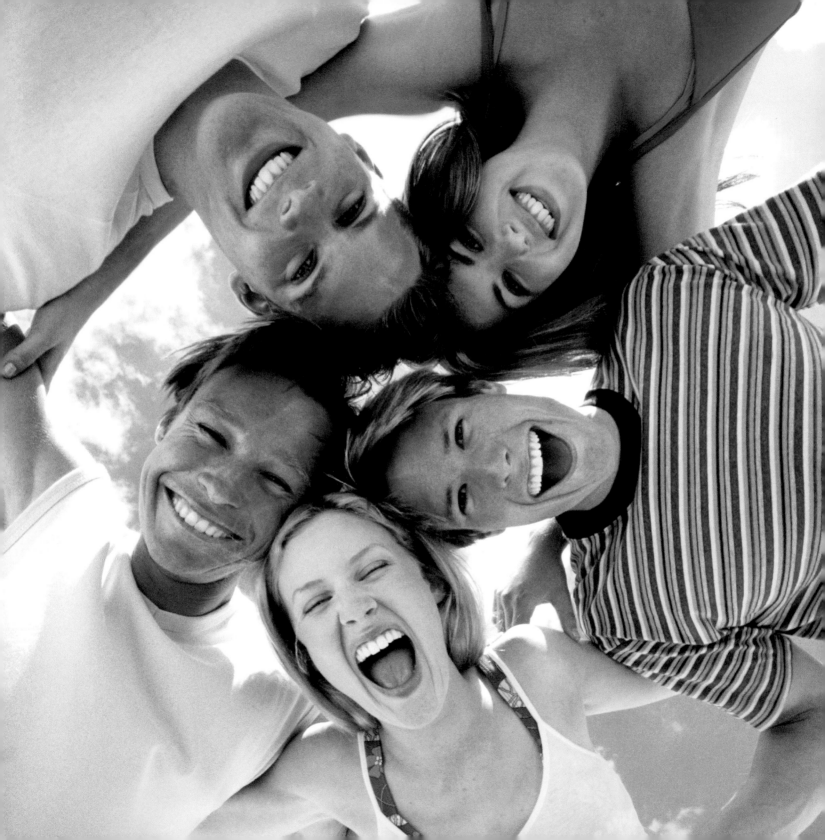

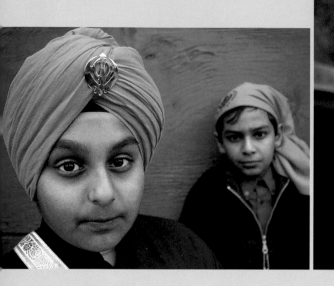

SPECIAL OCCASIONS

Everyone dusts off the camera for a special occasion, but getting good pictures isn't as easy as you might think, especially when it comes to big events like a wedding. Knowing what to photograph and when in a rapidly changing situation can be demanding, so you'll need to plan the kinds of shots you want to take ahead of time, or be quick on your feet and able to go with the flow of whatever happens. Either route requires skill and practice, as this section shows.

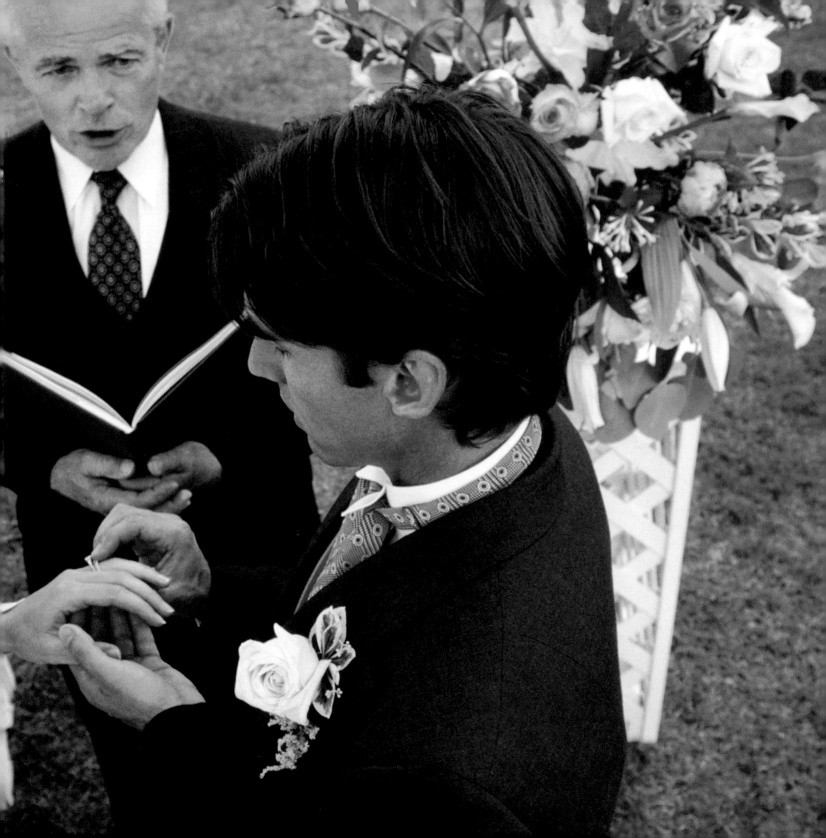

CELEBRATIONS

Every day in a family's life is important, but some days are more notable than others. Birthdays, parties, and graduation days are just some of the happy times you'll want to capture on film.

HAPPY BIRTHDAY!

Birthdays give each member of the family his or her moment in the spotlight. Traditional activities—opening presents, blowing out the candles, playing party games—present perfect photo opportunities.

Most of these pictures will be taken indoors, so you will need to use a flash. The majority of compact cameras have a built-in electronic flash, which fires automatically when required, so there is no need to worry about the technicalities. The same is true of many new SLR (Single Lens Reflex) cameras, but with older models you may need to add an accessory flash unit. Switching on the room lights will minimize the risk of red-eye (see page 171).

You may not have any control over the proceedings, but try to photograph your subject against the most attractive background and clean up any unnecessary clutter.

Pictures with an unusual subject of focus are often eye-catching, so use your imagination.

▲▲ WHY IT WORKS

This is an original approach to a well-worn subject. The photographer has focused on the candles, making the girl out of focus. The cake and the candles stand out dramatically, but the expression on the girl's face is still recognizable. The flash was switched off to avoid swamping the candles wth light.

With children's parties you'll want to capture anything and everything that happens. Assuming that you're indoors, you'll almost certainly need flash, so try to be about 4.5–6 feet (1.5–2m) from your subjects to achieve the best results.

◄◄ WHY IT WORKS

The photographer discreetly cleared away any clutter and waited until his subjects were suitably arranged before taking these shots. The shots are well lit because the photographer wasn't too close when he used flash.

Top tip

Get to the party early to familiarize yourself with the indoor and, if applicable, outdoor settings. Take some of the pictures before people start eating and the surroundings become too messy.

PARTY TIME

Whatever the reason for a party, it's a time for fun, not for formal poses. Some of the best party pictures are taken in the candid style, when people have little or no warning before the shutter is clicked.

That doesn't mean you should snap away indiscriminately. Just getting your subjects to move closer together can improve results dramatically. Make sure everybody's eyes are open and most are looking toward the camera at the same time.

For indoor pictures using flash, position yourself about 6 feet (2m) from your subjects, so they are not overexposed. A zoom lens will enable you to take pictures that include the background or crop in for a tighter composition. At summer parties and barbecues, you can take informal pictures using daylight—with no burst of flash to announce your presence.

Look for opportunities to photograph people "letting their hair down" as the party moves into full swing—some of the best shots will probably occur toward the end of the evening!

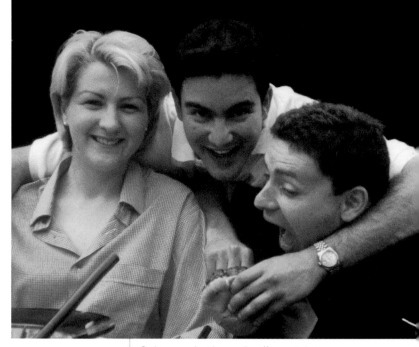

Barbecues and outdoor parties offer great photo opportunities. Don't go around asking people to pose—simply catch the fun as it unfolds.

▲▲ WHY IT WORKS
It's the expression of the man on the right that makes this picture. While the other two subjects are smiling for the camera, he's making a face.

When you go to parties in public places, don't expect to take great pictures. In fact, it's probably safer to buy a cheap "single-use" camera to avoid the risk of losing or damaging a more expensive model.

◄◄ WHY IT WORKS
All too often with party pictures, the flash is so strong that it overpowers everything. But this picture has really caught the party atmosphere, with the flash balancing out the existing indoor light.

CEREMONIES AND TRADITIONS

If flash photography is not allowed in a house of worship, use fast film to compensate. The resulting photos may be slightly flawed, but at least they're better than no picture at all.

▼▼ WHY IT WORKS

This shot has an orange tint because no flash was used. Instead, fast film was used to allow for a fast shutter speed, which overcomes camera shake. Yet the orange cast works here: It gives a warmth to the photo while evoking the feel of a church's interior.

Most religious ceremonies take place in a house of worship, and even with tungsten lamps or fluorescent tubes to boost illumination from windows, light levels are often low. This means you will need to use a flash. Be sure to check with the religious leader ahead of time, because some have strong views about flash photography during ceremonies.

Find the best position for yourself, and take your pictures as the ceremony unfolds. For example, at a christening, your most important shot is the anointment of the child with water, and you will not have long to capture it—so stay alert. Some ministers will let you take pictures after the service, when you'll have more time to think about and set up some memorable images.

CULTURAL TRADITIONS

Other ceremonies with cultural or religious significance, such as confirmations or bar mitzvahs, each have key moments to be recorded. There is usually a "before, during, and after" element, and photographic coverage should take in all of these stages. In addition to the formal shots, you might want to capture more relaxed images in a journalistic style.

Traditional holidays, such as Thanksgiving, Halloween, Christmas, New Year, and the Fourth of July, are often events that bring family members of several generations together; these gatherings would not be complete without a photographic record. The approach to use for these occasions is similar to that for parties—which is essentially what they are.

Many communities have their own national costume, and if that's true for you then you may want to commit your heritage to film as part of a family photo archive.

▶▶ WHY IT WORKS

This could have been just another picture of a couple in traditional dress. But interest has been added with the placement of one subject close up and in focus and the other farther back and slightly out of focus. The dramatic effect is heightened by the bold colors of both clothes and background, and the boys' pensive expressions.

CELEBRATING SUCCESS

Many special occasions celebrate achievement or change—from graduation to retirement, engagement to anniversary. A graduation picture is an individual portrait but one in which the occasion is clearly identified. This can be done through a location, clothes—or both. A retirement is often marked by a gift, which can be featured in the shot. An environmental portrait is usually the best choice for this type of picture—showing the retired person at home or in the workplace that he or she is leaving. Engagement and anniversary pictures are essentially couple shots, so follow the guidelines in the *Composing Couples* section for the best results.

If you want to focus on one subject in a photo, leaving the others unsharp, use a long setting on a zoom lens together with a wide aperture. Be sure to wait until your main subject has the expression you want.

▶▶ **WHY IT WORKS**

The use of selective focus concentrates attention on the girl in the middle, while the shot's composition describes optimism and forward thinking.

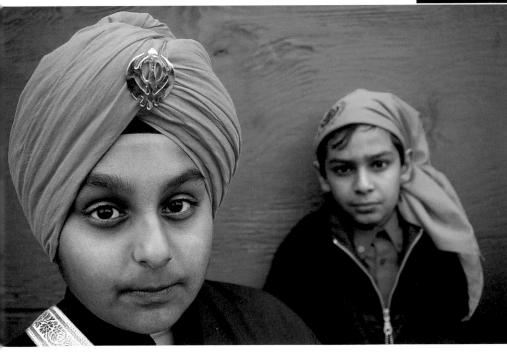

▶▶ **JARGON BUSTER**

Selective Focus Selective focus describes the effect achieved when just part of the picture is in focus, and the rest is rendered deliberately unsharp, creating a sense of depth. The effect is enhanced by the use of a long lens with a wide aperture.

WEDDINGS

Weddings are one of the great family occasions, when anyone with a camera will dust it off and take some pictures. This is the time for some unforgettable shots—but if the couple asks you to be their official photographer, think carefully before saying "I do."

The problem with wedding photography is that there is no second chance. A wedding is a once-in-a-lifetime occasion, and if you are the chief photographer, you must be certain of success. That's something you can only guarantee with experience. A family wedding is not the occasion to test your skills for the first time.

INFORMAL VIEWS

Offer instead to take lots of supplementary shots—informal pictures of the guests that the professional photographer won't have time to shoot. You will also be present until the end of the celebration, so you can continue taking pictures long after the official photographer leaves.

If you do contemplate acting as the couple's main photographer, you will need more than photographic skills. Not only must your pictures be correctly exposed, in focus, and well lit, they must also be attractively composed. You must also be able

▶▶ JARGON BUSTERS

Saturation A picture is said to be saturated when the colors are rich and brilliant. This is achieved when the film is correctly exposed and accurately printed.

Rollfilm SLR Camera A camera that works on the same principle as a standard 35mm SLR, but offers additional advantages, including a larger negative size and quickly interchangeable film rolls (see page 16).

Pixel (from PICture ELement) The smallest unit of a digital image. Mainly square in shape, a pixel is one of a multitude of squares of colored light that together form a photographic image (see page 18).

Many wedding ceremonies now take place outdoors. If that's the case, then you'll have plenty of light and will be able to click away without interrupting the service. If the ceremony is indoors, you'll need to check whether flash is allowed. If not, load up with high-speed film.

▶▶ WHY IT WORKS
The vantage point from which this picture was taken enabled the whole story to be told in a single shot—the couple, the service, and the ring. The light is soft and attractive, and the wide-angle perspective just right.

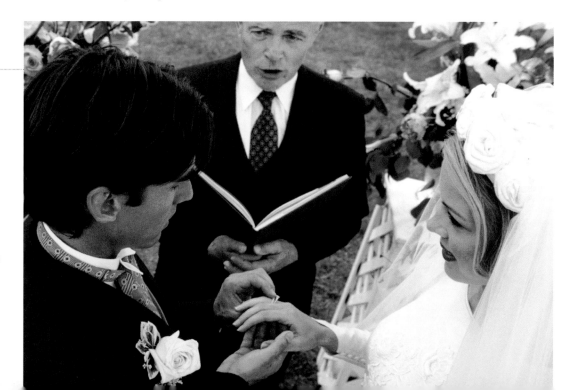

to arrange the couple and various groups quickly, under the gaze of guests and onlookers—some of whom may be getting in the way to take their own pictures. That's stressful! But some people have a flair for the task—and you may be one of them. Even so, it is essential to warn the couple that you are not experienced in wedding photogeaphy, that you'll do the best you can, but that you can't guarantee the results.

EQUIPMENT

Is your equipment good enough for wedding photography? Professionals use expensive "rollfilm" SLR (Single Lens Reflex) cameras for two main reasons: first, because the larger negative size makes it possible to enlarge pictures to poster size for wall mounting; and second, because it makes the photographers look professional. Regular 35mm equipment from a reputable company is more than adequate, provided you don't want pictures larger than 12 x 16 inches (30 x 51 cm). With digital cameras, the quality depends mainly upon the number of pixels captured. Cameras with a resolution of 4 million pixels will enable you to produce 8 x 11-inch (20 x 28-cm) inkjet prints that look and feel like traditional photographic prints—and 11 x 17-inch (28 x 43-cm) inkjet prints may be possible if the subject is sharp, saturated, and correctly exposed.

LENS OPTIONS

It is important to have lens options. The most suitable camera is an SLR with a range of interchangeable lenses, covering everything from wide-angle through telephoto. But a compact camera with a zoom can be just as effective. Though compact cameras lack the flexibility of an SLR, they are quicker and easier to use in fast-moving situations. The wide-angled view is essential for photographing groups, especially indoors where there's no room for you to step back and put more into the frame. The magnifying power of the telephoto is valuable for cropping tight shots of the couple and individual guests.

When taking pictures of the bride, try to get away from rigid, conventional backdrops and, if possible, find a place that's more sympathetic, such as a field, garden, or shady courtyard.

▶▶ **WHY IT WORKS**

The setting sun behind the bride gave the veil a lustrous sheen and ensured that her face was softly lit. The camera was tilted for a dynamic composition.

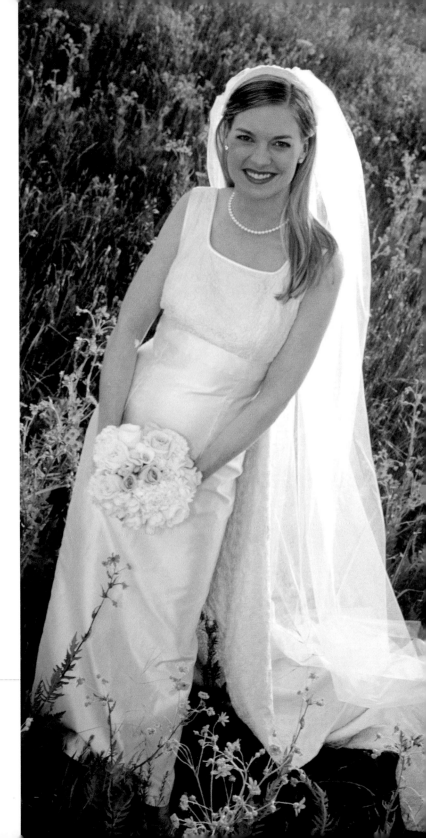

If you've been taking pictures in a house of worship, you'll need to get out quickly once the ceremony ends to take some shots of the now-married couple emerging—often to an avalanche of confetti. If you've done your homework, you'll know when to move to the exit!

▶▶ **WHY IT WORKS**
The photographer has caught this moment perfectly, with the confetti fluttering in the air. If you are taking pictures as a guest, it's hard to get any closer without blocking the view of the official photographer.

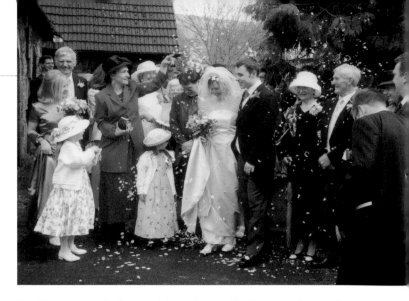

LIGHTING

The best conditions for outdoor wedding shots are bright and hazy days, with the sun covered by fluffy clouds. The light is plentiful but soft, and the shadows are not too harsh. But wedding-day weather is beyond anyone's control, so you need to know how to make the most of whatever conditions present themselves. Generally that means finding a shaded area if the sun is direct, and using fill-in flash if there are heavy clouds or rain. Don't forget to consider backgrounds when choosing your outdoor spot.

You will probably want flash for indoor shots, but check when and where it's appropriate to use it. Certainly you must be discreet and do nothing that will distract from the ceremony. It is often preferable to use a more sensitive film or a higher digital setting and to shoot by ambient light. Flash will normally be required at the reception, though—for the speeches, the cutting of the cake, and the party that follows.

POSING TECHNIQUES

The shots you must have, if you are the main photographer, are those of the couple and the various family groups. There must be several different shots of the couple on their own, then with the bridesmaids and groomsmen, with the groom's parents, then with his wider family, then with the bride's parents, and with her wider family—and a shot of everyone together at the end.

Since you'll be concentrating on the photography, ask one of the guests—perhaps the best man or an usher—to help organize the groups. Then you can move quickly from one picture to the next without awaiting the arrival of a stray participant. Suggestions for posing couples and groups are on pages 124–137. The key is to have group members facing slightly inward, one leg in front of the other with the toes pointed, and not lined up like a baseball team. Group shots

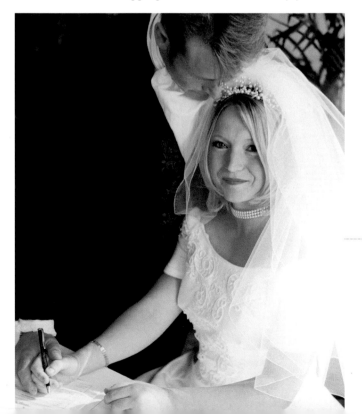

Signing the guest book is an essential wedding picture and generally requires flash because it's done indoors. Try to make sure the hands of both bride and groom are on the pen. Try, too, if possible, to capture a natural and intimate shot.

◀◀ **WHY IT WORKS**
The photographer made sure that the hands of both bride and groom were on the pen by making the groom stand behind the bride. The kiss on the head added the final, perfect touch.

often benefit from a high camera viewpoint. Keep a lookout for steps, walls, or balconies that can give you extra height, and, if needed, somewhere both practical and interesting to arrange your subjects.

BRIDE AND GROOM

Take the bridal couple away from the throng for some quiet pictures on their own. They'll be able to concentrate better, and you won't have someone else pointing a camera over your shoulder. The best time is often at the reception, when the atmosphere is more relaxed. Take the couple to a photogenic spot for just a few minutes, and you'll produce some romantic portraits they'll treasure for a lifetime. Don't forget to include some pictures featuring the ring(s), the dress, the flowers, and any other key details.

Top tip

Once you have an itinerary of the day's events, explore the wedding venue(s) in advance at the same time of day you'll be taking the photos. You can find the best locations for your shots and know where the light will be coming from.

THE BRIDE BEFORE

Wedding photography doesn't begin with the ceremony. Some of the best pictures are taken beforehand: not just the classic shots of the bride arriving, and the groom and best man waiting patiently—or nervously!—but also photos of the bride and groom preparing earlier in the day. This can be a great opportunity for individual portraits, provided you judge your moment carefully and don't get in the way. You can include pictures of the bride and bridesmaids being dressed up or any last-minute preparations by family members. Your aim is to produce a "storybook," with pictures of all that happened, as a permanent keepsake of a very special day.

If the bride allows you into her dressing room, you will find lots of opportunities for reportage-style photos. Even a handful of such pictures will enable you to produce a more complete and interesting "storybook" album.

▼▼ **WHY IT WORKS**

The photographer took this shot just before the bridal party left for the church. A gentle burst of fill-in flash was used to balance the natural light coming through the glass doors.

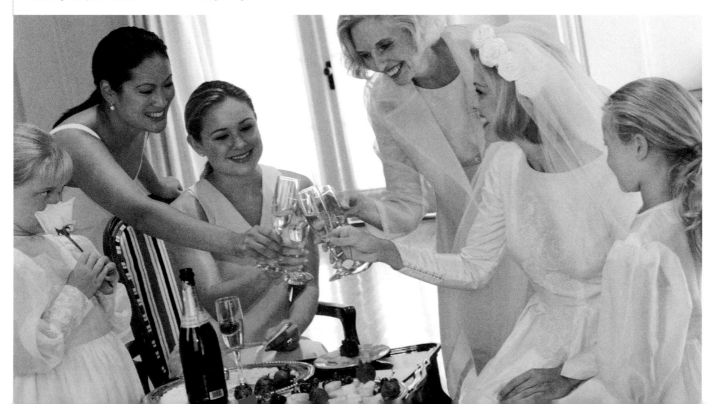

VACATIONS

In a busy life, opportunities for taking family pictures are often rushed. Vacations offer not only a more leisurely pace but also the stimulus of new locations. The key to success is to keep your camera on hand, ready to capture the new sights that you find. Keep a spare roll of film in your pocket in case you need to reload in the middle of some interesting shots. Be sure to check that you have spare batteries of the correct kind—some are not widely available.

Top tip
If you are going far from home for your vacation, always take twice as much film as you think you will need. Camera film is often very expensive in tourist locations and carrying extra film spares you the trouble of interrupting your trip to buy more.

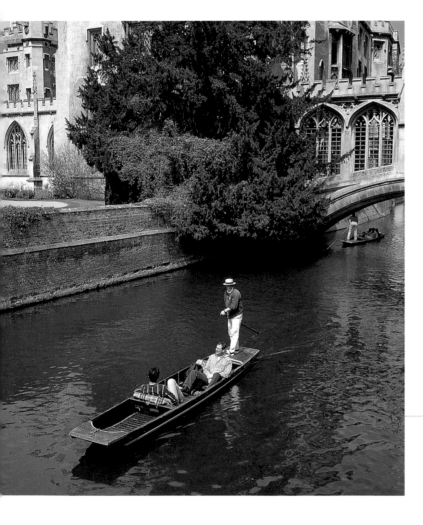

If you have an SLR (Single Lens Reflex) camera, with several lenses, a flash unit, and filters, think carefully about what you want to carry around with you. Choose just a couple of lenses that will cover most situations. By traveling light, you'll have less to distract you and more stamina to enjoy your photography and your vacation.

A DAY'S OUTING

The ever-expanding growth in the entertainment industry means that there's plenty of choice for an exciting day away from home. A theme park is specially built for having fun and offers nonstop photo opportunities. So be selective. Unless you have a digital camera with an enormous storage capacity, don't shoot too many pictures too soon. Take one or two shots every now and then, unless an exceptional situation arises.

Though you might not want to risk taking pictures during a roller-coaster ride, you can achieve excellent results from the ground, provided you choose your spot carefully. Spend a few minutes observing where the track runs and where the movement is slowest—then position yourself accordingly. You'll almost certainly need a zoom lens to fill the frame with your subjects. Chances are it will be sunny, and shutter speeds will be fast enough to freeze the action.

Rivers offer romantic—and dramatic— photo opportunities, especially if flanked by an impressive bank or building. Try taking at least one picture when the water is relatively calm.

◄◄ WHY IT WORKS
The water's stillness and color convey a lovely calm that is enhanced by the height of the tree and the graceful arch of the bridge in the background.

Vacationers are all too often placed right in the middle of the frame, obscuring the location behind. It is often far better to position your subject to one side.

▶▶ **WHY IT WORKS**
In this picture you get the best of both worlds: the glorious waterfall and the person visiting it. Placing the person in the bottom left corner of the image leads your eye into the picture as it follows the spray to the center of the frame—the lightest area. Had the subject been positioned in the center, the effect would have been far less eye-catching.

IN THE COUNTRY

The countryside offers different but equally abundant photo opportunities. If you're planning to walk, travel light to make the most of them. The scenery and landscapes will be a key feature, but you'll want pictures of your family members in it. Pictures are too often composed with the person in the center, which obscures the view. Position your subjects more to the side, and both they and the vista will be equally visible. Try to have a center of interest in your composition, avoiding general views. Place the horizon low if the sky is dramatic, or high if you want to emphasize the foreground. You can suggest scale in a picture by including a small figure in a large frame. You can also use foreground objects like trees to frame a scene.

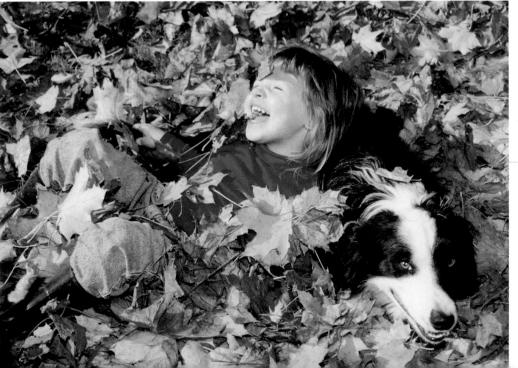

Top tip
Before your trip, read about the places you are going to visit to give you ideas for interesting places and scenery to photograph. Don't ignore your impressions of a place when you first arrive there, however, as these are also useful.

A walk in the country offers a wide range of photo opportunities, especially in the fall, when leaves are thick on the ground and the colors composed of warm, intense reds, golds, and oranges.

◀◀ **WHY IT WORKS**
This picture radiates pure, unguarded delight, the girl's enjoyment echoed by the dog's smiling face and the million glinting shades of the fallen leaves.

When photographing a family on vacation, it's even more important that you group them into a tight formation—if not, they will fill the whole frame, and the photo will have no background scenery.

▲▲ WHY IT WORKS

The "triangle" composition allows the group to be placed at the left so that the Golden Gate Bridge of San Francisco can be seen to the right. The hazy lighting may not be great for the view, but is ideal for pictures of people.

Top tip

When a subject or scene is especially appealing or photogenic, take several different pictures instead of just one to increase your chances of taking the perfect shot.

ON THE TOWN

If a city is your destination, you'll want to record its famous sights. However, try to include your family members in shots that capture a city's atmosphere, and not just its monuments and buildings. Photographs of homes, transport systems, people, and market stalls are all excellent ways of capturing the soul of a place. To photograph your family at night, amid the city lights, you must support the camera. That way, the bright lights in the background are correctly recorded without camera shake, while a burst of flash illuminates the subjects in the foreground.

ON THE BEACH

The beach is a number-one vacation destination, but taking pictures there can be a nightmare. A single grain of sand can grind the mechanism of your zoom lens to a halt, and one splash of seawater can corrode the electric circuitry. So you must store and handle your equipment carefully. Observe how the sea changes in appearance according to the weather and time of day, and time your pictures accordingly. Try to avoid views that look straight out to the sea, as these are often uninteresting, and to include strong foreground interest in your photos of sea and sand.

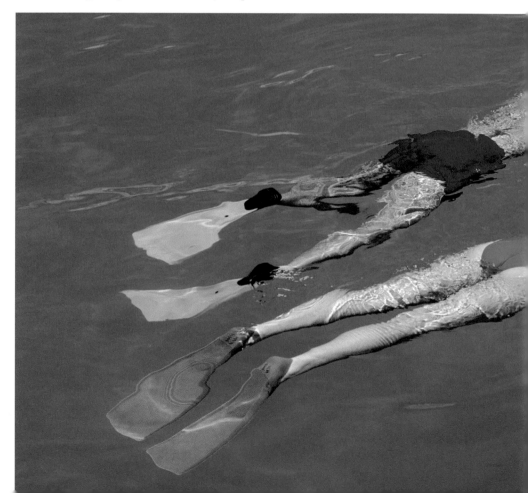

Children love playing in the sand, as do many adults, but take care when you carry your camera onto the beach. A single grain of sand can bring your expensive equipment to a grinding halt.

▶▶ WHY IT WORKS

Using the telephoto setting of a compact camera, the photographer was able to isolate his daughter from all the distractions of a busy beach—capturing her as she plays diligently on the beach.

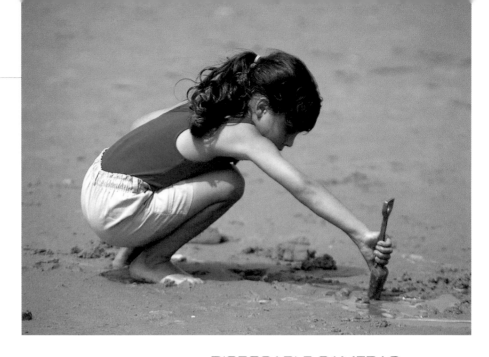

DISPOSABLE CAMERAS

For a simpler and safer way to take pictures at the beach, consider buying an inexpensive disposable camera, to be used only once. The picture quality may be not as good as your own, but you avoid any risk to your equipment. Waterproof disposable cameras are also available; these allow you to shoot in water—to a depth of around 10 feet (3m)—and can give the family an entirely new perspective on themselves.

SHOOTING IN THE SUN

Beach weather is often intensely sunny, and unless you're careful, your subjects will emerge with dark shadows under the eyes, nose, and chin. The beach acts like a golden reflector, bouncing light upward to give instant suntans. The solution is to shoot early or late in the day, when the light is softer, or to block out the overhead light with some improvised shade (see page 61). Tuck your subjects under a sun umbrella, and you're virtually guaranteed attractive lighting.

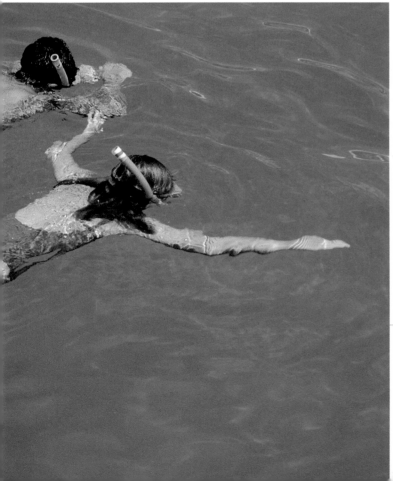

Water is almost always photogenic and makes a wonderful, clear backdrop for all kinds of pictures. The same pool of water can also change dramatically in color throughout the day.

◀◀ WHY IT WORKS

The brightly colored costumes of the swimmers combine with the blue of the water to create a rich, saturated image with strong impact.

Snow provides a stunning backdrop to bright colors and usually looks best when photographed in the morning or evening sun.

▼▼ WHY IT WORKS

The photographer caught both these shots in the early evening. A fast shutter speed was used for the action shot, the trail of snow behind indicating that the subject is moving. The second shot uses the subject as the main point of interest but also captures the layers of scenery disappearing into the distance.

SNOW FUN

Cold weather can stop batteries from working and prevent you from taking any pictures at all, since most modern cameras are dependent upon power. Avoid the problem by keeping the battery warm in a pocket next to your skin until you need to use it. If possible, have two batteries that you can swap around—one in the camera, the other in your pocket.

The other main problem is underexposure. Acres of that snow can make the camera's meter believe there is more light than there actually is, and your subject can be rendered too dark. With a fully automatic camera, the only solution is to use flash for a subject within about 10 feet (3m). Most SLRs, on the other hand, offer some form of exposure compensation, so that you can increase the amount of light that falls on the film. Aim for a mix of static and moving shots. Be aware that there's a slight delay from the time you press the shutter to the time when the picture is taken, and you'll need to anticipate that with fast-moving subjects (see *Active Portraits*).

Top tip

When taking pictures in the snow, try to avoid overcast conditions, as snow will appear gray and flat. Daylit snow looks best in the morning or evening sun, which shows off the snow's texture.

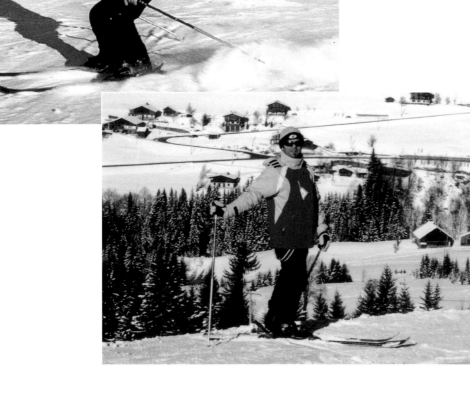

When you are on vacation, try, if possible, to take pictures of the people who live in the places you visit. This can bring a more enduring, documentary-style touch to your vacation shots.

▶▶ WHY IT WORKS

The photographer took this picture of a local man while she was on vacation in South Africa. The man's stance and pose convey dominance and strength, suggesting that he may be a leader or chieftain. But the location of the portrait— just outside his home—prevents the picture from looking staged or posed.

OVERSEAS TRIPS

When you go on an overseas trip, aim to produce as complete a record of your vacation as possible, including shots taken from trains, airplanes, or cars, using a fast shutter speed. Look out for interesting details, such as the menu at a restaurant or unusual street sights. When you get to a new destination, check out the postcards for sale—they'll give you ideas for the best vantage points and angles. Photograph your traveling companions on sightseeing visits, but also outside your stopping places. Look out for opportunities to photograph people in national dress and local characters who tell you something about the place. Above all, have fun taking pictures!

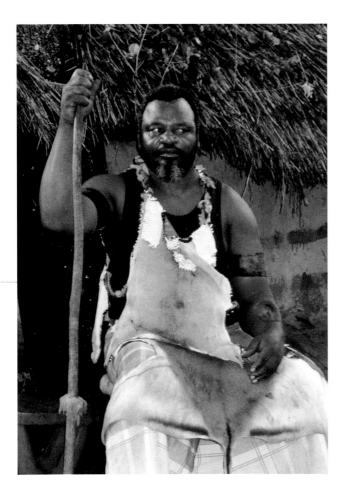

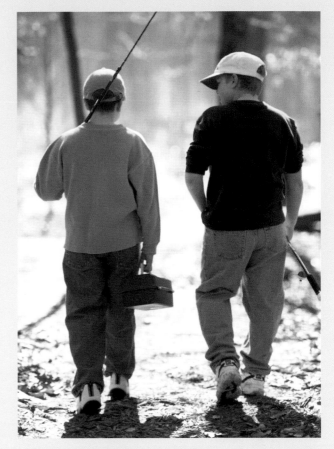

"Snapshot" mode

The way you approach your photography is more important than the equipment you have. When you're out and about, it's easy to slip into "snapshot" mode—simply lifting the camera to your eye and shooting without much thought. Although taking pictures may not be the purpose of the trip, and you'll probably want to avoid formal poses, you'll certainly get better results if you follow these four basic guidelines:

Consider (1) the quality and direction of the light, (2) whether the background is attractive and appropriate, (3) where you place your subjects, and (4) how big they are in the frame. That may sound like a lot to have in mind, especially if you're taking pictures on the move, but with experience you'll be able to assess a situation in seconds and know exactly what you want to do.

DIGITAL DIALOGUES

These days, taking a picture is only the beginning. If you shoot digitally, or scan a photograph that was taken with a conventional camera, you give yourself virtually unlimited control over the image. Once it's in the computer, you can correct poor exposure and bad light, improve colors, and manipulate your images to achieve all kinds of special effects and compositions. In fact, it's fair to say that the main limit to what you can do lies in your imagination.

This typical toolbar from one of the leading graphics manipulation software packages provides some idea of the wide range of tools available when you come to enhance and manipulate your digital images.

DIGITAL ESSENTIALS

Whether you shoot your photo electronically or scan a picture from a conventional camera, once the image is in the computer, you have virtually unlimited control over it.

Marquee

Lasso

Crop

Airbrush

Clone stamp

Eraser

Blur/Sharpen/Smudge

Path component selection

Pen

Notes

Hand

Foreground color

Default colors

Standard mode

Standard screen mode

Move

Magic wand

Slice

Pencil/Paintbrush

Art history brush

Gradient

Sponge/Dodge/Burn

Type

Line/Shapes

Eyedropper

Zoom

Switch colors

Background color

Quick mask mode

Full screen mode

Jump to ImageReady

Full screen mode with menu bar

The software supplied with your computer allows you to manipulate your photographs in ways that are unimaginable in the traditional photographic darkroom. Examples include changing the position of elements within a single picture or combining parts of different images to produce something completely new. Even the most basic programs have more than enough features to satisfy the needs of amateur photographers—and if you outgrow them, there are always more advanced packages to explore.

KEY TOOLS

The array of options can seem overwhelming at first, but take one step at a time and you will soon gain confidence. Begin by studying the various tools that are available to you. These are accessed by means of icons on floating "palettes" via pull-down menus (see left). Although tools vary from program to program, all packages share common tools and commands that perform fundamentally the same functions.

The key tools are those that enable you to select a part of the image on which to work. These are generally known as "marquee" or "lasso" tools. The area selected can be a conventional shape, such as a square or circle, or a free form defined by the user. It can be just a small part of the picture or all of it. Once an area is selected, you can move it, copy and paste it, or change it in whatever way you choose.

SEND IN THE CLONES

Some of the manipulation tools, such as the "rubber stamp" and "magic wand," allow you to clone parts of an image—that is, to copy it exactly. This is useful if you want to fill in areas of the sky, for example, or remove a spot on someone's face. Select part of the adjacent area and then copy it over. The "paintbrush" tool allows you to color different parts of the image. You can vary the size of the paintbrush and the "pressure" used, giving you enormous control. The

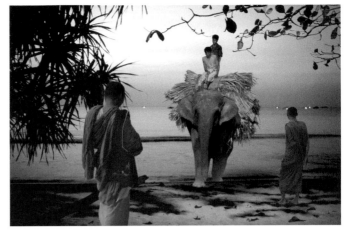

Layers make it easy to produce complex montages like the one shown right. The layers are stacked one on top of the other and are transparent until something is added to them. You can continue to adjust each layer separately until you are completely satisfied with the overall result.

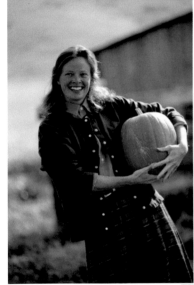

In the first image (above), the object in the background merges with the woman's head. The "rubber stamp" or similar cloning tool can be used to copy the color of the sky and then paint it over the object to remove it from the image.

"airbrush" tool has a spray-paint effect that allows you to spray your image, graffiti-like, with color. The "pencil" draws hard-edged lines on your image. There is usually also a tool for "sampling" any color that already exists in the image, so that you can choose any color from one part of the image and match it exactly when coloring another part.

ZOOM PRECISION

When the image is displayed on the screen at normal size, it's often hard to see precise details, especially when you're working on a small area, such as an eye. The "zoom" facility on the toolbar allows you to enlarge the image to the point of seeing the pixels that make it up, giving you the ultimate in retouching accuracy. An "eraser" tool, which enables you to remove parts of the image, works in essentially the same way as a regular pencil eraser. More subtle control can be found in the "dodge" and "burn" tools, which let you progressively lighten and darken any area of the picture without altering its color.

LAYER CONTROL

One of the most important features of current imaging software programs is the ability to place various parts of the image, and manipulations, on separate "layers"—like sheets of clear plastic with designs on them. This makes it possible to combine, resize, and alter elements with unparalleled control.

CORRECTING BRIGHTNESS AND CONTRAST

Despite the accuracy of modern exposure meters, lighting can sometimes spoil a photo. The background may be too bright and the people too dark; the subject may be overexposed; the lighting may be too flat or too harsh. With digital imaging, many such defects can be remedied.

If your original photographed image is too flat (low in contrast), you can increase the contrast using the Contrast slider (below, right). If your image is too bright, you can use the Brightness slider to make your image darker.

You can use the Curves control (below) to increase contrast and manipulate color.

All software packages offer control over brightness and contrast, sometimes with a wide array of tools and techniques to choose from.

AUTO SETTINGS

In most cases there is an "auto" function that resets the brightness and contrast—and sometimes the color—for you. Use this first. It generally brings a considerable improvement, which may be enough in itself. Sometimes, though, you'll still need to fine-tune the brightness and contrast to a greater degree. Most programs have separate controls for each of these, in the form of simple slider controls, for example (see above). The effect is clearly shown on the screen, so it is usually a matter of adjusting the controls until you achieve the effect you want.

Some programs have more advanced options, such as "levels" and "curves." Levels allow you to alter a picture's brightness and contrast by means of sliders beneath a map of the picture's tonal values (called a "histogram"). The curves control is a highly powerful means of color adjustment that also affects brightness and contrast.

In the top image of this girl, the picture is very dark. The center image is brighter than the first, making the overall lighting more balanced. The third image is far too bright.

SELECTIVE CONTROL

You won't always want to change the contrast or brightness of the entire image. A tool—usually known as a "marquee"—enables you to select just part of the photo. Then any changes you make in contrast and brightness affect only that area. If your subjects were harshly lit by the sun and the background was dark and flat because of shade, for example, you could select the people and soften the contrast on them while increasing the contrast on the background.

You can use a tool, usually called the "marquee," to select a dark, unexposed face (above) and brighten just that, leaving all else unchanged.

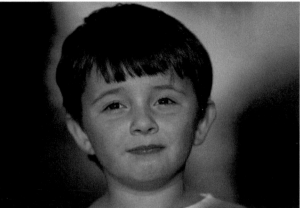

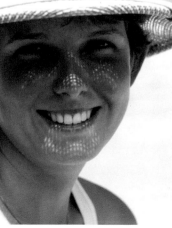

DODGING AND BURNING

An even more subtle way of controlling brightness and contrast is to emulate some techniques from traditional photographic printing. "Dodging" is a way of making one area of the picture lighter. It is done by placing a circle of the right size over the area that's too dark, and clicking the mouse until you achieve the degree of lightness that you want. The colors remain the same—it's just the tone that changes. "Burning" has the opposite effect—enabling you to darken an area selectively.

In the first picture (above), specific areas of the woman's face were selected and either darkened using the "burn" tool or lightened using the "dodge" tool. The result (right) is a more attractive shot. The size of the area to be changed is indicated by the size of the circle (above).

Top tip
Don't be too heavy-handed when dodging and burning. Add or remove a little at a time until you achieve the results you want. If you are too hasty, you can ruin the picture.

ADJUSTING COLORS

When colors come out wrong, the computer can make them right.

It takes a certain amount of experimentation at first to achieve the color you want, but once you surmount the initial learning curve, you'll find yourself making adjustments quickly and easily. Take some notes as you go along for reference purposes.

Sometimes a pervasive tinge, or color cast, is a desirable effect—the glow of a sunset, for example. Other times, the color is accurate but neutral, and the image lacks mood. Try adding a little orange or blue—or any color you choose—to help enhance it.

STRONG OR SUBTLE

Sometimes, simply using the "auto" option to correct brightness or contrast (see page 158) corrects the colors also. But often a little more adjustment is necessary.

The exact process depends upon your software, but it

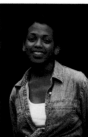
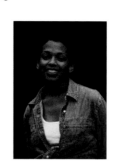

Too little yellow

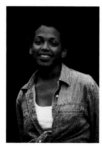

Too much magenta

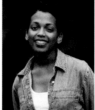

Too little cyan

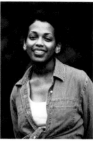

Correct version

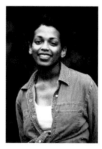

Too much cyan

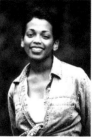

Too little magenta

Too much yellow

Simple sliders for the adjustment of an image's color balance (left) are found in all imaging programs. Experimenting with the controls is the best way of learning how to improve color in a picture (right).

Lighting conditions

Photos taken in fluorescent or tungsten lighting can appear green or deep orange; shade can give the image a faint blue tint; and evening sun can give it too much warmth. These are some of the problems you can solve on a computer.

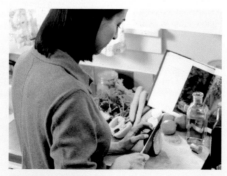

Fluorescent lighting

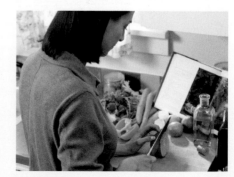

Corrected color

usually consists of slider controls that allow you to alter the three constituent colors of a photograph—cyan (blue), magenta, and yellow. The cyan slider enables you to add cyan and remove red; the magenta slider lets you add magenta and remove green; and the yellow slider allows you to add yellow and remove blue. Why so complicated? Because color itself is complex, and there is no easy way of matching the multiplicity of tones and tints found in the real world.

HUE AND SATURATION

It is usually also possible to adjust the saturation, or depth, of the color. Increasing the saturation enriches the color—useful if the shot was taken in flat, soft lighting and needs more sparkle. Be cautious, though, because it's easy to go too far and make the saturation unnatural. Reducing the saturation is another effective way to change the mood of a picture, giving it more pastel tones. In general, small changes in saturation produce the most realistic results.

CHANGING COLORS

One of the most enjoyable aspects of digital enhancement is being able to change the color of anything in the picture. If you photographed someone wearing a red top that now looks too bright, you can change it to green or pink—or any color you like. Just select the area you want to change, then choose the color to replace it. Be careful, however, to select *all* of the item, and no part of any other object of a similar color.

The imaging program's hue and saturation control box enables you to increase image color or drain it away at will.

Original image

Color-changed image

BLACK-AND-WHITE IMAGING

Black and white can sometimes have greater impact than color. That's why it continues to be widely used in fine art, photojournalism, and advertising. With digital, you can transform color images into monochrome.

When you remove color, you concentrate attention on the line, form, and shape of the subject, which is why so many photographers find black and white a more expressive medium.

REMOVING THE COLOR

Make a copy of your original photo before you strip out the color. The exact method of removal varies depending on the software used, but to eliminate the color permanently, begin by converting the image from a "color" file to a "grayscale" file. The grayscale file is considerably smaller in size, making it easier to work with and to store. If you think you might want to bring the color back at some stage, "desaturate" the image completely instead. While it will look black and white, and print black and white, the color information will be stored, and the image file will remain the same size.

Original image

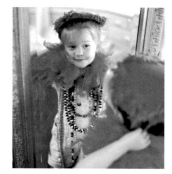
Black-and-white conversion

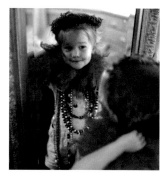
Sepia toned

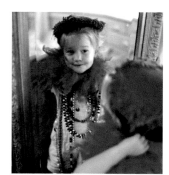
Touch of color

JUST THE BEGINNING

That may sound like the end of it. You simply print out your picture. But in fact, producing a black-and-white image is just the beginning. Next, you can use your computer to apply a host of creative effects.

First, you can vary the contrast of the image, as you would in conventional printing, by using different printing papers. Some images look better with delicate tones and little contrast, while others benefit from a "soot and whitewash" approach, with strong blacks and pronounced contrast.

TINTING AND TONING

You can then "tone" the image. Many people love the sepia effect that was popular before color film and paper were invented. Most software packages offer this effect, and with greater precision than that of the traditional darkroom. Blue can work in a similar way, and so can green and orange—why not sample the range of choices to see which ones you like?

TOUCHES OF COLOR

Your family album may contain old photos that were hand-colored—taken in black and white, and then painted in whole or in part. You can replicate this effect on the computer—though it does need practice. "Import" your black-and-white image as a "layer" into a new color file, and then use any of the paintbrush tools to add color selectively. The effect is most successful when only part of the subject is painted.

CROPPING AND CHANGING FORMAT

You can't always frame your picture precisely—but with digital help, you can crop the image and change the format to your heart's desire.

If your subject is too distant to fill the frame, or you think that your horizontal composition would look better upright, you can easily make the necessary changes.

CROP SHOP

Use the selection tool to define the area you want to keep, and then either "crop" or "cut." If you're not sure how you want to crop the picture, make several copies and check out different options—saving the one that looks best.

Viewing frames

Make a viewing frame from two "L"-shaped strips of black cardboard. Place the frame on top of the prints, or against the computer screen, to check how different crops will look before you do them.

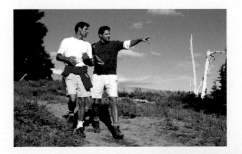

By moving one or both of the two L-shaped strips outward and inward, you can preview the crop of your final image.

Software cropping allows you to convert one kind of crop into another, depending on the emphasis you wish to achieve in your photograph. (see also page 49).

CREATIVE POTENTIAL

Old photos that you scanned into the computer call for a creative approach. Instead of seeing the picture as it is, think about its potential. With digital, it costs nothing to try things out. You can be totally unorthodox—cutting a face in half and placing one part at the edge of the frame, for example—and in the space of a minute you'll know whether the idea worked or not.

Top tip

Don't think you can simply use the computer in place of your zoom lens, however. Every time you crop an image and throw part of it away, you lose quality, which can limit the size at which you can ultimately print it.

So instead of regarding digital after-treatment solely in terms of salvaging unsuccessful pictures, plan for computer enhancement at the time you take the shot. When photographing a group, for example, you could have in mind a long, thin panoramic print, and shoot accordingly.

ARTISTIC AND PHOTO EFFECTS

Many people would like to be able to commission a painting of their loved ones—or to paint it themselves if they could. Digital images can be turned into paintings with a few clicks of the mouse.

With the variables on your watercolor tool, you can create a watercolor image with a few clicks of a mouse.

Almost all software packages include a range of filters that change the image in fundamental ways. Among these you'll find "artistic" filters in different painting styles, such as watercolor, pastel, fresco, palette knife, colored pencil, and sponge. Just choose your image, select the filter, and wait a few minutes while the computer does its work.

The computer's default settings don't always give the best results, however, so experiment with the various options offered. You can also combine several of the artistic filters in a single image, using them one after the other to produce a unique picture.

The "watercolor" filter is a good starting point. It doesn't distort the image too much—not everyone wants to see his children in a cubist style!—and it gives a subtle and pleasing effect. Chances are you'll dislike some of the filters, and you may only return to one or two. But you're sure to produce some interesting portraits that will impress your family and friends.

PHOTO EFFECTS

Digital imaging also makes it easy to replicate some of the classic effects developed by photographers, such as grain, lith, solarization, and reticulation. These can be demonstrated, and implemented, with a few clicks of the mouse. Use them to take you beyond "picture-taking" into "picture-making"— where the image you captured in the camera is transformed into an original work.

Advanced painting techniques are easily emulated using the various filters available to you on your imaging software.

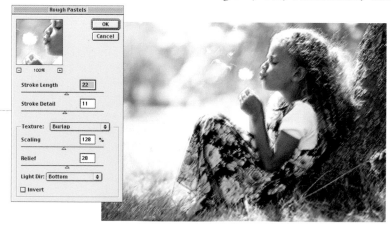

VIGNETTES, BORDERS, AND FRAMES

Add interest to your portraits by framing them. The frame concentrates attention on the subject and completes the picture.

Once you have drawn the shape you want over the picture, simply apply a feather to make a soft, diffused edge.

VIGNETTES

A vignette is a plain white or colored area—usually a circle or an oval—placed around the picture. To create a vignette, select the part of the image you want to frame. "Feather" the selection so that its edges will merge into the surrounding area, and then use the cropping tool to remove the part that's not required. Use 20 pixels as a starting point for feathering, and proceed gradually.

IRREGULAR SHAPES

Circles and ovals are not the only shapes. How about the more contemporary look of a diamond, or an S-shape? Or use the "eraser" tool to rub away the edge of the image to create an irregular shape.

Vignettes can be any color, but because they take up a large part of the image area, they look heavy if they are too dark. Pastel colors or white are a better choice.

Many software programs offer extensive framing options that allow you to frame your pictures with decorative borders.

BORDER OPTIONS

If you want a darker frame for your picture, choose a border whose width can be varied depending on the effect that you want. To make a plain border, create a new layer that is slightly larger than your picture, give it the color you want, and then place the photo on top of it, so that the edges of the layer form the border.

With the aid of a scanner, you can scan in natural textures and colors, such as wood grain, and bring the two images together to produce your own inventive borders.

FANCY FRAMES

When choosing your frame, be sure to check out your software. Many programs feature "guided activities" and templates for an extensive range of framing options, from the subtle to the exotic. Select the frame, and the program automatically places it around the image for you.

COMBINING IMAGES

Top tip
To avoid images standing out unnaturally from the background, it's a good idea to soften the edges by "feathering" when you cut them out. When transposing a person from one setting to another, a one- or two-pixel "feather" usually works well.

Combining elements from different pictures is useful and enjoyable. You can swap backgrounds, fill in for whoever missed a group photo or blinked in a shot, or even create fantasy compositions.

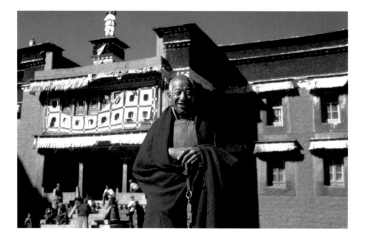

Suppose you have a photo that captures someone beautifully, but the background is unattractive—and in another picture the background is perfect. All you need to do is cut the person out and then place him or her in front of the background you favor. Many software programs automate the process for you. If not, you must use the "lasso" tool with care to achieve a convincing effect. Work at the maximum enlargement possible, and feather the selection (see page 165), so it doesn't show a hard edge against the other image.

When choosing a new background, be sure it matches the person in terms of lighting and overall mood. With the subject and the background on separate layers, you can resize the subject to fit the background.

Once you have carefully cut your subject out from the background, you can place him in front of any scene you like, although the lighting in both shots must be similar in strength and direction for the picture to look right.

The Copy and Paste commands are common to all software applications. A copy of a selected area is transferred to a part of your computer called the clipboard. It can then be pasted onto another image. Here, leaving a space in the grouped shot (left) made it possible to add a subject at a later stage (below).

MONTAGING ELEMENTS

In a series of group pictures, it often happens that one or another person blinked, looked away, or frowned. Assuming that the position, lighting, and poses didn't change, it's possible to replace the unsatisfactory parts with more pleasing ones. Make a copy of the files you want to "cannibalize," carefully cut out the part you want, paste it into position in the other photo, and then blend to make it look natural. This needs to be done meticulously, but it becomes easier with practice, and patience during the learning stages will repay you with rewarding results.

MISSING PERSONS

Montaging elements can also be useful when someone is forced to miss a family occasion. Leave a space for the absentee in the lineup, and next time you see the person, photograph him or her in the same way so you can complete the image.

Top tip

When combining images, it's best to use the layer control (see page 157) to allow you to manipulate images more easily. You can also use the "blending" options available in most software packages to help you determine how the layers relate to each other—for example, one layer completely covered by another, or the two merging together in a ghostly way.

SHARING YOUR DIGITAL IMAGES

After you've cropped and manipulated your photos, you can print them, e-mail them, or post them on the Web for your friends and family to see.

The obvious way to share your images is to print them. A basic inkjet printer, fed with special paper, can produce "photo-quality" color prints. The regular format is 8 x 11 inches (20 x 28 cm), but printers that take 11 x 17-inch (28 x 43 cm) are also available. You can print a single image or put several together on the same sheet. Inkjet printers also accommodate smaller sheets of paper and a wide range of other media, including labels, postcards, greeting cards, banners, iron-on transfers—and even temporary tattoos.

You can also have your digital images printed by a laboratory onto traditional photographic paper. This lasts longer than inkjet material, which can fade, especially when exposed to light for extended periods. However, some manufacturers of inkjet printers now offer specialist media that guarantee the long-term quality of images.

E-MAILING

Within minutes of capturing an image, you can have it in your computer and on its way to relatives anywhere in the world—thanks to e-mail.

You may not want to send an image exactly as you downloaded it, however, because the file size may be too big and take a long time to mail. How you send it will depend upon what the recipients are going to do with the image. If they will only be viewing it on screen, save a copy that can be resized to fill the screen of a 17-inch (43-cm) monitor (the most widely used screen size), at a resolution of 100 dpi. The file will almost certainly be in a JPEG compression format, but if not, save it in that format. If the recipient is likely to want to print the photo at a high quality, you must send the file in the resolution at which it was captured. This process will take longer, but if you have a high-speed modem or cable connection, the transfer time should not be excessive.

WEB PAGES

Many people have their own Website—whether for business or pleasure. And as anyone who surfs the Net knows, the speed at which images load is extremely important. If they take too long, all but the most determined visitors will go elsewhere. Yet the images must also be sharp and clear.

Slide show

Another way of sharing your photos is to put on a show, using your computer monitor. You can either open the images individually, or more conveniently, use the "slide show" facility included on many digital software programs or available separately at a reasonable cost. This can be programmed to show all of the images in a particular folder and preset to change after a specified period—so you can sit back and enjoy the show also. Slip a music CD into the tray, and you'll have a soundtrack.

Images on digital cameras can normally be viewed on a regular television set using the wires provided. Pictures on a computer can be "uploaded" to the memory storage card on a digital camera for presentation purposes.

You must therefore strike the right balance between quality and download time. The files will almost certainly be 100 dpi JPEGs—the standard "currency" of the Web—but if your program offers you the option of JPEG compression, try a "low" setting first, because it will load much quicker. Only proceed to "medium" or "high" compression if the on-screen quality is not good enough.

WEB GALLERIES

Many photo processing labs offer to upload your processed films to an Internet photo album. Others let you upload images to an Internet photo album from your computer using a Web browser. With this kind of service, for which there is usually a small monthly charge, you don't control the page design and cannot create links to other sites. But once the images are uploaded, you can give the Web address (formally called the Uniform Resource Locator—or URL) to your friends and they can order prints direct from the online lab.

There are lots of free sites on the Web that allow you to share your photos with the world. It is one of the easiest ways of letting family members and friends across the country or overseas keep up with all your news.

TROUBLESHOOTING

Sometimes photos are disappointing, and you can't figure out why. Here are some of the likely answers. Over the next four pages we show examples of common faults, discuss what happened to cause them, and offer suggestions for avoiding them in the future.

THE SUBJECT IS TOO CLOSE

◄◄ **WHAT WENT WRONG**
The camera was nearer to the subject than the minimum focusing distance.

HOW TO AVOID THE PROBLEM
Check your camera manual to see how close you can be while keeping the subject in focus.

THE EYES ARE OUT OF FOCUS AND THE PHOTO LOOKS "WRONG"

FOCUS IS ON THE BACKGROUND, NOT THE SUBJECT

▼▼ **WHAT WENT WRONG**
Because the subject was off-center, the autofocusing system focused the lens on the background.

HOW TO AVOID THE PROBLEM
When you use an autofocus camera and the subject is not in the middle of the frame, you must operate the focus lock. Place the central focusing sensor over the subject, press the shutter release part way, and then reframe the shot (see page 128).

▲▲ **WHAT WENT WRONG**
Focus was not on the eyes.

HOW TO AVOID THE PROBLEM
When shooting close-up pictures, you must make sure the focus is on the eyes, or the entire picture can look ill-defined.

GREEN COLOR CAST

▶▶ WHAT WENT WRONG
The picture was taken under fluorescent lighting.

HOW TO AVOID THE PROBLEM
Switch the light off and use daylight; use flash;
find a different location; or, if using a digital
camera, set the "white balance" to fluorescent.

ORANGE COLOR CAST

▼▼ WHAT WENT WRONG
The picture was taken in regular
household lighting.

HOW TO AVOID THE PROBLEM
Switch the light off and use daylight to
illuminate the subject; use flash; find
a location that has a different form of
lighting; or if using a digital camera,
set the "white balance" to tungsten.

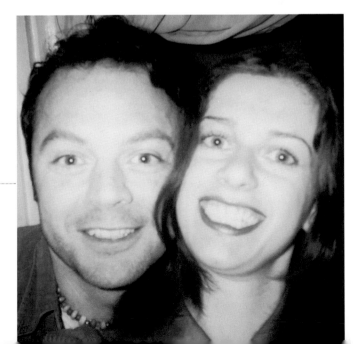

SUBJECT HAS GLOWING RED EYES

▶▶ WHAT WENT WRONG
Flash reflected back from the blood vessels at the back
of the eyes, making them appear red.

HOW TO AVOID THE PROBLEM
Use the camera's red-eye reduction system, if present;
switch on the room lights, so that the eyes open up
more; if you have an SLR (Single Lens Reflex) with a
removable flash unit, place the unit higher than the
camera, or to one side of it.

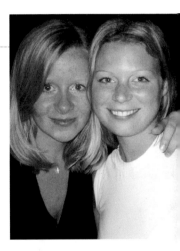

FOREGROUND SUBJECT IS OVEREXPOSED

▶▶ WHAT WENT WRONG
The subject was too close to the flash,
and so received too much light.

HOW TO AVOID THE PROBLEM
Flash units usually operate best when the
subject is 5–10 feet (1.7–3m) from the
camera, depending on the speed of the
film. With fast film the range is greater,
but care must still be taken not to have
the subject too close to the camera.

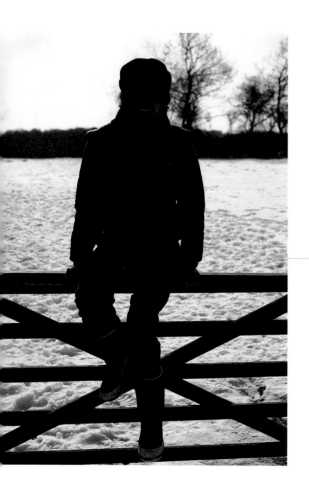

ORANGE LINES ACROSS THE PICTURE

▶▶ **WHAT WENT WRONG**
Film has been "fogged" by stray light.

HOW TO AVOID THE PROBLEM
Never open the camera back until the film is completely rewound.

SUBJECT IS TOO DARK

◀◀ **WHAT WENT WRONG**
The subject was too far away for the flash to illuminate it fully.

HOW TO AVOID THE PROBLEM
Check the effective range of your flash unit; get closer; use faster film; check that your fingers aren't over the flash.

PICTURE TOO DARK OR TOO LIGHT

▶▶ **WHAT WENT WRONG**
The picture is underexposed (or overexposed) because too little (or too much) light hit the film or digital CCD (see page 18).

HOW TO AVOID THE PROBLEM
If all of the pictures are affected, have the camera's meter checked. If only one or two pictures are affected, lighting conditions could have caused the problem.

THE SUBJECT IS BLURRED

▶▶ WHAT WENT WRONG
The subject moved during a relatively long exposure.

HOW TO AVOID THE PROBLEM
Use a faster film to increase the shutter speed; ask the subject to stand completely still; use a tripod.

STRANGE SHAPE IN THE PICTURE

THE PICTURE IS BLURRED

◀◀ WHAT WENT WRONG
Lack of light caused the shutter to remain open for too long, resulting in camera shake.

HOW TO AVOID THE PROBLEM
Use a faster film to increase the shutter speed; find a brighter location; use flash.

▲▲ WHAT WENT WRONG
The photographer's finger, or part of the camera strap, slipped in front of the lens.

HOW TO AVOID THE PROBLEM
Hold the camera at the sides and keep the strap around your neck.

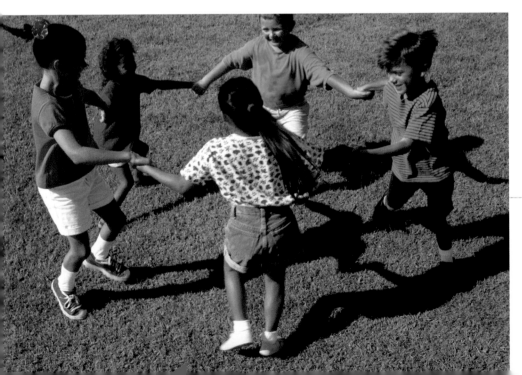

THE PICTURE IS NOT AS YOU FRAMED IT

◀◀ WHAT WENT WRONG
"Parallax error"—on a compact camera, what the lens "sees" is different from what the viewfinder shows at close quarters (see page 12).

HOW TO AVOID THE PROBLEM
Don't go too close to the subject.

Glossary

Aperture Circular hole in front of or within a lens, the size of which determines the amount of light that reaches the film. Aperture size is measured in f-numbers or f-stops.

Autofocus System featuring in most compact and SLR cameras that focuses an image automatically without the need for manual adjustment by the photographer. Most autofocus systems operate by means of an infrared light signal that bounces off the subject and returns to the camera. The distance is measured by the autofocus sensor, and the lens elements adjust in order to focus accurately on the subject.

Back lighting Light that comes from behind the subject in a photograph.

Camera shake Term used to describe the slight movement of the photographer's hand when a picture is taken. Most intentionally out-of-focus pictures are caused by camera shake. Camera shutter speed must be fast enough to prevent camera shake.

CCD (Charged Coupled Device) Light-sensitive receptor in a digital camera, the equivalent of film in conventional cameras. It consists of a rectangular grid of light-sensitive picture elements (pixels) that generate an electrical current according to the amount of light they receive.

Compact Flash Thicker type of removable memory card used in many digital cameras (see SmartMedia). Compact Flash cards are used by Canon, Fuji, and other manufacturers.

Contrast Difference between the amount of light reaching the lightest and darkest parts of a scene. Contrast is influenced by a number of factors including the subject, the lighting, flare, and film speed.

Depth of field Distance in front of and behind the subject which is acceptably sharp. For most subjects it extends one-third of the distance in front of, and two-thirds of the distance behind, the precise part of the subject focused on.

Digital zoom False zoom effect used in some digital cameras that enlarges information from the center of the CCD using interpolation.

DPI (Dots Per Inch) Measure of resolution on printed paper.

Exposure Amount of light allowed on to the film or CCD (controlled by the size of the lens aperture) and the length of time the light is allowed to act (controlled by the shutter speed).

Fill in Lighting used to lighten shadows and therefore reduce contrast.

Firewire Connector used to download digital data at extremely high speeds from a high-end digital camera to a computer.

f-number Measure of a lens's aperture. The smaller the f-number, the larger the aperture.

Flare Unwanted light scattering within the lens, resulting in a loss of contrast and sharpness in the final image. Flare often occurs when the subject is back-lit.

Image manipulation software Computer software that enables the user to enhance and alter a photograph that is stored in digital form.

Interpolation Process in digital imaging that uses software to add new pixels to an image by analyzing adjacent pixels and creating new ones to go between them. This process can reduce quality.

JPEG (Joint Photographic Experts Group) Universal format for storing digital image files so that they take up less space. Most digital cameras save images as JPEG files to make more efficient use of limited-capacity memory cards.

LCD (Liquid Crystal Display) Flat screen display in digital cameras that enables the photographer to compose and preview pictures.

Megabyte (Mb) A unit of computer information storage capacity equal to 1,048,576 bytes.

Memory cards Digital cameras have removable memory cards sold in varying capacities, from 8 Mb to 32 Mb and more. Bigger cards are more expensive but allow the photographer to shoot more images before they are transferred to a computer.

Pixel (from PICture ELement) Smallest unit of a digital image. Mainly square in shape, a pixel is one of a multitude of squares of colored light that together form a photographic image. Pixels are arranged in a mosaic-like grid called a bitmap. The more pixels used for an image, the higher its resolution.

PPI (Pixels Per Inch) Measure of resolution on a computer screen.

Scanner Any device designed to convert a photograph, document, or picture into a digital image, which can be saved and later edited on the computer. The most common type of consumer scanners are flatbed scanners, sheetfed scanners, and film/negative scanners.

Shutter Mechanism that allows the photographer to control when and for how long the camera film is exposed to light. It

is activated by pressing the button—called the shutter release button—that takes the picture. Shutter speed is measured in fractions of a second, so a shutter speed of 1/1000 second describes a faster shutter speed than 1/200 second.

SLR (Single Lens Reflex) Describes a camera design that allows the photographer to see the exact image formed by the picture-taking lens, ruling out the possibility of parallax error.

SmartMedia The thinner type of removable memory cards, available in various sizes up to 128 Mb.

Telephoto lens A lens with a long focal length, which enlarges distant subjects within its narrow angle of view. Depth of field increases as focal length increases. The term 'telephoto' is also used to describe the long-focal-length settings on a zoom lens.

USB (Universal Serial Bus) Interface standard designed to attach different peripherals to the computer. It allows peripherals to be plugged and unplugged while the computer is still on.

Viewfinder System through which the photographer is able to see what he is shooting.

Wide-angle lens A short-focal-length lens. Also used to describe the short-focal-length settings on a zoom lens.

Zoom lens A lens that is constructed to allow for a number of focal lengths within a specific range (e.g., 35–80mm or 35–200mm). This enables the photographer to adjust the focal length (and therefore the photograph's composition) quickly without changing the lens.

Index

Credits

Quarto would like to thank and acknowledge the following for permission to reproduce their pictures;

Key: b=bottom, t=top, c=center, l=left, r=right

Steve Bavister 32, 35, 36r, 37r, 43, 44 b, 45 tl, tr, 53 t, 55 br, 56, 57b, 58 , 61, 63 c, r, 70, 72, 73, 75, 76, 77 t, 78 t, 81 bl, br, 82 bl, 93, 94, 95 t, 96, 97 t, 100 t , 103, 105 bl, br, 110 tc, 112 t, 115 r, 116, 118 br, 119 tl , tr, 120 b, 125 cl, 126 br , 129 c, 131 c, 142, 148, 151 t, 170 r, 171 l, 172 tl, br.

Belkin 22c, b.

Ronnie Bennett 33 tl, tr, 40 t, 51 b, 59, 68, 82 t, 100-101 b, 117 bl, 122 t, 126 t, 129 t, 134 l.

Sally Bond 146 t, 150.

Canon 8 l, 11, 13, 19, 22 t, 29 t.

Moira Clinch 66, 69 b, 88 bl, 173 cl.

Compaq 23 b.

Roger Cope 98 t.

Andy Davis 63 l, 127 br.

Epson 168.

Lee Frost Photography 97 b.

Fuji 20 tl, tr.

Giselle Gimblett 51t, 136 t, 153 l.

Hasselblad 17 l .

IBM 20 b.

Karla Jennings 2 c, 55 t, 141 b, 171 r.

Kodak 15 t, 16 b, 18.

Tracie Lee 170 t

Lexar Media 21,

Mark Laita Photography 23 t.

Nadia Naqib 141 t.

NMPFT/Science & Society Picture Library 17 b.

Karen Parker 102, 105 t.

Polaroid 16 t.

P.S.Images 41 r, 50, 78 b, 108, 113, 117 t, 119 b, 129 b, 138 l, 143 b.

Laetitia Raginel 152, 170 b, 171 b, 172 bc.

Paul Ridsdale 37 l, 39 t, 49, 51 bl, 53 br, 54, 95 b, 106.

Chris Rout 31 tc, 60, 62, 69 tc, 101 r, 126 bl , 131 t.

© Sinar AG Switzerland 25.

Piers Spence 48 l.

Umax 28.

Jim Winkley 36 l.

All other photographs and illustrations are the copyright of Quarto.